continuous CROCHET

D0128738

CALGARY PUBLIC LIBRARY

AUG 2016

continuous
CROCHET

CREATE SEAMLESS SWEATERS, SHRUGS, SHAWLS, AND MORE
—— with ——
MINIMAL FINISHING!

KRISTIN OMDAHL

INTERWEAVE.
interweave.com

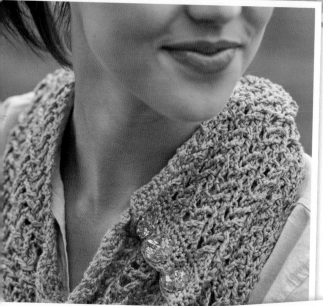

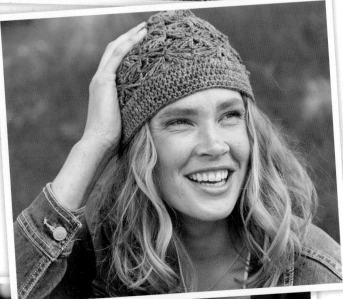

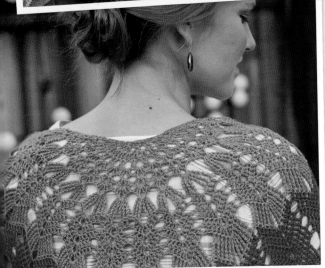

contents

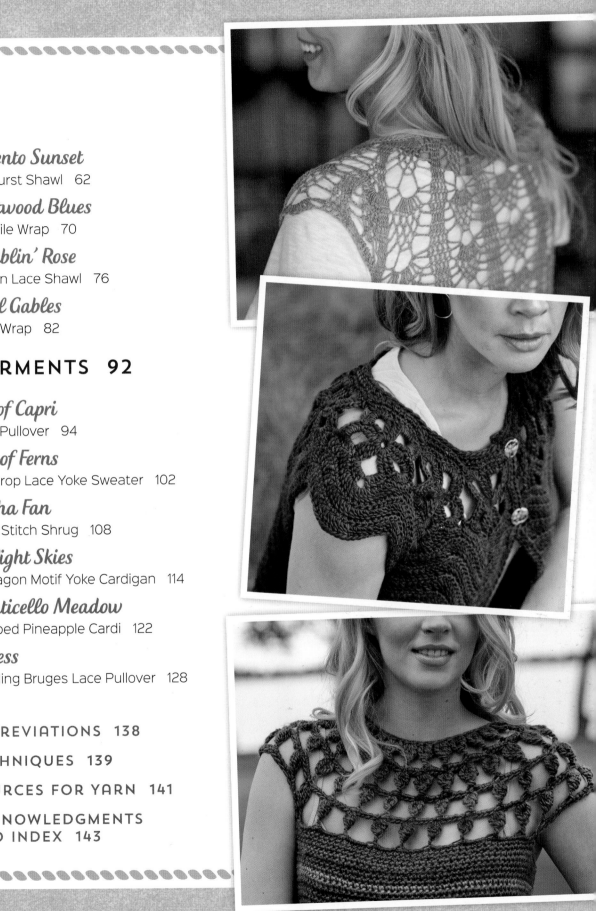

INTRODUCTION

Continuous Crochet sounds like such an innocuous title, doesn't it? Prepare for a delightful surprise as you explore the designs in this book. Because there are so many ways to be "seamless" and "continuous," I decided to try to interpret familiar motifs and techniques in ways that are inventive and striking. As a result, I have found new limits!

This collection is dedicated to a variety of ways in which one can crochet designs and shapes and joining, all without cutting the yarn. I love sewing as much as the next person, but not when crocheting. So in this collection, I've placed considerable emphasis on reducing the number of ends to weave in, while pushing the envelope on what can be done within the parameters of garment design.

I've explored three-dimensional shaping within the conventions of traditionally two-dimensional techniques: hairpin lace and bruges lace specifically. I've also spent some time showcasing ombré-gradient yarns because I love them so much.

Of course, I've also added a variety of ways to do seamless top-down garments—from crazy teardrop stitches you will love to beautiful lace stitch patterns, motif yokes, and even raglan yokes in motifs! The yokes vary from raglan to round and more.

Thank you for joining me on this journey of ways to move, meander, join, and feature beautiful yarns!

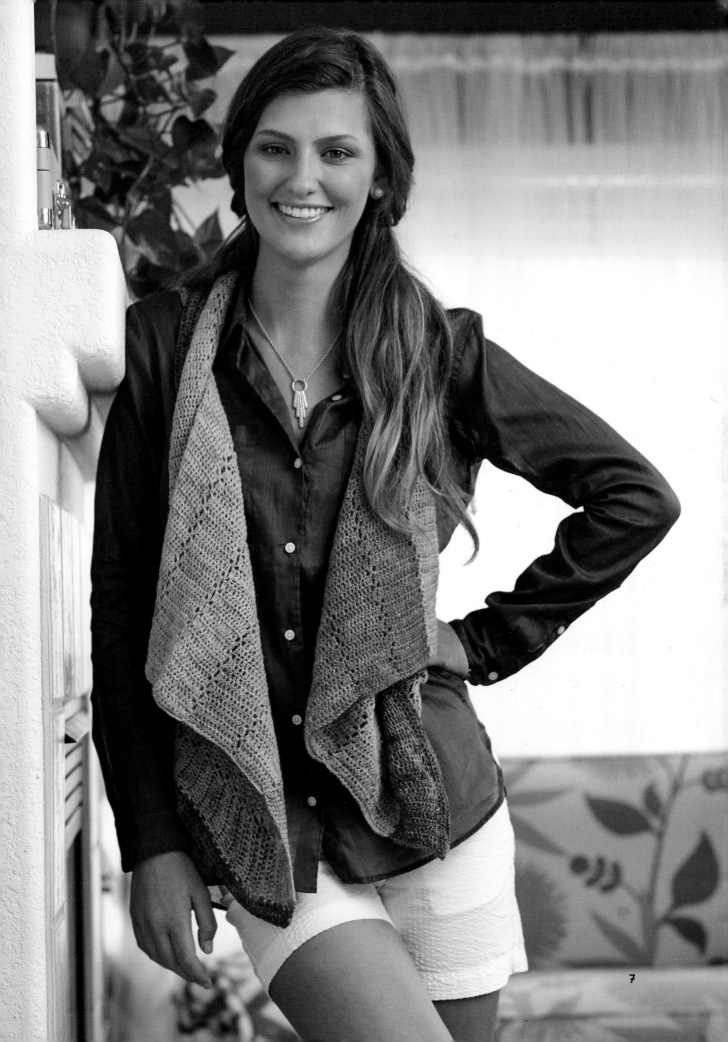

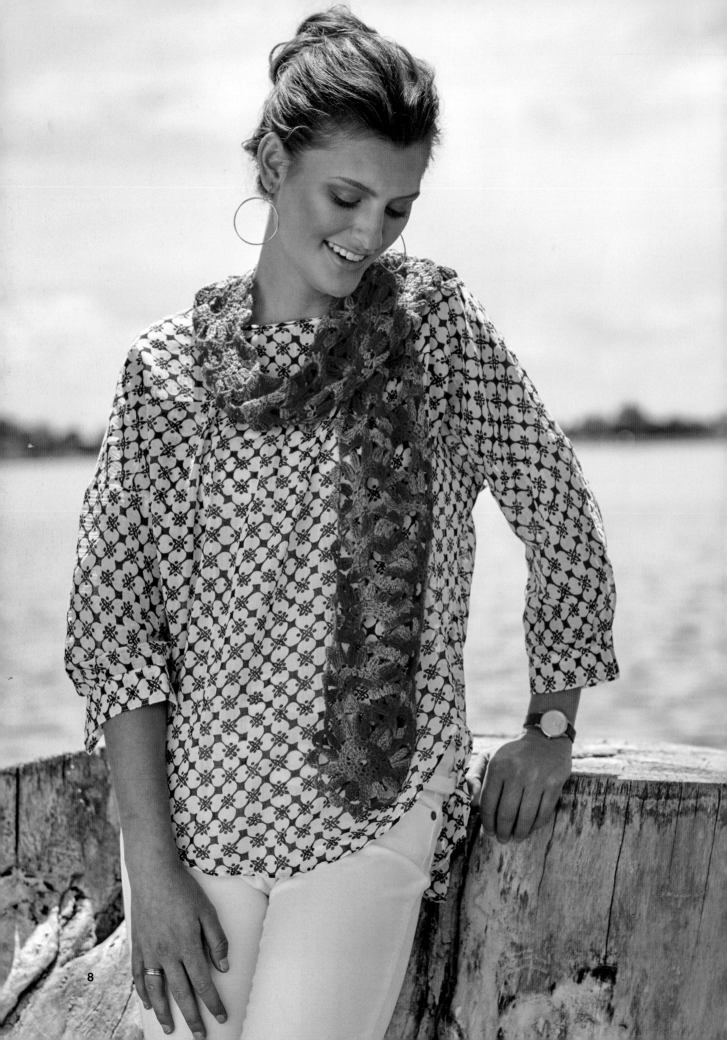

ACCESSORIES

Accessories are a wonderful way to learn new techniques: they are small, portable, and quick to gratify! Each of the hats offers a simple twist on traditional seamless, in-the-round construction methods. The cowls feature inventive texture and colorwork, and the buttoned herringbone cowl can be worn in a variety of ways because of the versatility of the buttons! The scarves explore even more skills. Think about applying these techniques in bigger projects once you master the basics. Nothing but showstoppers to follow!

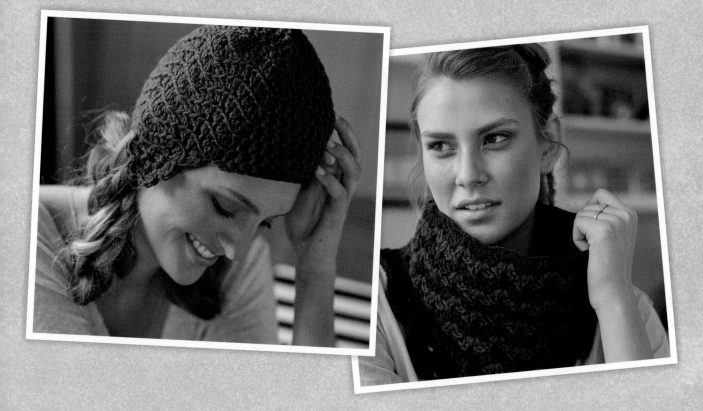

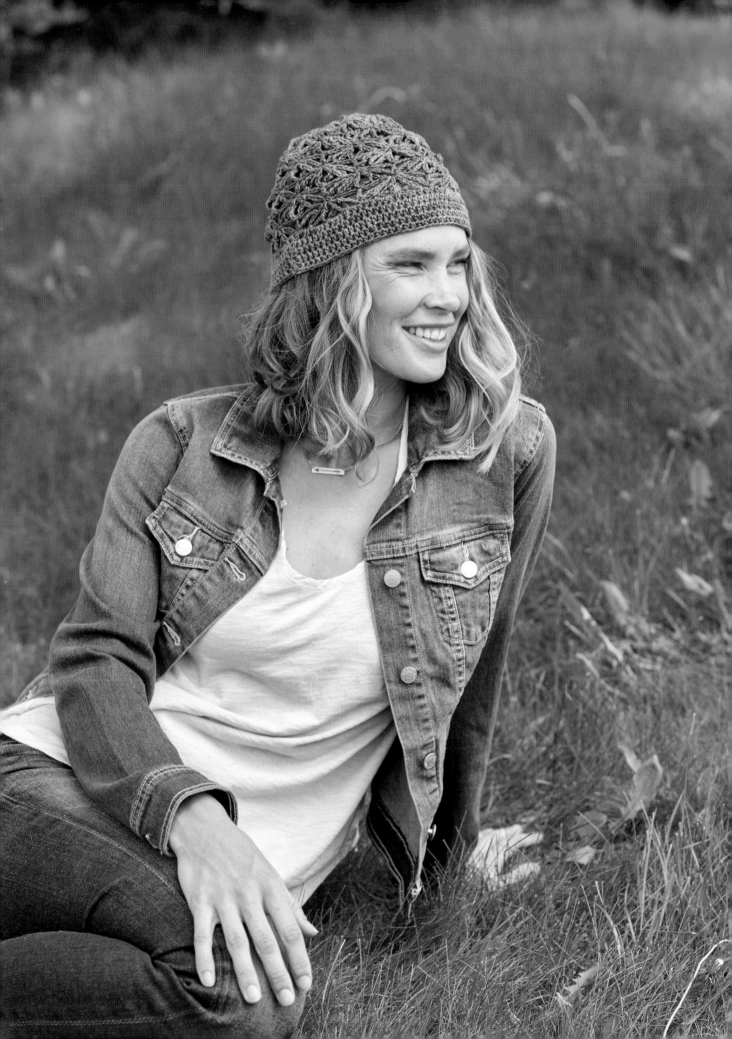

heather plum
CHAIN FLOWER HAT

This hat features a beautiful offset lace stitch pattern. It has concentric increases only in the beginning of the crown, so you can crochet the rest of the hat in the round without fussing with increases within the pattern! It's a deceptively simple technique, easy to stitch up quickly.

FINISHED SIZE
22½" (57 cm) in circumference × 8" (20.5 cm) tall.

YARN
Fingering weight (#1 Superfine).

Shown here: Bijou Basin Ranch Lhasa Wilderness (75% yak, 25% bamboo; 250 yd [229 m]/2.7 oz [76.5 g]): #14 Amethyst, 1 hank.

HOOK
G/6 (4 mm).

Adjust hook size if needed to obtain gauge.

NOTIONS
Yarn needle.

GAUGE
First 2 rnds = 3" (7.5 cm) in diameter; 17 sts = 4" (10 cm) in half double crochet.

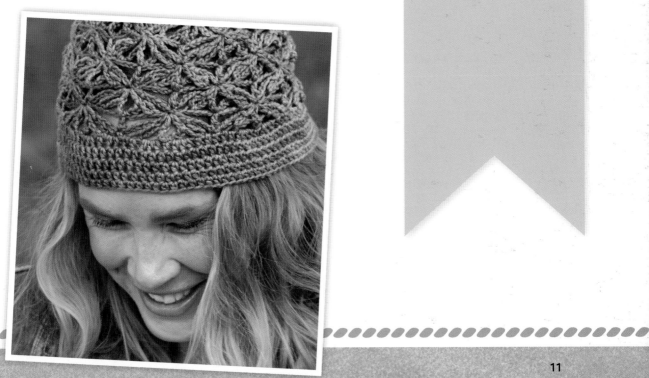

stitch guide

FAN: ([Sc, ch 5] 3 times, sc) in same st.

HAT

Ch 6, sl st in first ch to form a ring.

RND 1: Ch 3 (counts as dc), 15 dc in ring, sl st to top of beg ch-3 to join—16 dc.

RND 2: Ch 8 (counts as dc, ch 5), *sk next st, fan in next st, ch 5, sk next st**, dc in next st; rep from * around, ending last rep at **, sl st to 3rd ch of beg ch-8 to join—4 fans.

RND 3: Ch 1, sc in first st, ch 1, sc in next ch-5 loop, *(ch 3, sc) in each of next 2 ch-5 loops**, ch 1, sc in next dc, ch 1, sc in next ch-5 loop; rep from * around, ending last rep at **, ch 1, sl st in first sc to join—8 ch-1 sps; 8 ch-3 sps.

RND 4: Ch 1, fan in first st, *ch 5, dc in next sc**, ch 5, fan in next sc; rep from * around, ending last rep at **, dtr in first sc to join (counts as last ch-5 sp)—8 fans.

RND 5: Ch 1, sc in first dtr, ch 1, *sc in next ch-5 loop, (ch 3, sc) in each of next 2 ch-5 loops, ch 1**, sc in next dc, ch 1; rep from * around, ending last rep at **, sl st to first sc to join.

RNDS 6–21: Rep Rows 4 and 5 (8 times).

RND 22: Ch 2 (counts as hdc here and throughout), work hdc in each st, hdc in each ch-1 sp and 3 hdc in each ch-3 sp around, sl st in top of beg ch-2 to join—96 hdc.

RND 23: Ch 2, hdc in each st around, sl st in top of beg ch-2 to join.

RNDS 24–26: Rep Rnd 23. Fasten off. Weave in ends.

FINISHING

Weave in ends. Handwash, block to finished measurements, and allow to dry.

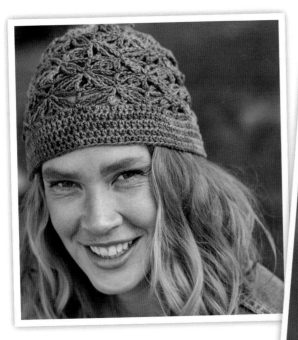

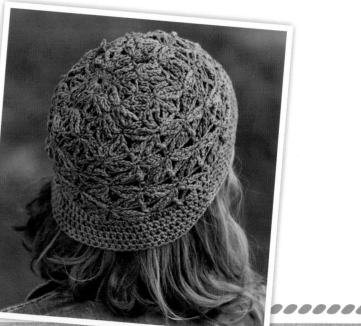

○ = chain (ch)

• = slip st (sl st)

+ = single crochet (sc)

T = half double crochet (hdc)

† = double crochet (dc)

‡ = double treble crochet (dtr)

 = fan

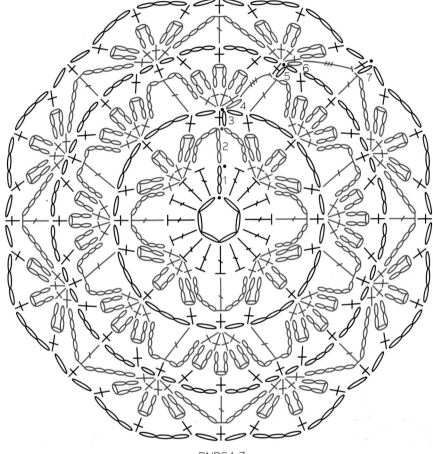

RNDS 1–7

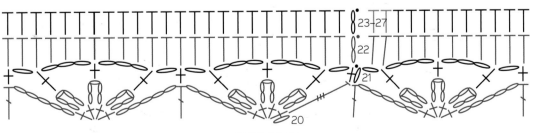

RNDS 20–27

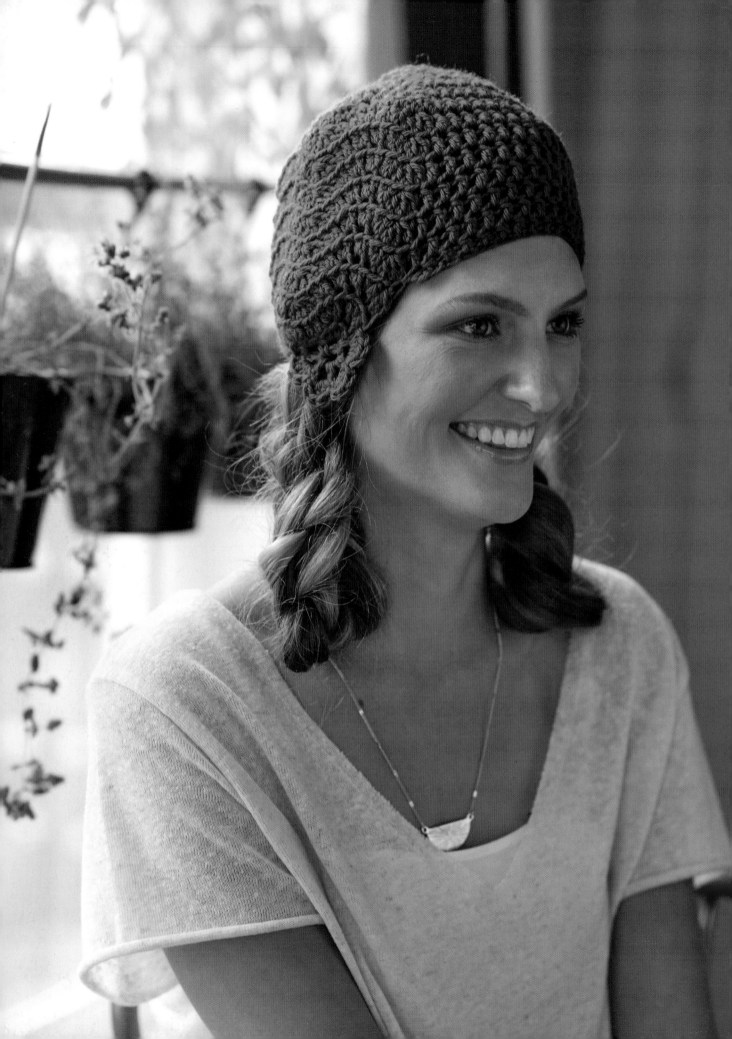

rhythm & blues
FLOWER SCALLOPED HAT

This hat begins with the flower. As you join in the round to start the hat, the scalloped edges of the flower mimic ripples on the water. For added warmth, repeat the flower flap on both sides!

FINISHED SIZE
19" (48.5 cm) in circumference × 8" (20.5 cm) tall.

YARN
Worsted weight (#4 Medium).

Shown here: Cascade Yarns Cascade 220 (100% Peruvian highland wool; 220 yd [200 m]/3.5 oz [100 g]): #2404 Atlantic, 1 hank.

HOOK
H/8 (5 mm).

Adjust hook size if needed to obtain gauge.

NOTIONS
Yarn needle; stitch marker.

GAUGE
12 sts and 8 rows = 4" (10 cm) in double crochet.

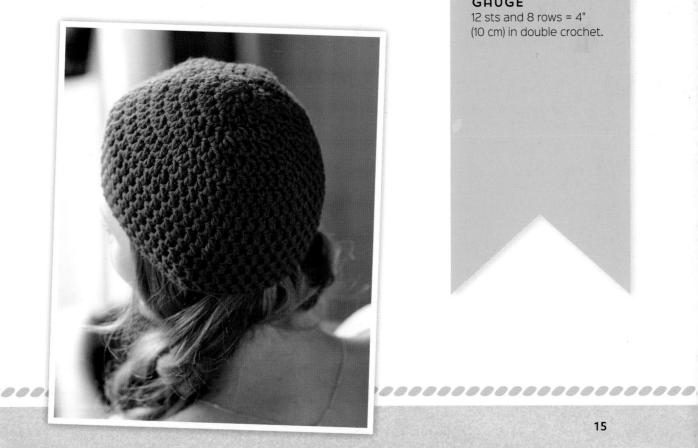

stitch guide
(see Techniques)

FOUNDATION SINGLE CROCHET

HAT

Note: Hat begins at the flower flap and works upward to the crown.

FLOWER

Ch 4, sl st in first ch to form a ring.

RND 1: Ch 5 (counts as dc, ch 2), [dc, ch 2) 5 times in ring, sl st in 3rd ch of beg ch-5 to join—6 ch-2 sps—6 petals.

RND 2: Sl st in next ch-2 sp, ch 1, (sc, 3 dc, sc) in each ch-2 sp around, sl st in first sc to join.

ROW 3: Ch 3 (counts as dc), working in blo, 1 dc in same st, 2 dc in each of next 3 sts, dc in each of next 2 sts, 2 dc in each of next 4 sts, (first 18 sts are flower flap section), fsc 42, do not join, without twisting foundation just made, begin working in first st of Rnd 2 on next rnd—60 sts. Work in a spiral marking first st of the rnd and moving marker up as work progresses.

RND 4: Working in blo over flower flap section, dc3tog over first 3 sts, 2 dc in each of the next 4 sts, dc4tog over next 4 sts, 2 dc in each of next 4 sts, dc3tog over next 3 sts, working in both loops of sts, dc in each st around—61 sts.

RND 5: Working in blo over flower flap section, dc3tog over first 3 sts, 2 dc in each of the next 4 sts, dc5tog over next 5 sts, 2 dc in each of next 4 sts, dc3tog over next 3 sts, working in both loops of sts, dc in each st around—61 sts.

RNDS 6–10: Rep Rnd 5.

RND 11: Working in blo over flower flap section, dc3tog over first 3 sts, dc in each of next 4 sts, dc5tog over the next 5 sts, dc in each of next 4 sts, dc3tog over next 3 sts, working in both loops of sts, dc in each st around—52 sts.

RND 12: *Dc2tog over next 2 sts, dc in each of the next 2 sts; rep from * around—40 sts.

RND 13: *Dc2tog over next 2 sts, dc in each of the next 3 sts; rep from * around—32 sts.

RND 14: *Dc2tog over next 2 sts, dc in each of the next 2 sts; rep from * around—24 sts.

RND 15: *Dc2tog over next 2 sts, dc in next st; rep from * around—16 sts.

RND 16: *Dc4tog over next 4 sts; rep from * around, sl st in next st to join—4 sts. Fasten off, leaving a long sewing length.

FINISHING

With yarn needle, weave sewing length through tops of st in last rnd, gather tightly and secure. Weave in ends. Handwash, block to finished measurements, and allow to dry.

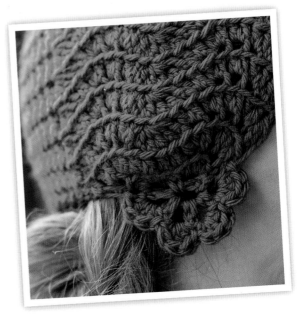

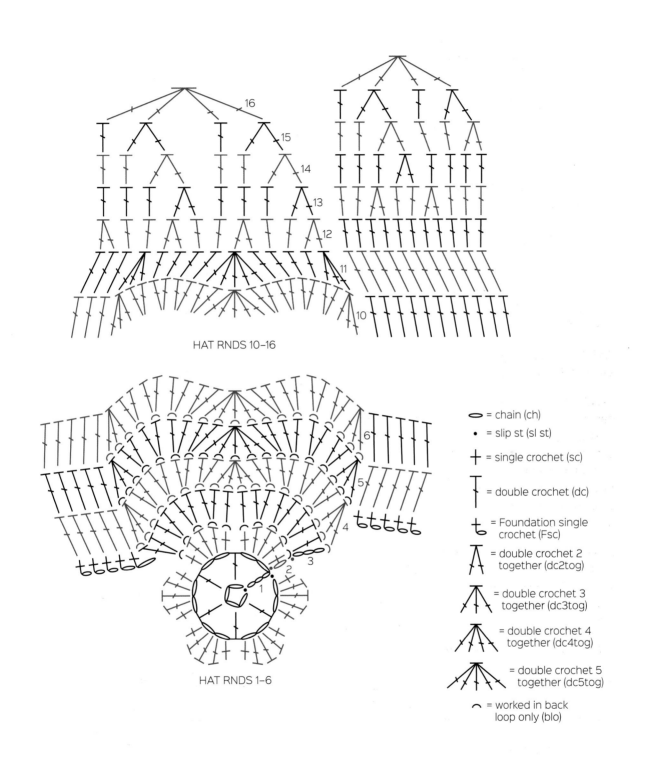

HAT RNDS 10–16

HAT RNDS 1–6

◯ = chain (ch)

• = slip st (sl st)

+ = single crochet (sc)

⊤ = double crochet (dc)

⊥₀ = Foundation single crochet (Fsc)

⋀ = double crochet 2 together (dc2tog)

⋀ = double crochet 3 together (dc3tog)

⋀ = double crochet 4 together (dc4tog)

⋀ = double crochet 5 together (dc5tog)

⌒ = worked in back loop only (blo)

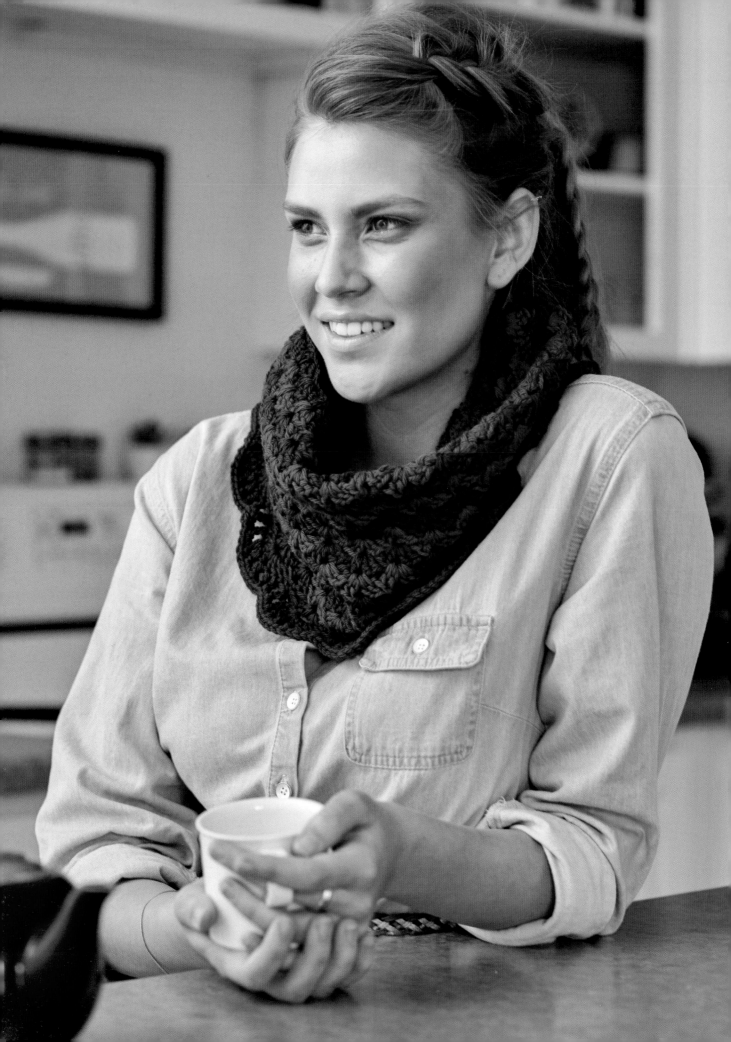

laguna surf
WAVY STRIPED COWL

Worked in the round, this clever blue-on-blue scarf mimics ocean waves within a simple stitch pattern. As a bonus, you carry up the stripes as you go; so it's still seamless, too! It's crocheted extra long, so you can wear this one tall for wind protection under your coat or low and draped for a more casual look.

FINISHED SIZE
24" (61 cm) in circumference at neck × 28" (71 cm) in circumference at lower hem × 10" (25.5 cm) tall.

YARN
Worsted weight (#4 Medium).

Shown here: Cascade Yarns Cascade 220 (100% Peruvian highland wool; 220 yd [200 m]/3.5 oz [100 g]): #2433 Pacific (A), #2404 Atlantic (B), 1 ball each.

HOOK
I/9 (5.5 mm).

Adjust hook size if needed to obtain gauge.

NOTIONS
Yarn needle.

GAUGE
16 sts = 4" (10 cm); 2 pattern reps = 4" (10 cm); 6 rows = 3¾" (9.5 cm) in body pattern.

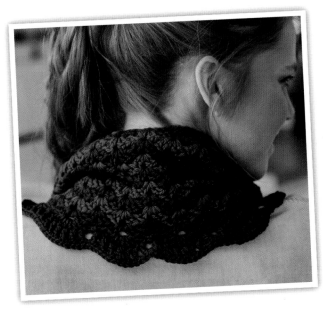

stitch guide

SHELL: (2 dc, ch 1, 2 dc) in same st or sp.

COWL

With A, ch 104, and without twisting ch, sl st in first ch to form a ring.

RND 1: Ch 1, sc in first ch, *ch 1, sk next 3 ch sts, shell in next ch, ch 1, sk next 3 ch sts**; sc in next ch; rep from * around, ending last rep at **, sl st in first sc to join—13 shells.

RND 2: Working over sc in previous rnd, sl st in first ch in foundation ch, ch 3 (counts as dc here and throughout), (dc, ch 1, 2 dc) in same sp, *ch 1, sk next 2 dc, sc in next ch-1 sp, ch 1, working over

sc in row below, shell in next ch in foundation ch, ch 1**; rep from * around, ending last rep at **, sl st in top of beg ch-3 to join—13 shells.

RND 3: Sl st to next ch-1 sp, drop A to WS to be picked up later, join B, with B, ch 1, sc in same sp, *ch 1, working over sc in previous row, shell in next ch-1 sp 2 rnds below, ch 1, sk next 2 dc**, sc in next ch-1 sp; rep from * around, ending last rep at **, sl st in first sc to join.

RND 4: Sl st in first ch-1 sp 2 rnds below first sc, ch 3, (dc, ch 1, 2 dc) in same sp, *ch 1, sk next 2 dc, sc in next ch-1 sp, ch 1, sk next 2 dc**, working over sc, shell in next ch-1 sp 2 rnds below; rep from * around, ending last rep at **, sl st in top of beg ch-3 to join.

RND 5: Sl st to next ch-1 sp, drop B to WS to be picked up later, pick up A from WS, with A, ch 1, sc in same sp, *ch 1, working over sc in previous

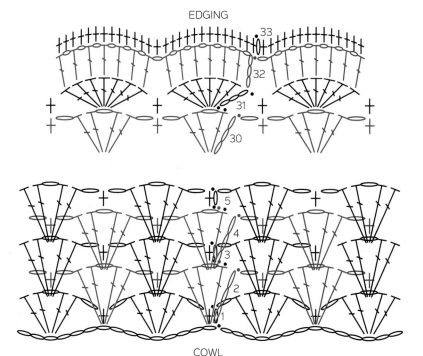

EDGING

COWL

⬯ = chain (ch)

• = slip st (sl st)

╂ = single crochet (sc)

╋ = double crochet (dc)

= shell

row, shell in next ch-1 sp 2 rnds below, ch 1, sk next 2 dc**, sc in next ch-1 sp; rep from * around, ending last rep at **, sl st in first sc to join.

RND 6: Rep Rnd 4.

RNDS 7–30: Rep Rnds 3–6 (6 times).

EDGING

RND 31: Sl st to next ch-1 sp, drop A to WS and fasten off, pick up B from WS, with B, ch 3, 6 dc in same sp, sc in next sc, *sk next 2 dc, 7 dc in next ch-1 sp, sc in next sc; rep from * around, sl st in top of beg ch-3 to join.

RND 32: Ch 4 (counts as dc, ch 1), (dc, ch 1) in each dc around, sl st in top of beg ch-3 to join.

RND 33: Ch 1, sc in each dc and ch-1 sp around, sl st in first sc to join. Fasten off.

FINISHING

Weave in ends. Handwash, block to finished measurements, and allow to dry.

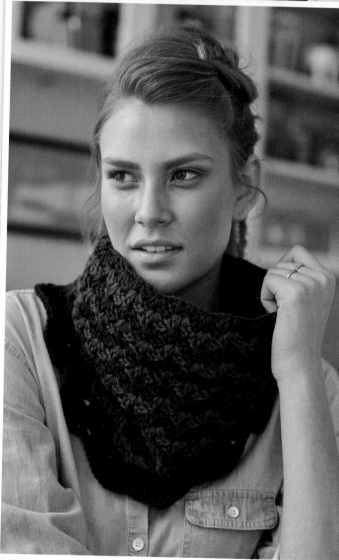

mardi gras gold
HERRINGBONE COWL

This versatile project can be worn in a number of ways—flat, tubular, twisted or partially closed—thanks to the buttons! Choose beautiful jeweled buttons to give it a touch of sparkle. I love how the gold yarn and herringbone textured post stitches remind me of my old bling from the 1980s and 1990s.

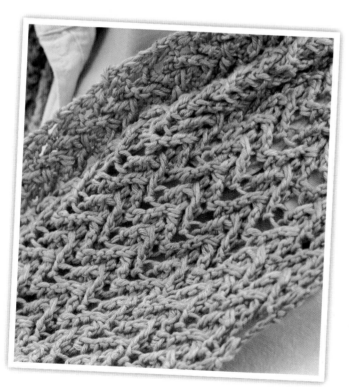

FINISHED SIZE
25" (63.5 cm) in circumference × 8½" (21.5 cm) tall.

YARN
Sportweight (#2 Fine).

Shown here: Kristin Omdahl Yarns Be So Sporty (100% bamboo; 325 yd [297 m]/4 oz [113 g]): Pure Gold, 1 hank.

HOOK
G/6 (4 mm).

Adjust hook size if needed to obtain gauge.

NOTIONS
Yarn needle; five ⅞" (22 mm) buttons. Sample features Crafting with Buttons yellow flower #470001806.

GAUGE
18 sts and 9 rows = 4" (10 cm) in pattern.

stitch guide
(see Techniques)

FOUNDATION SINGLE CROCHET (FSC)

FRONT POST TREBLE CROCHET (FPTR)

BACK POST TREBLE CROCHET (BPTR)

COWL

ROW 1: Fsc 39. Rotate to work across "chain side" of foundation sts. This makes the outside edge look like the top of a single crochet row, which will look more cohesive with the other end of the finished cowl.

ROW 2: Ch 1, sc in each ch across, turn—39 sc.

ROW 3: Ch 1, sc in each st across, turn.

ROW 4: Rep Row 3.

ROW 5: Ch 3 (counts as dc here and throughout), dc in each st across, turn.

ROW 6: Sl st in sp between first 2 dc, ch 3, dc in same sp, *sk next 3 sts, fptr around the post of next st, working behind last post st, dc in last skipped st and each of next 2 sts, fptr around the post of same st as previous fptr; rep from * across to last 3 sts, 2 dc in sp between last 2 sts, turn—7 V's formed.

ROW 7: Sl st in sp between first 2 dc, ch 3, dc in same sp, *sk next 3 sts, bptr around the post of next st, working in front of last post st, dc in last skipped st and each of next 2 sts, bptr around the post of same st as previous fptr; rep from * across to last 3 sts, 2 dc in sp between last 2 sts, turn—7 V's formed.

ROWS 8–59: Rep Rows 6 and 7 (26 times).

BUTTONBAND
ROW 1: Ch 1, sc in each st across, turn—39 sts.

ROW 2: Rep Row 1.

ROW 3: Ch 1, sc in each of next 4 sts, *ch 3, sk next 3 sts, sc in each of next 4 sts; rep from * across, turn—5 buttonholes.

ROW 4: Ch 1, sc in each of next 4 sts, *3 sc in next ch-3 sp, sc in each of next 4 sts; rep from * across, turn—39 sc.

ROW 5: Ch 1, sc in each st across. Fasten off.

FINISHING
Weave in ends. Handwash, block to finished measurements, and allow to dry. Sew buttons to buttonband opposite buttonholes.

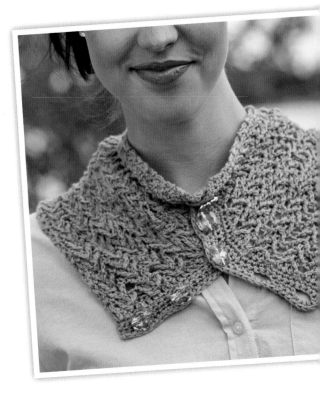

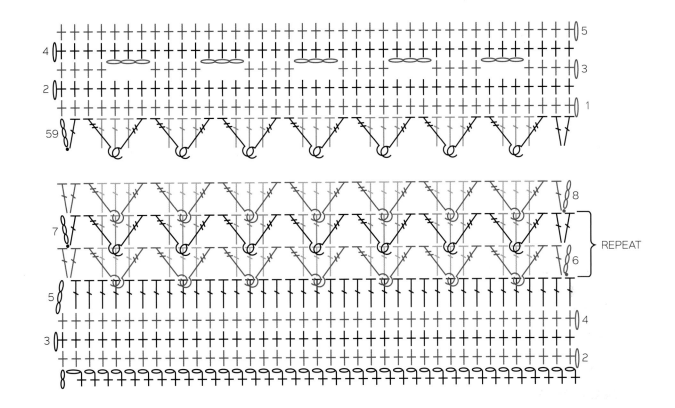

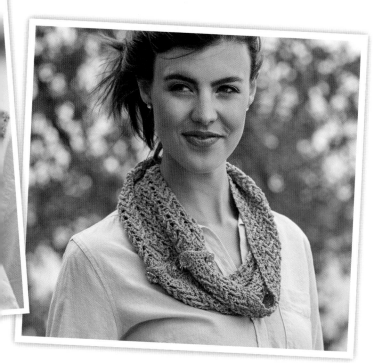

○ = chain (ch)

• = slip st (sl st)

✝ = single crochet (sc)

ᵼ = Foundation single crochet (Fsc)

Ⱦ = double crochet (dc)

Ⱦ = front post tr (fptr)

Ⱦ = back post tr (bptr)

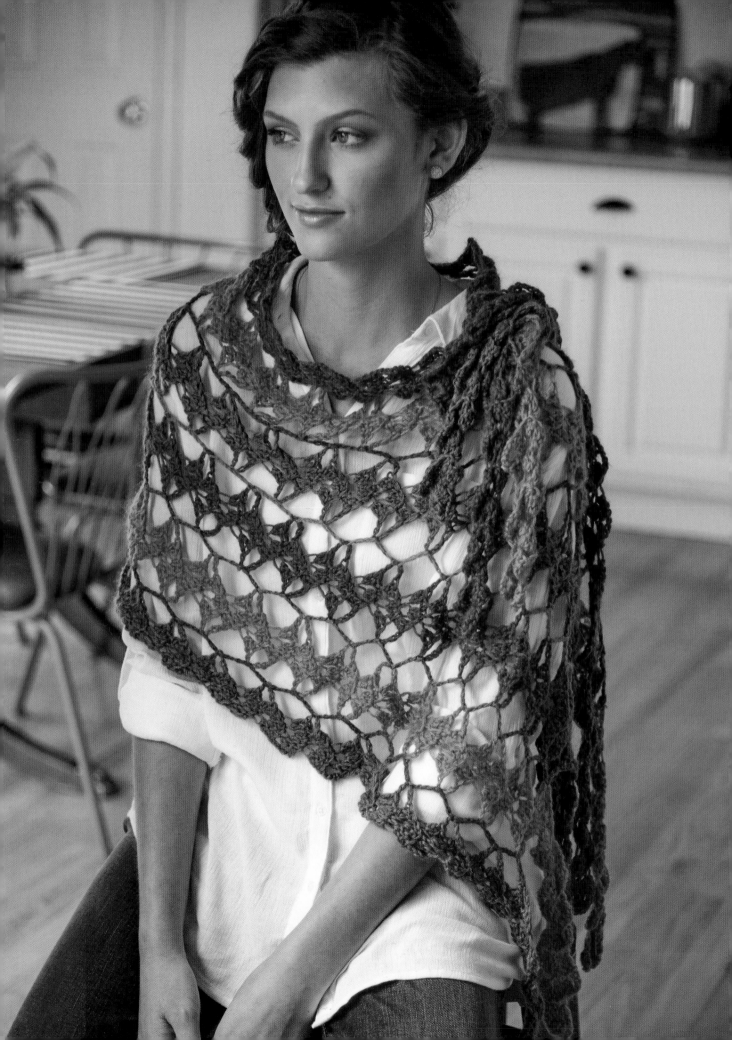

urban fringe
JEN'S STRIPS OF STRIPES SCARF

A few chilly winters ago in NYC, a friend and I were shopping in a makeup store, and I admired the way a chic woman was wearing her wrap over her coat. She had tied the thick fringes so it was more like a möbius or cowl. I promised myself that at the right time, I would make a bulky fringed wrap just so I could style it in exactly that way.

FINISHED SIZE
20" (51 cm) wide × 64" (162.5 cm) long.

YARN
Aran weight (#4 Medium).

Shown here: Rowan Kid Classic (70% lambswool, 22% kid mohair, 8% polyamide; 153 yd (140 m)/1.75 oz [50 g]): #866 Bitter Sweet (A), #870 Rosewood (B), #872 Earth (C), 1 ball each.

HOOK
J/10 (6 mm).

Adjust hook size if needed to obtain gauge.

NOTIONS
Yarn needle.

GAUGE
4 rows = 4" (10 cm); strip = 3" (7.5 cm) wide.

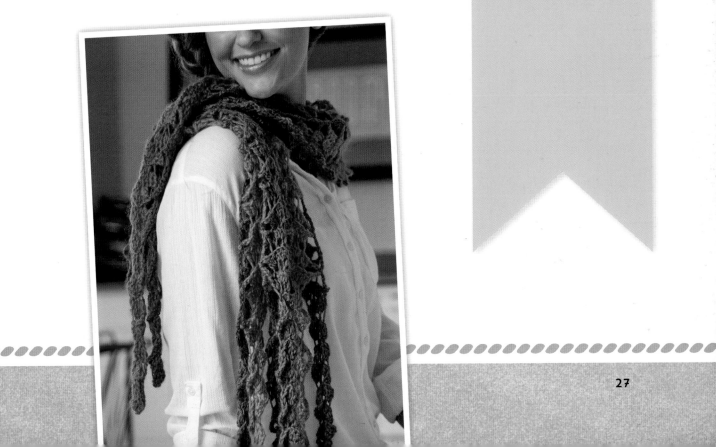

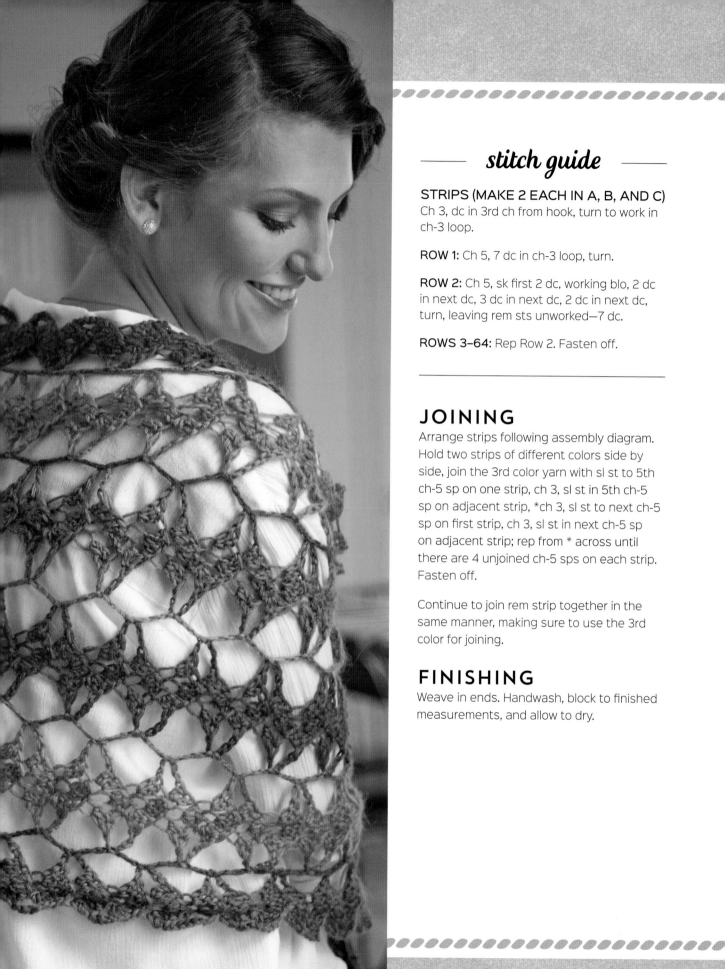

stitch guide

STRIPS (MAKE 2 EACH IN A, B, AND C)
Ch 3, dc in 3rd ch from hook, turn to work in ch-3 loop.

ROW 1: Ch 5, 7 dc in ch-3 loop, turn.

ROW 2: Ch 5, sk first 2 dc, working blo, 2 dc in next dc, 3 dc in next dc, 2 dc in next dc, turn, leaving rem sts unworked—7 dc.

ROWS 3–64: Rep Row 2. Fasten off.

JOINING

Arrange strips following assembly diagram. Hold two strips of different colors side by side, join the 3rd color yarn with sl st to 5th ch-5 sp on one strip, ch 3, sl st in 5th ch-5 sp on adjacent strip, *ch 3, sl st to next ch-5 sp on first strip, ch 3, sl st in next ch-5 sp on adjacent strip; rep from * across until there are 4 unjoined ch-5 sps on each strip. Fasten off.

Continue to join rem strip together in the same manner, making sure to use the 3rd color for joining.

FINISHING

Weave in ends. Handwash, block to finished measurements, and allow to dry.

SAMPLE
OF JOINING
ROW

FIRST STRIP

SECOND STRIP

REPEAT

◯ = chain (ch)

• = slip st (sl st)

+ = single crochet (sc)

┬ = double crochet (dc)

⌒ = worked through back loop only (tbl)

C B A C B A

ASSEMBLY DIAGRAM

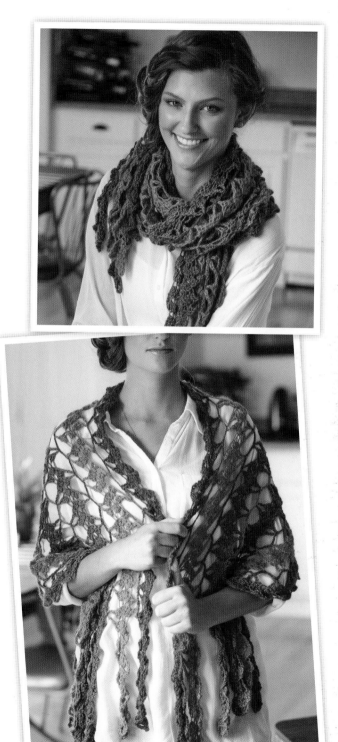

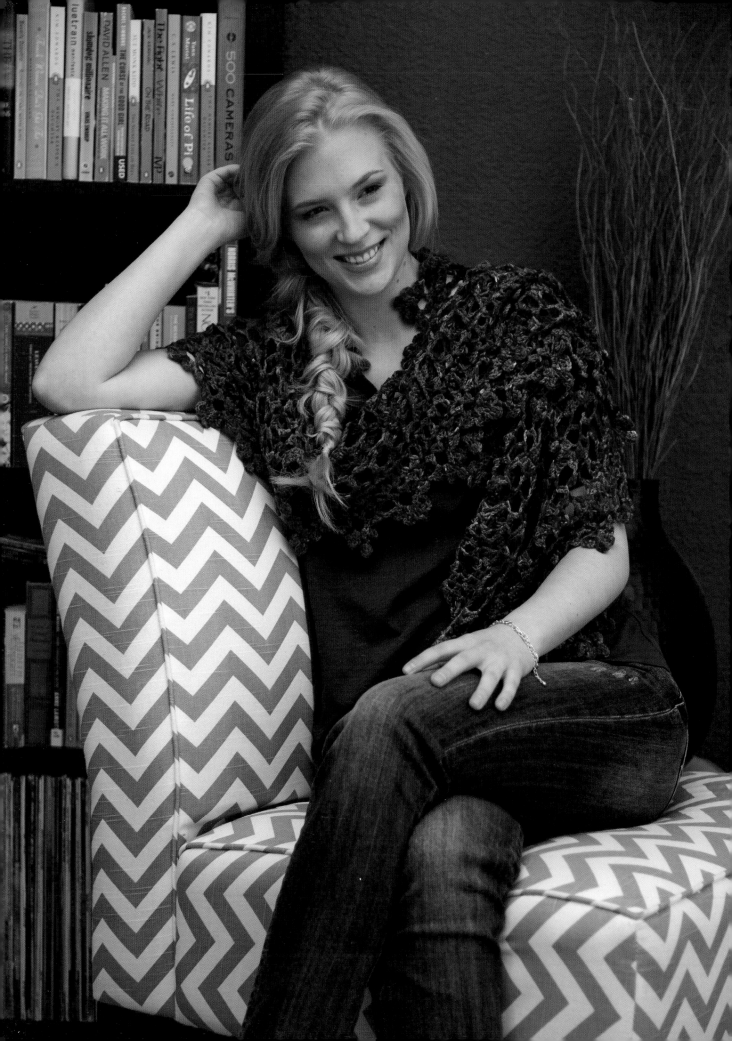

enchanted diamonds
TEXTURED & PICOT MESH SCARF

The interior panel stitch pattern looks complicated but is easy to understand after a repeat or two. I love how the scalloped flower edging is worked and joined as you go within the rows of the shawl. Constructed from the center outward, this piece has symmetrical ends; the narrow edging then matches the long edging as well.

FINISHED SIZE
16" (40.5 cm) wide × 68" (173 cm) long.

YARN
Sportweight (#2 Fine).

Shown here: Drew Emborsky Gemstones (90% merino wool, 10% nylon (polyamide); 440 yd [402 m]/4 oz [113 g]): Amethyst, 2 hanks.

HOOK
H/8 (5 mm).

Adjust hook size if needed to obtain gauge.

GAUGE
(Shell, 2 ch-5 sps, shell) = 5" (12.5 cm) in Row 5 of pattern; 6 rows = 4" (10 cm) in pattern.

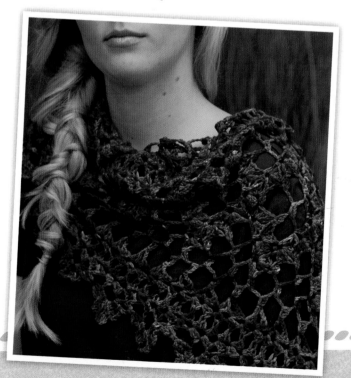

stitch guide

SMALL SHELL (SM SHELL): (2 dc, ch 2, 2 dc) in same sp.

LARGE SHELL (LG SHELL): (3 dc, ch 3, 3 dc) in same sp.

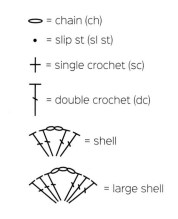

◦ = chain (ch)

• = slip st (sl st)

+ = single crochet (sc)

⊤ = double crochet (dc)

= shell

= large shell

FIRST HALF

Note: Wrap is worked from a set-up row down the middle, then each side is worked outward.

SET-UP ROW: *Ch 4, tr in 4th ch from hook; rep from * 12 times, turn to work in ch-4 sps.

ROW 1: (WS) Ch 5, sm shell in first ch-4 sp, sm shell in next ch-4 sp, (sc, ch 3, sc) in next ch-4 sp, [ch 5, (sc, ch 3, sc) in next ch-4 sp] twice, lg shell in next ch-4 sp, (sc, ch 3, sc) in next ch-4 sp, lg shell in next ch-4 sp, (sc, ch3, sc) in next ch-4 sp, [ch 5, (sc, ch 3, sc) in next ch-4 sp] twice, sm shell in each of next 2 ch-4 sps, turn—4 sm shells; 2 lg shells; 4 ch-5 sps; 7 ch-3 sps.

ROW 2: Ch 5, sm shell in each of next 2 ch-2 sps, ch 3, sk next ch-3 sp, (sc, ch 3, sc) in next ch-5 sp, ch 5, sk next ch-3 sp, (sc, ch 3, sc) in next ch-5 sp, ch 5, sk next ch-3 sp, (sc, ch 3, sc) in next ch-3 sp, lg shell in next ch-3 sp, (sc, ch 3, sc) in next ch-3 sp, [ch 5, sk next ch-3 sp, (sc, ch 3, sc) in next ch-5 sp] twice, ch 3, sm shell in each of next 2 ch-2 sps, do not turn.

ROW 3: Work 10 dc in next ch-5 sp, 2 rows below, turn, ch 2, dc in next st, ch 2, sl st in each of next 2 sts, [ch 2, dc in next st, ch 2, sl st in next st] 3 times, ch 2, sm shell in each of next 2 ch-2 sps, sk next ch-3 sp, [ch 5, sk next ch-3 sp, (sc, ch 3, sc) in next ch-5 sp] twice, lg shell in next ch-3 sp, (sc, ch 3, sc) in next ch-3 sp, lg shell in next ch-3 sp, (sc, ch 3, sc) in next ch-3 sp, ch 5, sk next ch-3

sp, (sc, ch 3, sc) in next ch-5 sp, ch 5, sk next 2 ch-3 sps, sm shell in each of next 2 ch-2 sps, do not turn.

ROW 4: Work 10 dc in next ch-5 sp, 2 rows below, turn, ch 2, dc in next st, ch 2, sl st in each of next 2 sts, [ch 2, dc in next st, ch 2, sl st in next st] 3 times, ch 2, sm shell in each of next 2 ch-2 sps, sk next 2 ch-3 sps, ch 3, (sc, ch 3, sc) in next ch-5 sp, ch 5, sk next ch-3 sp, (sc, ch 3, sc) in next ch-5 sp, lg shell in next ch-3 sp, (sc, ch 3, sc) in next ch-3 sp, ch 5, sk next ch-3 sp, (sc, ch 3, sc) in next ch-3 sp, lg shell in next ch-3 sp, (sc, ch 3, sc) in next ch-5 sp, ch 5, sk next ch-3 sp, (sc, ch 3, sc) in next ch-5 sp, ch 3, sm shell in each of next 2 ch-2 sps, turn.

ROW 5: Ch 5, sm shell in each of next 2 ch-2 sps, ch 5, sk next 2 ch-3 sps, (sc, ch 3, sc) in next ch-5 sp, lg shell in next ch-3 sp, (sc, ch 3, sc) in next ch-3 sp, ch 5, sk next ch-3 sp, (sc, ch 3, sc) in next ch-5 sp, ch 5, sk next ch-3 sp, (sc, ch 3, sc) in next ch-3 sp, lg shell in next ch-3 sp, (sc, ch 3, sc) in next ch-5 sp, ch 5, sk next 2 ch-3 sps, sm shell in each of next 2 ch-2 sps, turn.

ROW 6: Ch 5, sm shell in each of next 2 ch-2 sps, ch 3, (sc, ch 3, sc) in next ch-5 sp, ch 5, sk next ch-3 sp, (sc, ch 3, sc) in next ch-3 sp, lg shell in

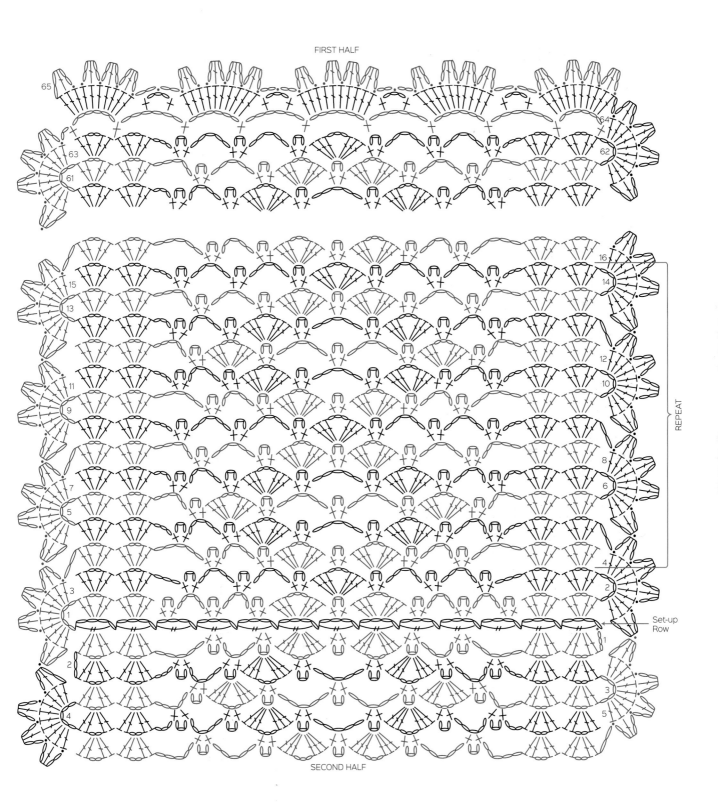

FIRST HALF

SECOND HALF

ch-3 sp, (sc, ch 3, sc) in next ch-5 sp, ch 5, sk next ch-3 sp, (sc, ch 3, sc) in next ch-3 sp, lg shell in next ch-3 sp, (sc, ch 3, sc) in next ch-3 sp, ch 5, sk next ch-3 sp, (sc, ch 3, sc) in next ch-5 sp, ch 3, sm shell in each of next 2 ch-2 sps, do not turn.

ROW 7: Work 10 dc in next ch-5 sp, 2 rows below, turn, ch 2, dc in next st, sl st in first dc, 4 rnds below on last end scallop, ch 2, sl st in each of next 2 sts, [ch 2, dc in next st, ch 2, sl st in next st] 3 times, ch 2, sm shell in each of next 2 ch-2 sps, sk next ch-3 sp, [ch 5, sk next ch-3 sp, (sc, ch 3, sc) in next ch-5 sp] twice, lg shell in next ch-3 sp, (sc, ch 3, sc) in next ch-3 sp, lg shell in next ch-3 sp, (sc, ch 3, sc) in next ch-3 sp, ch 5, sk next ch-3 sp, (sc, ch 3, sc) in next ch-5 sp, ch 5, sk next 2 ch-3 sps, sm shell in each of next 2 ch-2 sps, do not turn.

ROW 8: Work 10 dc in next ch-5 sp, 2 rows below, turn, ch 2, dc in next st, sl st in first dc, 4 rnds below on last end scallop, ch 2, sl st in each of next 2 sts, [ch 2, dc in next st, ch 2, sl st in next st] 3 times, ch 2, sm shell in each of next 2 ch-2 sps, ch 3, (sc, ch 3, sc) in next ch-5 sp, ch 5, sk next ch-3 sp, (sc, ch 3, sc) in next ch-5 sp, ch 5, sk next ch-3 sp, (sc, ch 3, sc) in next ch-3 sp, lg shell in next ch-3 sp, (sc, ch 3, sc) in next ch-3 sp, [ch 5, sk next ch-3 sp, (sc, ch 3, sc) in next ch-5 sp] twice, ch 3, sm shell in each of next 2 ch-2 sps, turn.

ROW 9: Ch 5, sm shell in each of next 2 ch-2 sps, sk next 2 ch-3 sps, [ch 5, sk next ch-3 sp, (sc, ch 3, sc) in next ch-5 sp] twice, lg shell in next ch-3 sp, (sc, ch 3, sc) in next ch-3 sp, lg shell in next ch-3 sp, [(sc, ch 3, sc) in next ch-5 sp, ch 5, sk next ch-3 sp] twice, sk next ch-3 sp, sm shell in each of next 2 ch-2 sps, turn.

ROW 10: Ch 5, sm shell in each of next 2 ch-2 sps, ch 3, (sc, ch 3, sc) in next ch-5 sp, ch 5, sk next ch-3 sp, (sc, ch 3, sc) in next ch-5 sp, lg shell in next ch-3 sp, (sc, ch 3, sc) in next ch-3 sp, ch 5, sk next ch-3 sp, (sc, ch 3, sc) in next ch-3 sp, lg shell in next ch-3 sp, (sc, ch 3, sc) in next ch-5 sp, ch 5, sk next ch-3 sp, (sc, ch 3, sc) in next ch-5 sp, ch 3, sm shell in each of next 2 ch-2 sps, do not turn.

ROW 11: Work 10 dc in next ch-5 sp, 2 rows below, turn, ch 2, dc in next st, sl st in first dc, 4 rnds below on last end scallop, ch 2, sl st in each of next 2 sts, [ch 2, dc in next st, ch 2, sl st in next st] 3 times, ch 2, sm shell in each of next 2 ch-2 sps, ch 3, (sc, ch 3, sc) in next ch-5 sp, ch 5, sk next ch-3 sp, (sc, ch 3, sc) in next ch-5 sp, lg shell in next ch-3 sp, (sc, ch 3, sc) in next ch-3 sp, ch 5, sk next ch-3 sp, (sc, ch 3, sc) in next ch-5 sp, ch 5, sk next ch-3 sp, (sc, ch 3, sc) in next ch-3 sp, lg shell in next ch-3 sp, (sc, ch 3, sc) in next ch-5 sp, ch 5, sk next ch-3 sp, (sc, ch 3, sc) in next ch-5 sp, ch 3, sm shell in each of next 2 ch-2 sps, do not turn.

ROW 12: Work 10 dc in next ch-5 sp, 2 rows below, turn, ch 2, dc in next st, sl st in first dc, 4 rnds below on last end scallop, ch 2, sl st in each of next 2 sts, [ch 2, dc in next st, ch 2, sl st in next st] 3 times, ch 2, sm shell in each of next 2 ch-2 sps, ch 3, (sc, ch 3, sc) in next ch-5 sp, ch 5, sk next ch-3 sp, (sc, ch 3, sc) in next ch-5 sp, lg shell in next ch-3 sp, (sc, ch 3, sc) in next ch-3 sp, ch 5, sk next ch-3 sp, (sc, ch 3, sc) in next ch-5 sp, lg shell in next ch-3 sp, (sc, ch 3, sc) in next ch-3 sp, ch 5, sk next ch-3 sp, (sc, ch 3, sc) in next ch-5 sp, ch 3, sm shell in each of next 2 ch-2 sps, turn.

ROW 13: Ch 5, sm shell in each of next 2 ch-2 sps, sk next ch-3 sp, [ch 5, sk next ch-3 sp, (sc, ch 3, sc) in next ch-5 sp] twice, lg shell in next ch-3 sp, (sc,

ch 3, sc) in next ch-3 sp, lg shell in next ch-3 sp, (sc, ch 3, sc) in next ch-3 sp, ch 5, sk next ch-3 sp, (sc, ch 3, sc) in next ch-5 sp, ch 5, sk next 2 ch-3 sps, sm shell in each of next 2 ch-2 sps, turn.

ROW 14: Ch 5, sm shell in each of next 2 ch-2 sps, ch 3, (sc, ch 3, sc) in next ch-5 sp, ch 5, sk next ch-3 sp, (sc, ch 3, sc) in next ch-5 sp, ch 5, sk next ch-3 sp, (sc, ch 3, sc) in next ch-3 sp, lg shell in next ch-3 sp, (sc, ch 3, sc) in next ch-3 sp, [ch 5, sk next ch-3 sp, (sc, ch 3, sc) in next ch-5 sp] twice, ch 3, sm shell in each of next 2 ch-2 sps, do not turn.

ROWS 15–62: Rep Rows 3–14 (4 times).

EDGING

ROW 63: Work 10 dc in next ch-5 sp, 2 rows below, turn, ch 2, dc in next st, sl st in first dc, 4 rnds below on last end scallop, ch 2, sl st in each of next 2 sts, [ch 2, dc in next st, ch 2, sl st in next st] 3 times, ch 2, sc in first dc of next sm shell, ch 6, sc bet 2 sm shells, ch 6, sk next shell, sk next ch-3 sp, sc in next ch-3 sp, [ch 6, sk next ch-5 sp, sc in next ch-3 sp] twice, ch 6, sk next lg shell, sc in next ch-3 sp, [ch 6, sk next ch-5 sp, sc in next ch-3 sp] twice, ch 6, sk next ch-3 sp, sc bet next 2 sm shells, ch 6, sc in last dc of last sm shell, do not turn.

ROW 64: Work 10 dc in next ch-5 sp, 2 rows below, turn, ch 2, dc in next st, ch 2, sl st in each of next 2 sts, [ch 2, dc in next st, ch 2, sl st in next st] 3 times, ch 2, *10 dc in next ch-6 sp, (sc, ch 3, sc) in next ch-6 sp; rep from * 3 times, 10 dc in next ch-6 sp, turn.

ROW 65: *Ch 2, dc in next st, ch 2, sl st in each of next 2 sts, [ch 2, dc in next st, ch 2, sl st in next st] 3 times**, ch 2, sl st in next ch-3 sp, ch 2, sl st in next dc; rep from * across, ending last rep at **. Fasten off.

SECOND HALF

ROW 1: Rotate wrap to work across opposite side of set-up row. With WS facing, join yarn with sl st in base of first tr on right-hand side of set-up row, ch 3, sm shell in first sp, sm shell in next sp, sk next sp, (sc, ch 3, sc) in next sp, [ch 5, (sc, ch 3, sc) in next sp] twice, lg shell in next sp, (sc, ch 3, sc) in next sp, lg shell in next sp, (sc, ch 3, sc) in next sp, ch 5, (sc, ch 3, sc) in next sp, ch 5, sk next sp, sm shell in each of next 2 sps, turn—4 sm shells; 2 lg shells; 4 ch-5 sps; 5 ch-3 sps, turn.

ROW 2: Ch 3, sm shell in each of next 2 ch-2 sps, ch 3, (sc, ch 3, sc) in next ch-5 sp, ch 5, sk next ch-3 sp, (sc, ch 3, sc) in next ch-5 sp, lg shell in next ch-3 sp, (sc, ch 3, sc) in next ch-3 sp, ch 5, sk next ch-3 sp, (sc, ch 3, sc) in next ch-3 sp, lg shell in next ch-3 sp, (sc, ch 3, sc) in next ch-5 sp, ch 5, sk next ch-3 sp, (sc, ch 3, sc) in next ch-5 sp, ch 3, sm shell in each of next 2 ch-2 sps, turn.

ROWS 3–4: Work same as Rows 3–4 of first half, joining with a sl st to corresponding dc in each side scallop as before.

ROWS 5–63: Rep Rows 7–65 of first half. Fasten off.

FINISHING

Weave in ends. Handwash, block to finished measurements, and allow to dry.

little falls
REVERSIBLE TEXTURED MÖBIUS

This really interesting reversible post stitch pattern cascades from front to back of the fabric identically in an ebb and flow. It looks far more complicated than it really is. Who doesn't love that kind of project? It is a generous size for a möbius, which means you can style it several ways and really take advantage of the reversible nature and the drape of this beautiful accessory.

FINISHED SIZE
30" (76 cm) in circumference × 13" (33 cm) tall.

YARN
Worsted weight (#4 Medium).

Shown here: The Fibre Company Organik (70% wool, 15% alpaca, 15% silk; 98 yd [90 m]/1.75 oz [50 g]): Highlands, 5 hanks.

HOOK
H/8 (5 mm).

Adjust hook size if needed to obtain gauge.

NOTIONS
Yarn needle.

GAUGE
3.5 sts and 2.5 rows = 1" (2.5 cm) in pattern.

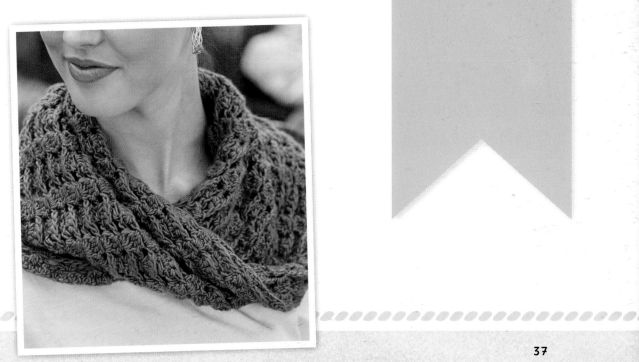

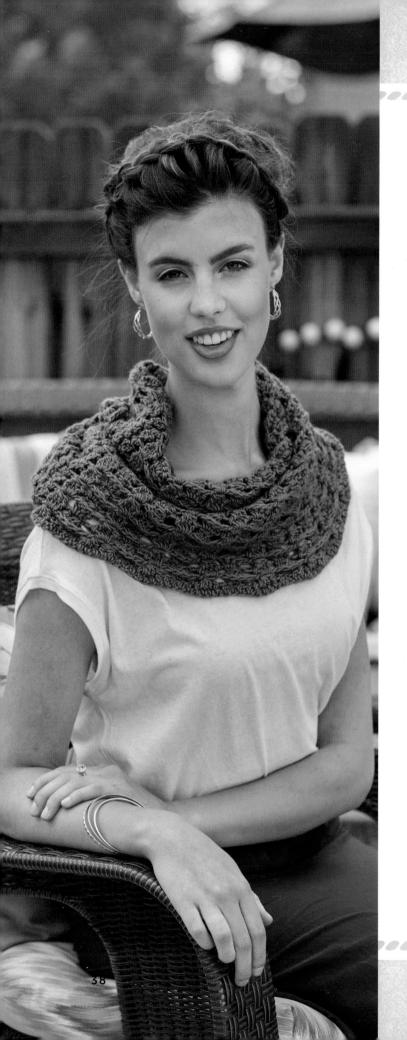

FOUNDATION DOUBLE CROCHET (FDC)

FRONT POST DOUBLE CROCHET
2 TOGETHER (FPDC2TOG)

FRONT POST DOUBLE CROCHET
3 TOGETHER (FPDC3TOG)

FRONT POST DOUBLE CROCHET
5 TOGETHER (FPDC5TOG)

MÖBIUS

ROW 1: Fdc 113.

ROW 2: Ch 3 (counts as dc here and throughout), 2 dc in first st, *ch 1, sk next st, fpdc5tog over next 5 sts**, 5 dc in next st; rep from * across, ending last rep at **, 3 dc in last st, turn—16 fpdc5tog.

ROW 3: Ch 3, fpdc2tog over next 2 sts, *5 dc in next ch-1 sp, ch 1**, fpdc5tog over next 5 sts; rep from * across, ending last rep at **, fpdc3tog over last 3 sts, turn.

ROW 4: Ch 3, 2 dc in first st,*ch 1, sk next ch-1 sp, fpdc5tog over next 5 sts**, 5 dc in next st; rep from * across, ending last rep at **, 3 dc in last st, turn—16 fpdc5tog.

ROWS 5–32: Rep Rows 3 and 4 (14 times). Fasten off, leaving a long sewing length.

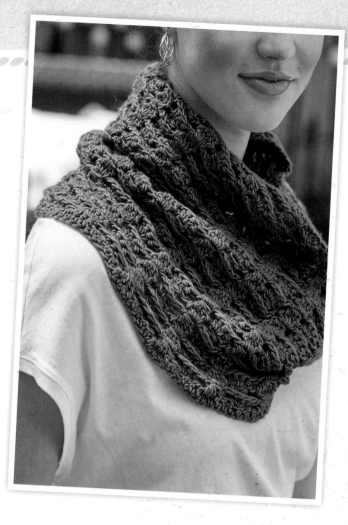

ASSEMBLY

Twist the flat fabric so that the left-hand corner of Row 32 is matched up with the right-hand corner of Row 1. With yarn needle and sewing length, sew last row to first row.

FINISHING

Weave in ends. Handwash, block to finished measurements, and allow to dry.

ASSEMBLY DIAGRAM

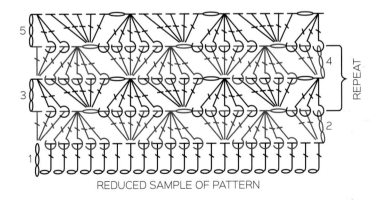

REDUCED SAMPLE OF PATTERN

◯ = chain (ch)

• = slip st (sl st)

+ = single crochet (sc)

⊤ = double crochet (dc)

⊥ = Foundation double crochet (Fdc)

= front post double crochet 2 together (fpdc2tog)

= front post double crochet 3 together (fpdc3tog)

= front post double crochet 5 together (fpdc5tog)

basket of light
ZENTANGLE-INSPIRED MOTIF SCARF

I love to draw. I am often inspired by textures in anything but textiles when designing in crochet. On a whim, I tried to re-create a lacy drawing into crochet, and voilà! This is the result. So fun!

FINISHED SIZE
7" (18 cm) wide × 61" (155 cm) long.

YARN
Fingering weight (#1 Superfine).

Shown here: Rowan Yarns Fine Art (45% wool, 25% polyamide, 20% mohair, 10% silk; 437 yd [400 m]/3.5 oz [100 g]): #301 Serin, 1 ball.

HOOK
F/5 (3.75 mm).

Adjust hook size if needed to obtain gauge.

GAUGE
First 2 rnds of first motif = 2" (5 cm) in diameter.

2 DOUBLE CROCHET CLUSTER
(2-DC CLUSTER)

2 DOUBLE TREBLE CROCHET CLUSTER
(2-DTR CLUSTER)

3 DOUBLE TREBLE CROCHET CLUSTER
(3-DTR CLUSTER)

DOUBLE CROCHET–HALF DOUBLE
CROCHET CLUSTER (DC-HDC CLUSTER)

TRIPLE TREBLE CROCHET (TRTR)

FIRST MOTIF

Ch 5, sl st to first ch to form a ring.

RND 1: Ch 3 (counts as dc), work 17 dc in ring, sl st in top of beg ch-3—18 dc.

RND 2: Ch 3, dc in first st (counts as 2-dc cluster), 2-dc cluster in each st around—18 clusters.

RND 3: Ch 5, 2-dtr cluster in same st (counts as 3-dtr cluster), *ch 3, 3-dtr cluster in next st; rep from * around, ch 3, sl st top of beg ch-5—18 clusters.

RND 4: (Sl st, ch 2, 3 dc, ch 2, sl st) in each of next 17 ch-3 sps, (sl st, dc, dc-hdc cluster) in last ch-3 sp, turn.

Note: This is done to end at the top of the last petal instead of the bottom so you are ready to begin the next motif.

SECOND MOTIF (HALF/ OVERLAPPING)

ROW 1: Trtr in top of next petal, ch 3 (counts as dc), sl st to end of last petal, turn, 9 dc over post of trtr, sl st in ch-2 sp of next petal on Rnd 4 of last motif, ch 3, sl st to end of same petal, turn.

ROW 2: Ch 3, sl st next ch-2 sp of same petal, turn, dc in next dc, 2-dc cluster in each st across, sl st first ch-2 sp of next petal on previous motif.

ROW 3: Ch 5, sl st in next petal on same previous motif, turn, 2-tr cluster in next st, *ch 3, 3-dtr cluster in next st; rep from * across, sk next petal, sl st in next petal on previous motif, turn.

ROW 4: (Sl st, ch 2, 3 dc, ch 2, sl st) in each of next 6 ch-3 sps, across, (sl st, ch 2, 2 dc, dc-hdc cluster) in last ch-3 sp, do not turn.

THIRD AND EACH SUCCESSIVE MOTIF (HALF/OVERLAPPING)

Rep Rows 1–4 of second motif until all yarn is used, ending with a complete motif. Fasten off.

Note: Half/overlapping motifs will alternate between the right and left side of the first motif.

FINISHING

Weave in ends. Handwash, block to finished measurements, and allow to dry.

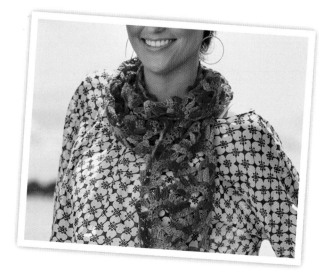

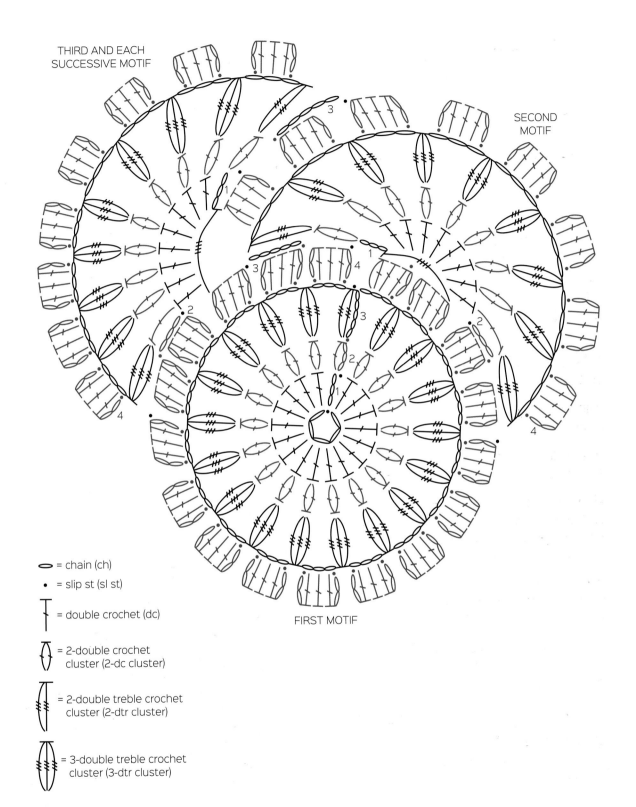

THIRD AND EACH
SUCCESSIVE MOTIF

SECOND
MOTIF

FIRST MOTIF

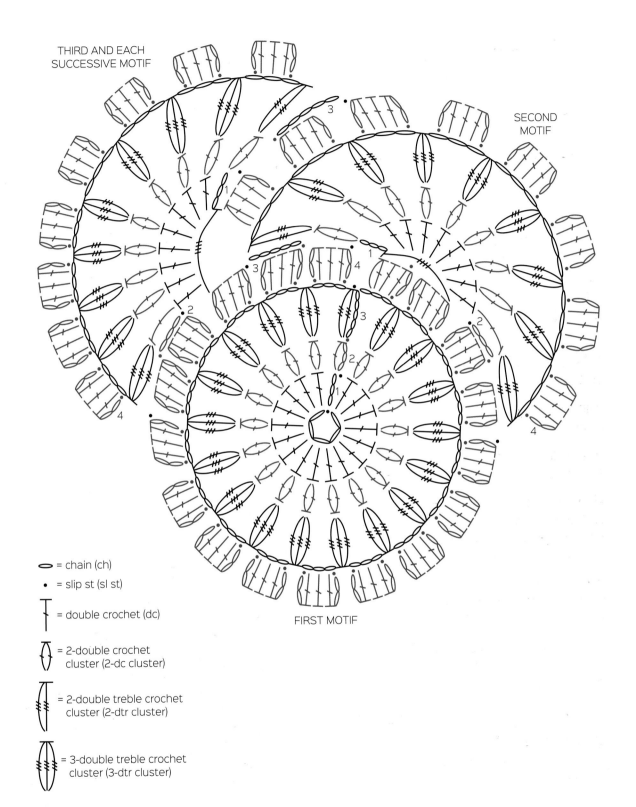 = chain (ch)

• = slip st (sl st)

= double crochet (dc)

= 2-double crochet
cluster (2-dc cluster)

= 2-double treble crochet
cluster (2-dtr cluster)

= 3-double treble crochet
cluster (3-dtr cluster)

SHAWLS & WRAPS

My first loves in crochet were shawls and wraps, and they will always hold a special place in my heart. They are a wonderful medium in which to experiment with technique and texture, and they make versatile works of art! Inspired by gradient colorwork, the cardi-wrap, tile wrap, and starburst shawl explore directional crochet in different ways to demonstrate the beauty and variety of color-changing yarns. The hairpin shawl is a showstopper and a fun variation on traditional strips. There are a wide variety of shapes and construction methods. Improve your repertoire of skills and try them all!

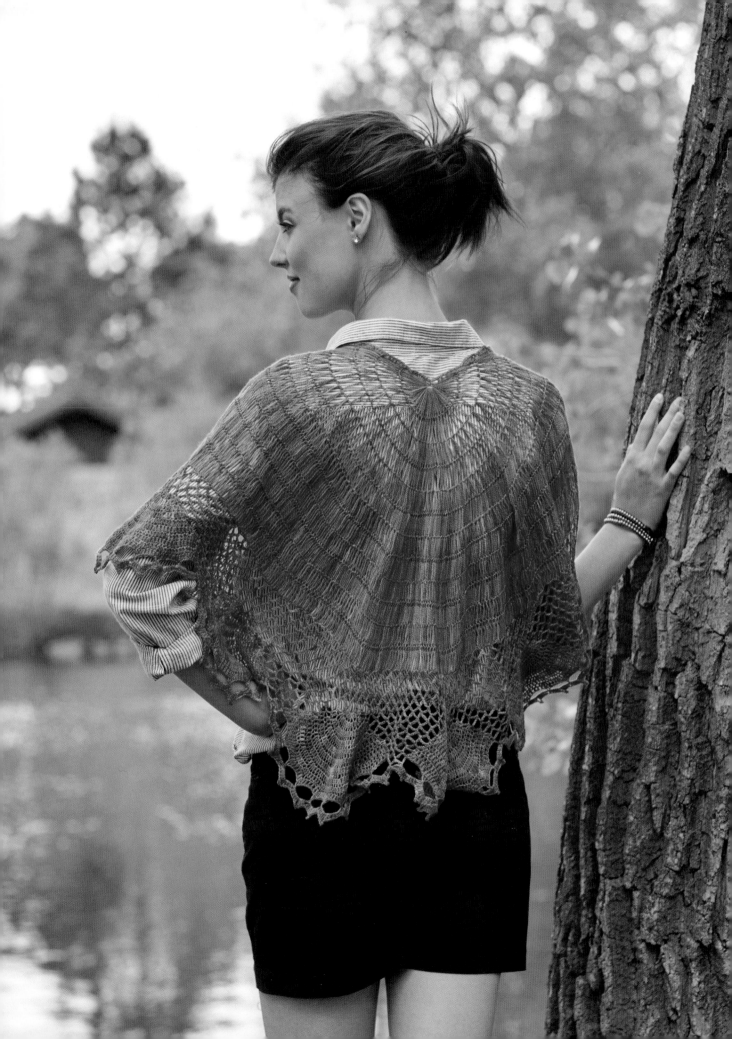

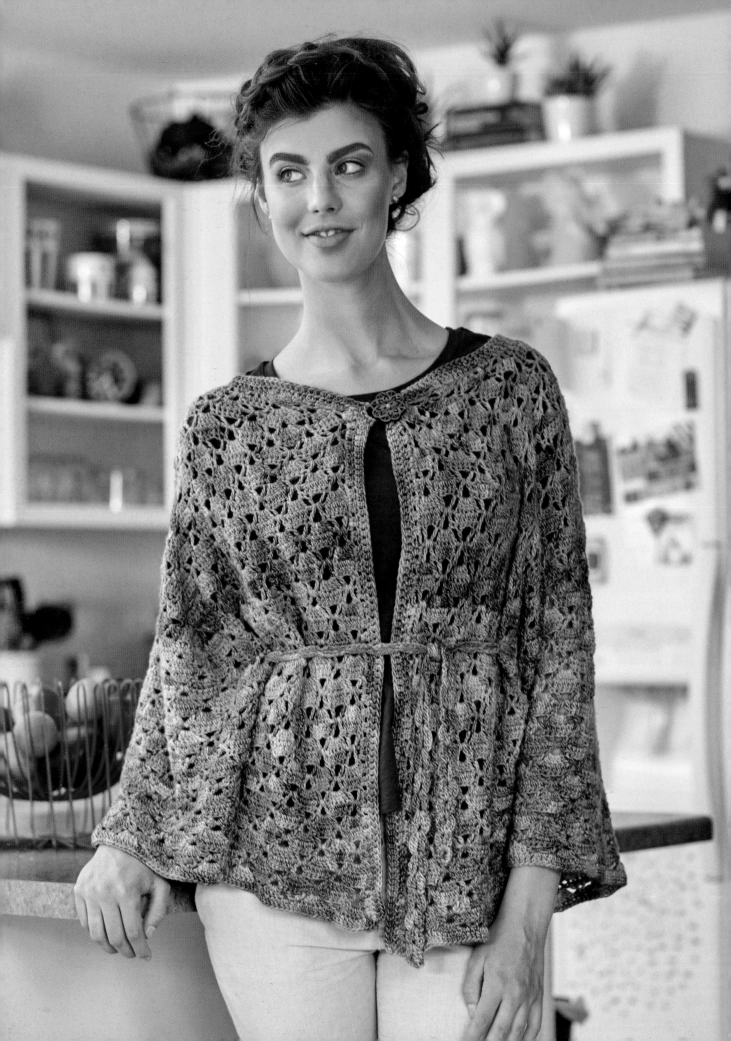

alfresco by the lake
BELTED CAPE

A beautiful top-down raglan shaped lace cape hides the increases beautifully within the stitch pattern. It has a button closure and a belt so you can wear it in a variety of ways. Figure-flattering and multipurpose—what's not to love?

FINISHED SIZE
25" (63.5 cm) deep.

Bottom edge: 100" (254 cm) across.

Neck edge: 24" (61 cm) across.

YARN
Shown here: Malabrigo Yarns Silky Merino (50% baby merino wool, 50% silk; 150 yd (137 m)/1.75 oz [50 g]): #411 Green Gray, 10 hanks.

HOOK
G/6 (4 mm).

Adjust hook size if needed to obtain gauge.

NOTIONS
Yarn needle; 4 stitch markers; one 1½" (3.8 cm) button. Sample features Blumenthal Lansing Co's Cut Outs #240002411.

GAUGE
2 pattern reps = 4" (10 cm); 4 rows in pattern = 3½" (9 cm).

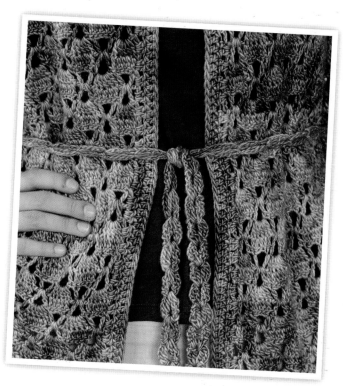

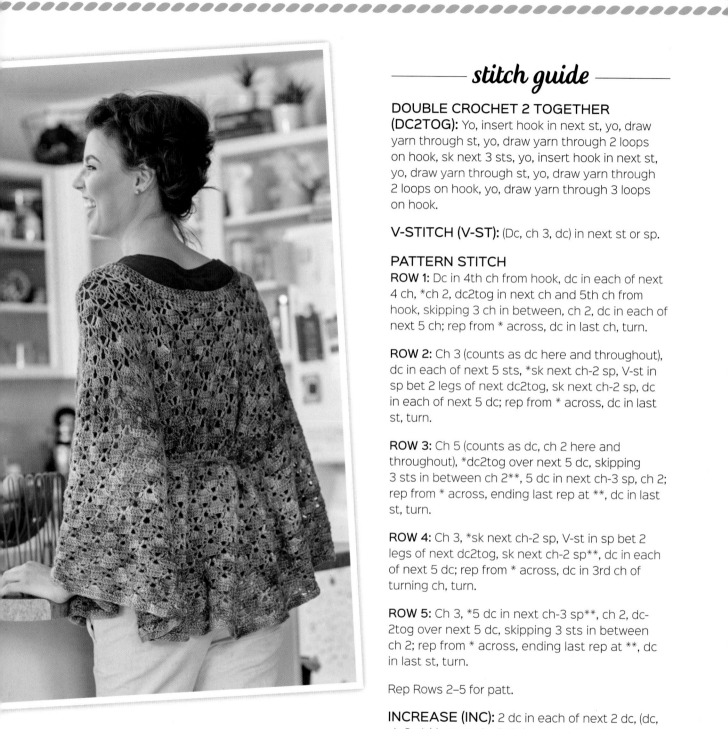

stitch guide

DOUBLE CROCHET 2 TOGETHER (DC2TOG): Yo, insert hook in next st, yo, draw yarn through st, yo, draw yarn through 2 loops on hook, sk next 3 sts, yo, insert hook in next st, yo, draw yarn through st, yo, draw yarn through 2 loops on hook, yo, draw yarn through 3 loops on hook.

V-STITCH (V-ST): (Dc, ch 3, dc) in next st or sp.

PATTERN STITCH

ROW 1: Dc in 4th ch from hook, dc in each of next 4 ch, *ch 2, dc2tog in next ch and 5th ch from hook, skipping 3 ch in between, ch 2, dc in each of next 5 ch; rep from * across, dc in last ch, turn.

ROW 2: Ch 3 (counts as dc here and throughout), dc in each of next 5 sts, *sk next ch-2 sp, V-st in sp bet 2 legs of next dc2tog, sk next ch-2 sp, dc in each of next 5 dc; rep from * across, dc in last st, turn.

ROW 3: Ch 5 (counts as dc, ch 2 here and throughout), *dc2tog over next 5 dc, skipping 3 sts in between ch 2**, 5 dc in next ch-3 sp, ch 2; rep from * across, ending last rep at **, dc in last st, turn.

ROW 4: Ch 3, *sk next ch-2 sp, V-st in sp bet 2 legs of next dc2tog, sk next ch-2 sp**, dc in each of next 5 dc; rep from * across, dc in 3rd ch of turning ch, turn.

ROW 5: Ch 3, *5 dc in next ch-3 sp**, ch 2, dc2tog over next 5 dc, skipping 3 sts in between ch 2; rep from * across, ending last rep at **, dc in last st, turn.

Rep Rows 2–5 for patt.

INCREASE (INC): 2 dc in each of next 2 dc, (dc, ch 3, dc) in next dc, 2 dc in each of next 2 dc.

CAPE

Ch 99.

ROW 1: Dc in 4th ch from hook, dc in each of next 5 ch, *ch 2, dc2tog in next ch and 5th ch from hook, skipping 3 ch in between, ch 2, dc in each of next 5 ch; rep from * across, dc in last ch, turn—ten 5-dc sections; 9 dc2tog.

ROW 2 (INC): Ch 3 (counts as dc here and throughout), [2 dc in each of next 2 sts, V-st in next st, 2 dc in each of next 2 sts] (inc made), V-st in sp bet 2 legs of next dc2tog, inc over next 5 dc, V-st in sp bet 2 legs of next dc2tog, dc in each of next 5 sts, V-st in sp bet 2 legs of next dc2tog, inc over next 5 dc, [V-st in sp bet 2 legs of next dc2tog, dc in each of next 5 sts] twice, V-st in sp bet 2 legs of next dc2tog, inc over next 5 dc, V-st in sp bet 2 legs of next dc2tog, dc in each of next 5 sts, V-st in sp bet 2 legs of next dc2tog, inc over next 5 dc, dc in last st, turn—sixteen 5-dc sections.

ROW 3: Ch 5 (counts as dc, ch 2, here and throughout), *dc2tog over next 5 dc, skipping 3 sts in between ch 2**, 5 dc in next ch-3 sp, ch 2; rep from * across, ending last rep at **, dc in last st, turn—fifteen 5-dc sections.

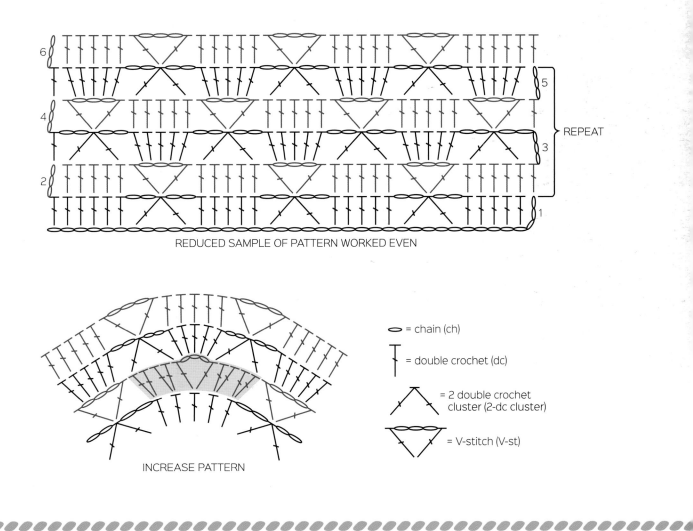

REDUCED SAMPLE OF PATTERN WORKED EVEN

INCREASE PATTERN

⬯ = chain (ch)

┬ = double crochet (dc)

⋀ = 2 double crochet cluster (2-dc cluster)

⋁ = V-stitch (V-st)

ROW 4: Ch 3, V-st in sp bet 2 legs of next dc2tog, inc over next 5 dc V-st in sp bet 2 legs of next dc2tog, dc in each of next 5 dc, V-st in sp bet 2 legs of next dc2tog, inc over next 5 dc, [V-st in sp bet 2 legs of next dc2tog, dc in each of next 5 dc] twice, V-st in sp bet 2 legs of next dc2tog, inc over next 5 dc, [V-st in sp bet 2 legs of next dc2tog, dc in each of next 5 dc] 3 times, V-st in sp bet 2 legs of next dc2tog, inc over next 5 dc, [V-st in sp bet 2 legs of next dc2tog, dc in each of next 5 dc] twice, V-st in sp bet 2 legs of next dc2tog, inc over next 5 dc, V-st in sp bet 2 legs of next dc2tog, dc in each of next 5 dc, V-st in sp bet 2 legs of next dc2tog, inc over next 5 dc, dc in last st, turn—twenty-one 5-dc sections.

ROW 5: Rep Row 3—twenty 5-dc sections.

ROW 6: Ch 3, *[dc in each of next 5 dc, V-st in sp bet 2 legs of next dc2tog] 3 times, inc over next 5 dc, V-st in sp bet 2 legs of next dc2tog*; rep from * to * once, [dc in each of next 5 dc, V-st in sp bet 2 legs of next dc2tog] 4 times, inc over next 5 dc, V-st in sp bet 2 legs of next dc2tog; rep from * to * once, [dc in each of next 5 dc, V-st in sp bet 2 legs of next dc2tog] twice, dc in each of last 6 sts, turn—twenty-four 5-dc sections. Place marker in ch-3 sp of each inc. Move markers up as work progresses.

ROW 7: Rep Row 3—twenty-three 5-dc sections.

ROW 8: Ch 3, V-st in sp bet 2 legs of next dc2tog, *[dc in each of next 5 dc, V-st in sp bet 2 legs of next dc2tog] across to next marked 5-dc section, inc over next 5 dc; rep from * to * 3 times, *[dc in each of next 5 dc, V-st in sp bet 2 legs of next dc2tog] across to last 5-dc section, dc in last st, turn—twenty-seven 5-dc sections.

ROW 9: Ch 3, *5 dc in next ch-3 sp, dc2tog over next 5 dc, skipping 3 sts in between; rep from * across, ending last rep at **dc in last st, turn—twenty-eight 5-dc sections.

ROW 10: Ch 3 (counts as dc), dc in each of next 5 sts, *[V-st in sp bet 2 legs of next dc2tog, dc in each of next 5 dc] across to next marked 5-dc section in over next 5 dc; rep from * 3 times, *[V-st in sp bet 2 legs of next dc2tog, dc in each of next 5 dc] across to last 5-dc section, dc in last st, turn—thirty-two 5-dc sections.

ROWS 11–18: Rep Rows 7–10 (twice)—forty-eight 5-dc sections at end of last row.

ROW 19–45: Starting with Row 3 of patt, work even in patt, ending with Row 5 of patt. Do not fasten off.

EDGING

RND 1: Ch 3, 2 dc in corner st, turn to work across left front edge, work 2 dc in each row-end dc to Row 6, place marker, continue to work 2 dc in each row-end dc across to neck edge, 3 dc in corner st, working across foundation ch, dc in each ch across, 3 dc in corner st, 2 dc in each row-end st across to bottom edge, 3 dc in corner st, dc evenly across, work dc in each st and 2 dc in each ch-2 sp, sl st in top of beg ch-3 to join hem.

ROW 2: Ch 3, dc in each dc across to marker, ch 9, sk next 2 sts for button loop, *dc in each st across to next corner, 3 dc in corner st; rep from * once, dc in each st across to bottom edge. Fasten off.

BELT

ROW 1: Ch 4, 3 tr in 4th ch from hook, turn.

ROW 2: Sl st in sp bet 2nd and 3rd tr, ch 4, 3 tr in same sp, turn.

Rep Row 2 until belt measures 60" (152.5 cm) from beg. Fasten off.

FINISHING

Weave in ends. Handwash, block to finished measurements, and allow to dry. Sew button to right front edge opposite button loop.

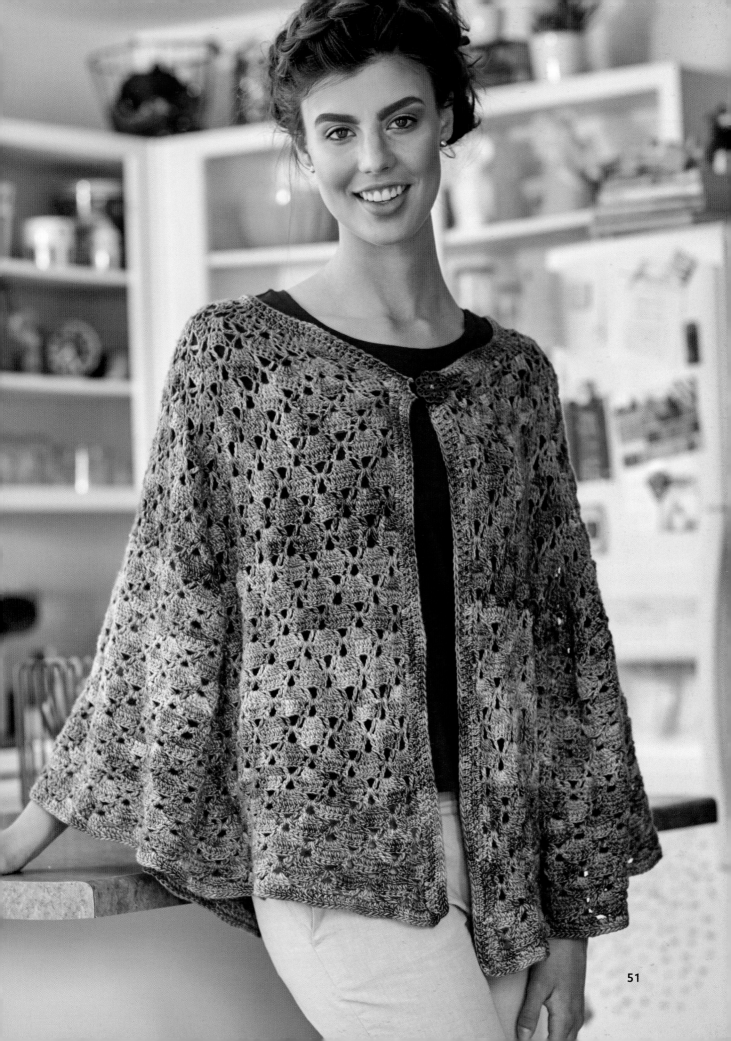

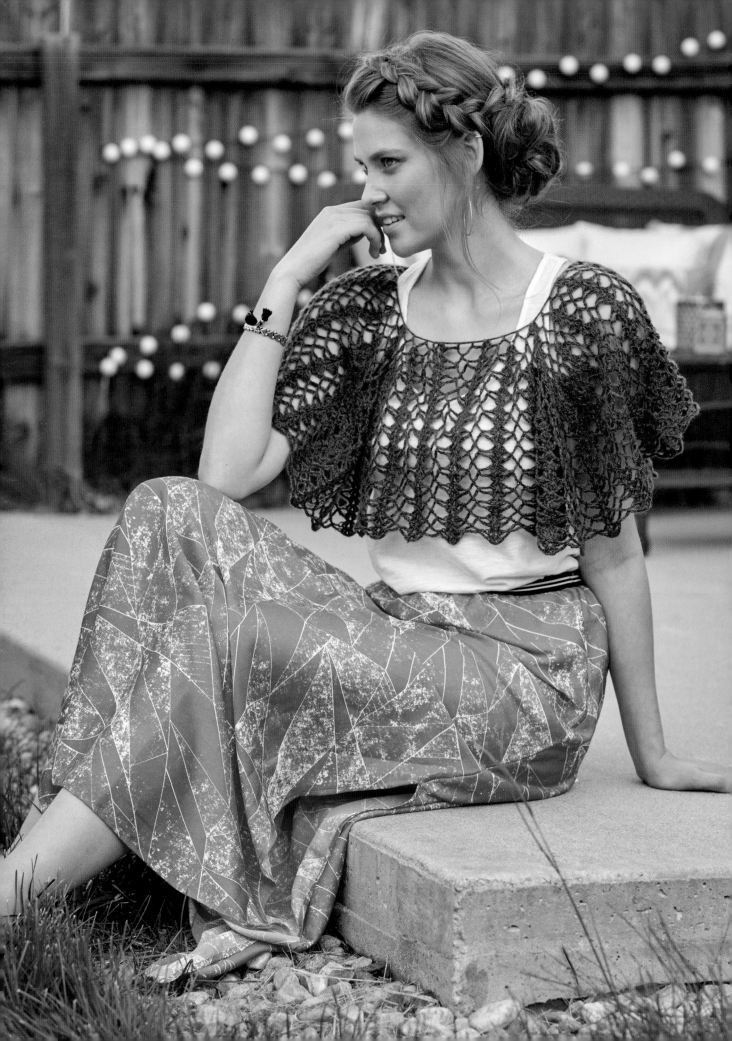

african violets
RAGLAN CAPELET

Inspired by the velvety texture of the namesake's petals, I chose a yarn with halo wisps of fiber for beautiful texture. The top-down, in-the-round capelet has four corners of raglan shaping. Wear it with the points on either side of your arms (for traditional raglan construction) or with the points down the center front and back for a more dramatic look!

FINISHED SIZE
11½" (29 cm) deep.

Neck opening: 28" (71 cm) in circumference.

Bottom edge: 99" (251 cm) in circumference.

YARN
Laceweight (#1 Superfine).

Shown here: Filatura di Crosa Superior (70% cashmere, 25% schappe silk, 5% extrafine merino wool; 328 yd (300 m)/0.88 oz [25 g]): #85 Deep Purple (A), 2 balls.

Laceweight (#1 Superfine).

Shown here: Filatura di Crosa Nirvana (100% extrafine superwash merino wool; 372 yd (340 m)/0.88 oz [25 g]): #44 Deep Purple (B), 1 ball.

HOOK
G/6 (4 mm).

Adjust hook size if needed to obtain gauge.

NOTIONS
Yarn needle.

GAUGE
1 pattern rep = 2¼" (5.5 cm); 8 rows of shells = 4" (10 cm).

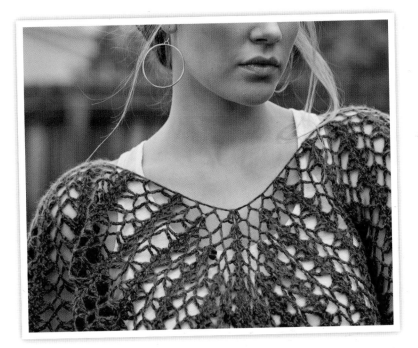

stitch guide

SHELL: (2 dc, ch 2, 2 dc) in same st or sp.

STITCH PATTERN (PATT)

Ch a multiple of 9 sts, without twisting ch, join with sl st in first ch.

RND 1: Ch 3 (counts as dc here and throughout), (dc, ch 2, 2 dc) in first ch, *ch 3, sk next 2 ch, sc in next ch, ch 5, sk next 2 ch, sc in next ch, ch 3, sk next 2 ch**, shell in next ch; rep from * around, ending last rep at **, join with sl st in top of beg ch-3.

RND 2: Sl st to next ch-2 sp, ch 3, (dc, ch 2, 2 dc) in same ch-2 sp, *ch 5, sk next ch-3 sp, sc in next ch-5 sp, ch 5, sk next ch-3 sp**, shell in ch-2 sp of next shell; rep from * around, ending last rep at **, join with sl st in top of beg ch-3.

RND 3: Sl st to next ch-2 sp, ch 3, (dc, ch 2, 2 dc) in same ch-2 sp, *ch 3, sc in next ch-5 sp, ch 5, sc in next ch-5 sp, ch 3**, shell in ch-2 sp of next shell; rep from * around, ending last rep at **, join with sl st in top of beg ch-3.

Rep Rnds 2 and 3 for patt.

INCREASE (INC): (Ch 5, sc in next ch-3 sp, ch 3, shell in next ch-5, ch 5, sc in next ch-3 sp, ch 5.

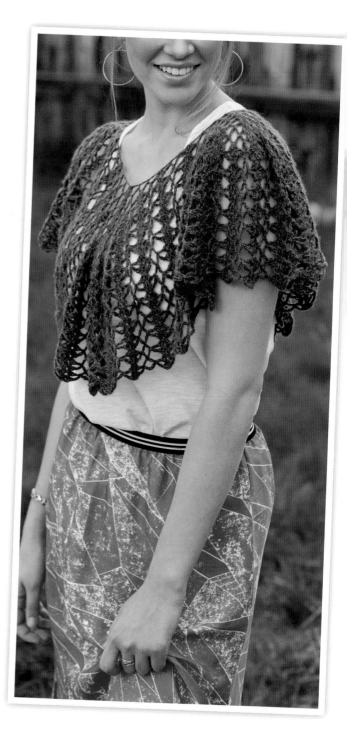

SHAWL

Note: One strand each of A and B are held together as one throughout entire project.

With A and B held together as one, ch 108, without twisting ch, join with sl st in first ch.

RND 1: Ch 3 (counts as dc here and throughout), (dc, ch 2, 2 dc) in first ch, *ch 3, sk next 2 ch, sc in next ch, ch 5, sk next 2 ch, sc in next ch, ch 3, sk next 2 ch**, shell in next ch; rep from * around, ending last rep at **, join with sl st in top of beg ch-3—12 shells.

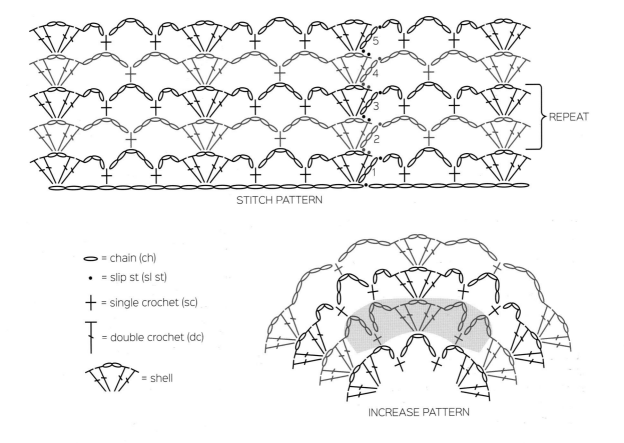

STITCH PATTERN

⬭ = chain (ch)

• = slip st (sl st)

✛ = single crochet (sc)

▯ = double crochet (dc)

🔱 = shell

INCREASE PATTERN

REPEAT

RND 2: Sl st to next ch-2 sp, ch 3, (dc, ch 2, 2 dc) in same ch-2 sp, *ch 5, sk next ch-3 sp, sc in next ch-5 sp, ch 5, sk next ch-3 sp, shell in ch-2 sp of next shell, [work inc over next 3 sps, shell in ch-2 sp of next shell] twice, ch 5, sk next ch-3 sp, sc in next ch-5 sp, ch 5, sk next ch-3 sp**, shell in ch-2 sp of next shell; rep from * around, ending last rep at **, join with sl st in top of beg ch-3—20 shells.

RND 3: Work Rnd 3 of patt.

RND 4: Sl st to next ch-2 sp, ch 3, (dc, ch 2, 2 dc) in same ch-2 sp, *[ch 5, sk next ch-3 sp, sc in next ch-5 sp, ch 5, sk next ch-3 sp, shell in ch-2 sp of next shell] twice, [work inc over next 3 sps, shell in ch-2 sp of next shell] twice, ch 5, sk next ch-3 sp,

sc in next ch-5 sp, ch 5, sk next ch-3 sp**, shell in ch-2 sp of next shell; rep from * around, ending last rep at **, join with sl st in top of beg ch-3— 28 shells.

RND 5: Work Rnd 3 of patt.

RND 6: Sl st to next ch-2 sp, ch 3, (dc, ch 2, 2 dc) in same ch-2 sp, *[ch 5, sk next ch-3 sp, sc in next ch-5 sp, ch 5, sk next ch-3 sp, shell in ch-2 sp of next shell] 3 times, [work inc over next 3 sps, shell in ch-2 sp of next shell] twice, ch 5, sk next ch-3 sp, sc in next ch-5 sp, ch 5, sk next ch-3 sp**, shell in ch-2 sp of next shell; rep from * around, ending last rep at **, join with sl st in top of beg ch-3—36 shells.

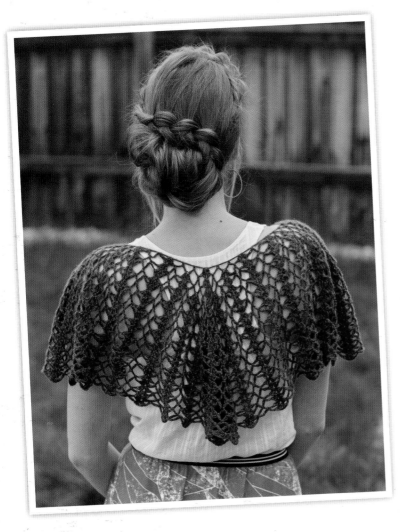

RND 7: Work Rnd 3 of patt.

RND 8: Sl st to next ch-2 sp, ch 3, (dc, ch 2, 2 dc) in same ch-2 sp, *[ch 5, sk next ch-3 sp, sc in next ch-5 sp, ch 5, sk next ch-3 sp, shell in ch-2 sp of next shell] 3 times, [work inc over next 3 sps, shell in ch-2 sp of next shell] twice, ch 5, sk next ch-3 sp, sc in next ch-5 sp, ch 5, sk next ch-3 sp**, shell in ch-2 sp of next shell; rep from * around, ending last rep at **, join with sl st in top of beg ch-3 —44 shells.

RNDS 9–25: Starting with Rnd 3, work even in patt. Fasten off.

FINISHING
Weave in ends. Handwash, block to finished measurements, and allow to dry.

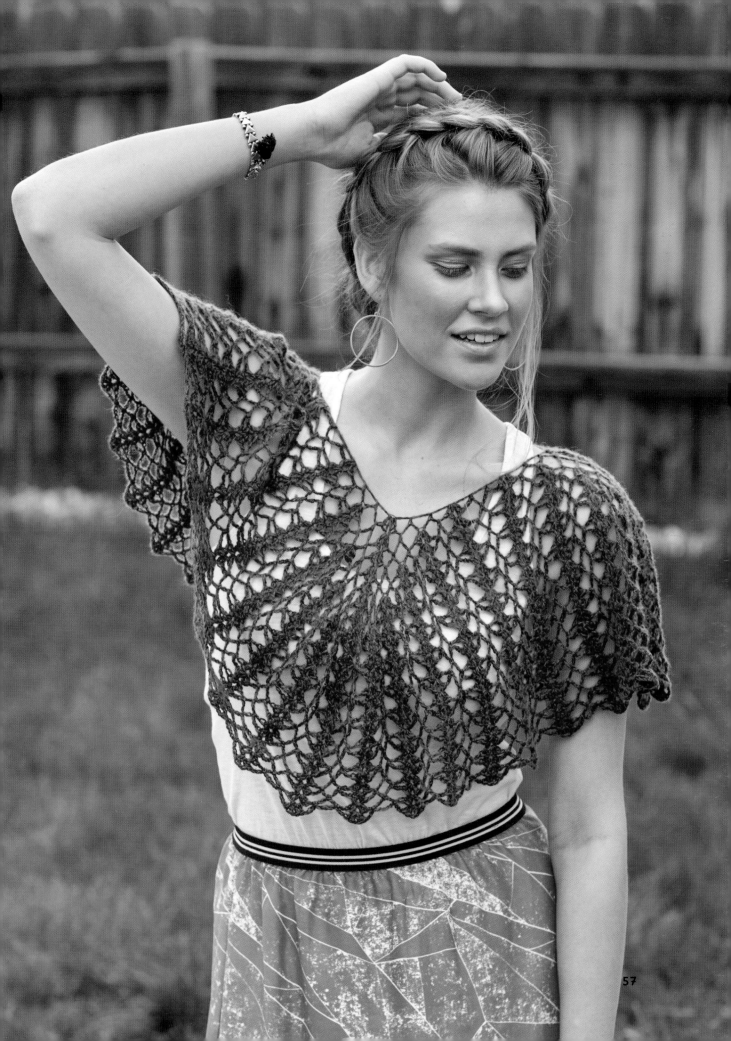

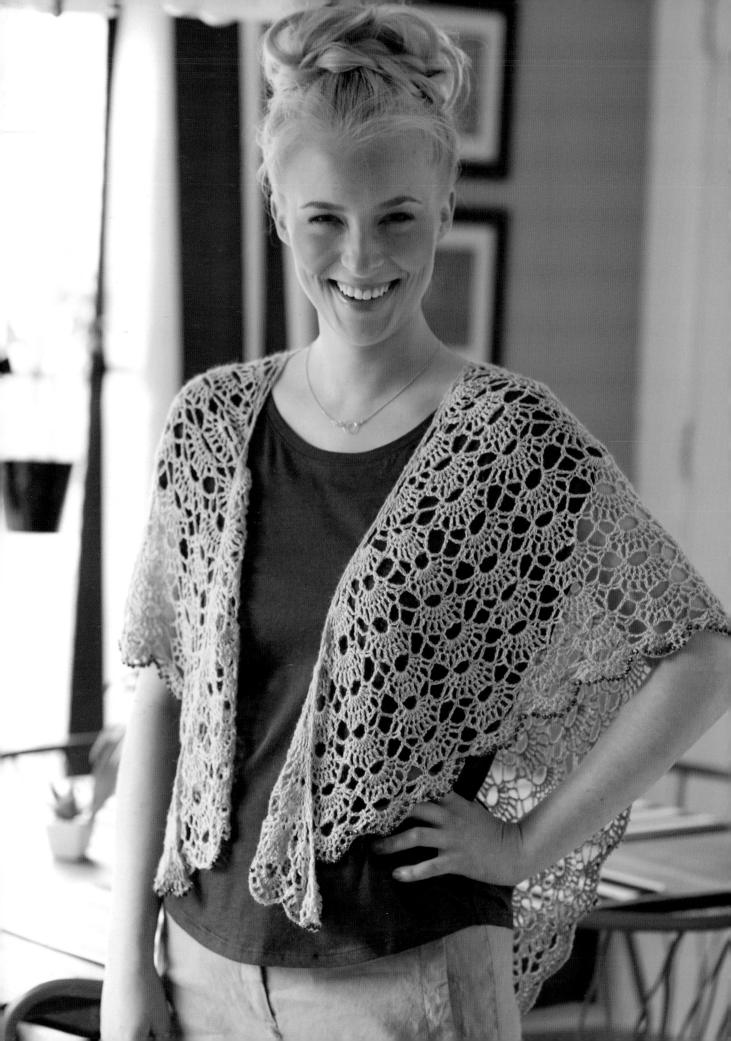

sausalito sparkle
OFFSET LACE SHAWL

Who doesn't love to crochet a top-down triangular shawl? I chose a beautiful offset fan stitch pattern and created the shaping invisibly in the stitch pattern for a flawless finish. Adding matching beads in the final round adds weight and sparkle to this beautiful wrap.

FINISHED SIZE
33" (84 cm) wide × 25" (63.5) deep.

YARN
Fingering weight (#0 Lace).

Shown here: Miss Babs Alpacacita (70% baby alpaca, 30% cultivated silk; 800 yd [731 m]/4 oz [113 g]): Warm Sienna, 1 hank.

HOOK
H/8 (5 mm).

Adjust hook size if needed to obtain gauge.

NOTIONS
Yarn needle; stitch marker; five 9 g tubes; 602 size 6/0 beads. Sample features TOHO 6/0 "E" beads, raspberry gold #1952-99.

GAUGE
1 fan in pattern = 2½" (6.5 cm) wide; 6 rows in pattern = 2½" (6.5 cm).

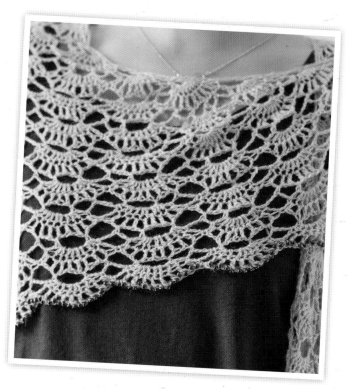

stitch guide

BEADED SINGLE CROCHET (BEADED SC):
Insert hook in next st, yo, draw yarn through st, slide bead up to hook, yo, draw yarn through 2 loops on hook.

SHAWL

Ch 4, dc in 4th ch from hook to form a ring.

ROW 1: Ch 3 (counts as dc here and throughout), work 7 dc in ch-4 sp, turn—8 dc.

ROW 2: Ch 4 (counts as dc, ch 1 here and throughout), (dc, ch 1) in each of next 6 sts, dc in last st, turn.

ROW 3: *Ch 5, sc in next ch-1 sp; rep from * across, turn—7 ch-5 sps.

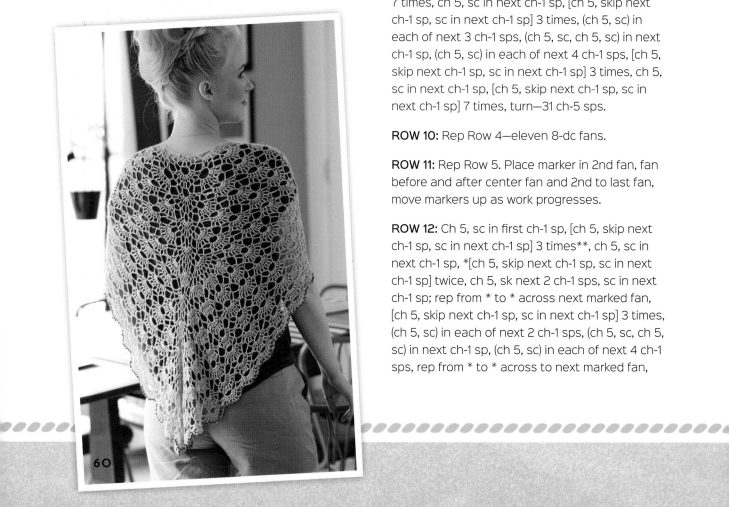

ROW 4: Ch 3 (counts as dc), 7 dc in next ch-5 sp, *sc in next ch-5 sp, ch 5, sc in next ch-5 sp, 8 dc in next ch-5 sp; rep from * across, turn—three 8-dc fans.

ROW 5: Ch 4 (counts as dc, ch 1 here and throughout), (dc, ch 1) in each of next 6 sts, dc in next dc, *sc in next ch-5 sp, (dc, ch 1) in each of next 7 sts, dc in next st; rep from * across, turn.

ROW 6: Ch 5, skip next ch-1 sp, sc in next ch-1 sp, (ch 5, sc) in each of next 8 ch-1 sps, ch 5, sk next ch-1 sp, sc in next ch-1 sp, (ch 5, sc) in each of next 9 ch-1 sps, turn—19 ch-5 sps.

ROW 7: Ch 3 (counts as dc), 7 dc in next ch-5 sp, *sc in next ch-5 sp, ch 5, sc in next ch-5 sp, 8 dc in next ch-5 sp; rep from * across, turn—seven 8-dc fans.

ROW 8: Rep Row 5.

ROW 9: [Ch 5, skip next ch-1 sp, sc in next ch-1 sp] 7 times, ch 5, sc in next ch-1 sp, [ch 5, skip next ch-1 sp, sc in next ch-1 sp] 3 times, (ch 5, sc) in each of next 3 ch-1 sps, (ch 5, sc, ch 5, sc) in next ch-1 sp, (ch 5, sc) in each of next 4 ch-1 sps, [ch 5, skip next ch-1 sp, sc in next ch-1 sp] 3 times, ch 5, sc in next ch-1 sp, [ch 5, skip next ch-1 sp, sc in next ch-1 sp] 7 times, turn—31 ch-5 sps.

ROW 10: Rep Row 4—eleven 8-dc fans.

ROW 11: Rep Row 5. Place marker in 2nd fan, fan before and after center fan and 2nd to last fan, move markers up as work progresses.

ROW 12: Ch 5, sc in first ch-1 sp, [ch 5, skip next ch-1 sp, sc in next ch-1 sp] 3 times**, ch 5, sc in next ch-1 sp, *[ch 5, skip next ch-1 sp, sc in next ch-1 sp] twice, ch 5, sk next 2 ch-1 sps, sc in next ch-1 sp; rep from * to * across next marked fan, [ch 5, skip next ch-1 sp, sc in next ch-1 sp] 3 times, (ch 5, sc) in each of next 2 ch-1 sps, (ch 5, sc, ch 5, sc) in next ch-1 sp, (ch 5, sc) in each of next 4 ch-1 sps, rep from * to * across to next marked fan,

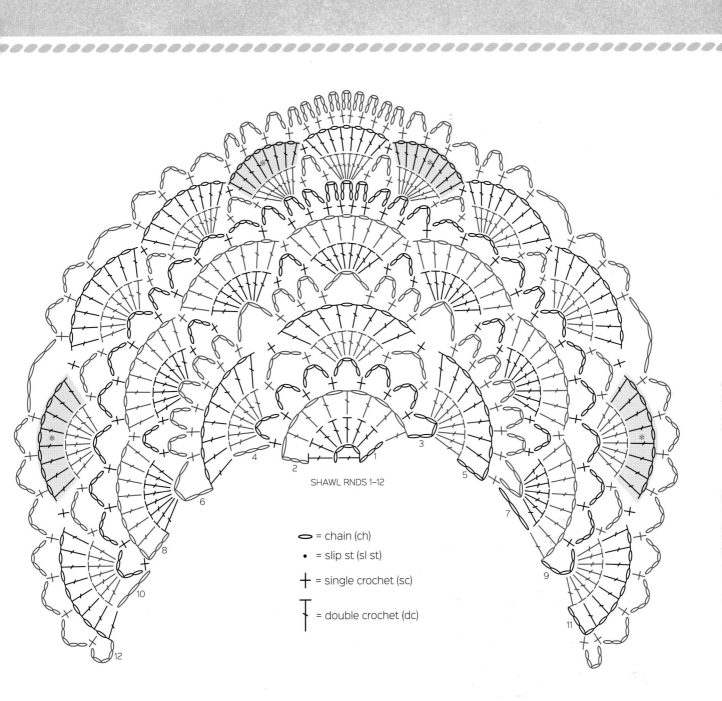

SHAWL RNDS 1–12

= chain (ch)

= slip st (sl st)

= single crochet (sc)

= double crochet (dc)

[ch 5, skip next ch-1 sp, sc in next ch-1 sp] 3 times, ch 5, sc in next ch-1 sp, ch 5, skip next ch-1 sp, sc in next ch-1 sp] 3 times, ch 5, sc in same ch-1 sp, turn—43 ch-5 sps.

ROWS 13–35: Rep Rows 10–12 (7 times); then rep Rows 10–11 (once). Fasten off.

ROW 36 (BEADED ROW): Thread 689 beads onto yarn. With WS facing, join yarn with a sl st in first dc, ch 1, beaded sc in each st and ch-1 sp across. Fasten off.

FINISHING

Weave in ends. Handwash, block to finished measurements, and allow to dry.

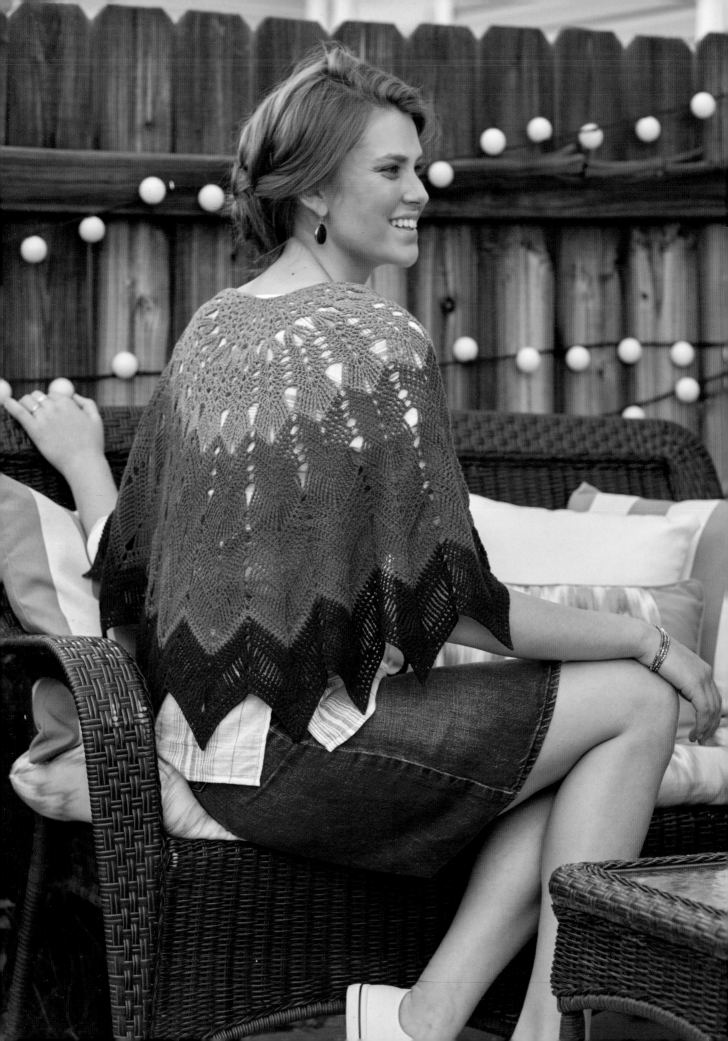

sorrento sunset
STARBURST SHAWL

Inspired by fiery red-and-gold sunsets, the yarn was designed specifically for this shawl. Gradient yarns can be manipulated in a variety of ways to create stunning visual effects. Alternating two skeins simultaneously allows for this generous shawl to change color only one time in the unique starburst stitch pattern.

FINISHED SIZE
46" (117 cm) deep × 23" (58.5 cm) wide.

YARN
Sock weight (#1 Superfine).

Shown here: Knitting Rose Yarns Budding Tracks Sock Yarn (90% superwash merino wool, 10% bison down; 400 yd [366 m]/3.5 oz [100 g]): Maleficent's Fire, 2 hanks.

HOOK
D/3 (3.25 mm).

Adjust hook size if needed to obtain gauge.

NOTIONS
Yarn needle.

GAUGE
First 4 rows = 4½" (11.5 cm) wide × 2" (5 cm) deep; 5 rows dc and 1 row quad st at peak = 4" (10 cm).

stitch guide

QUAD STITCH (QUAD ST): Yo 5 times, insert hook in specified st or sp, yo, draw up a loop, (yo, draw through 2 loops on hook) 6 times.

SHELL: (2 dc, ch 2, 2 dc) in same sp.

LARGE SHELL (LG SHELL): (3 dc, ch 2, 3 dc) in same sp.

QUAD SHELL: (2 quad sts, ch 2, 2 quad sts) in same sp.

LARGE QUAD SHELL: (3 quad sts, ch 2, 3 quad sts) in same sp.

Note: Because the yarn is a gradient (changes color only one time per hank), and the shawl requires two hanks of yarn, alternate each row with each hank of yarn.

⌒ = chain (ch)

• = slip st (sl st)

= double crochet (dc)

= quadruple treble crochet (quad)

= shell

= large shell (lg shell)

= quad shell

= large quad shell (lg quad shell)

SHAWL

ROW 1: Ch 4, 6 dc in 4th ch from hook—7 dc.

ROW 2: Ch 3 (counts as dc here and throughout), dc in same st, 2 dc in each st across, turn—14 dc.

ROW 3: Ch 3, dc in same st, 2 dc in each st across—28 dc.

ROW 4: Ch 3, dc in next st, *ch 2, dc in each of next 2 sts; rep from * across, turn—13 ch-2 sps.

ROW 5: Ch 3, shell in each ch-2 sp across, dc in top of last st, turn.

ROW 6: Ch 3, *shell in next ch-2 sp; rep from * across, dc in top of last st, turn.

ROW 7: Ch 3, *sk next st, dc in next st, lg shell in next ch-2 sp, dc in next st, sk next st; rep from * across, dc in top of last st, turn.

ROW 8: Ch 7 (counts as quad st here and throughout), *lg quad shell in next ch-2 sp; rep from * across, lg quad st in top of last st, turn.

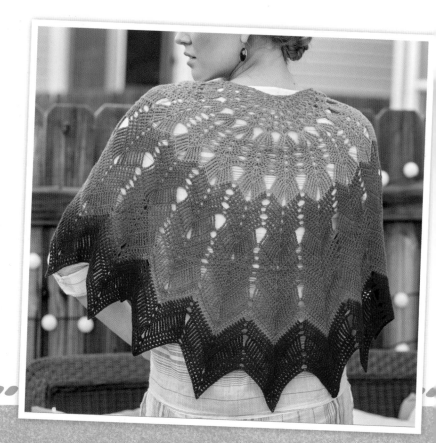

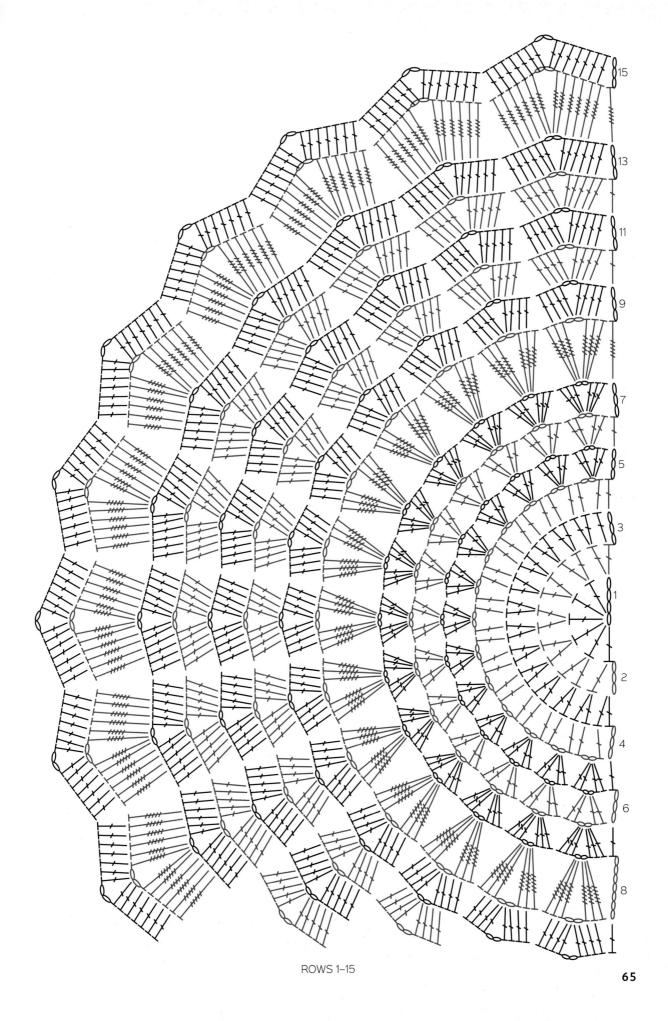

ROWS 1–15

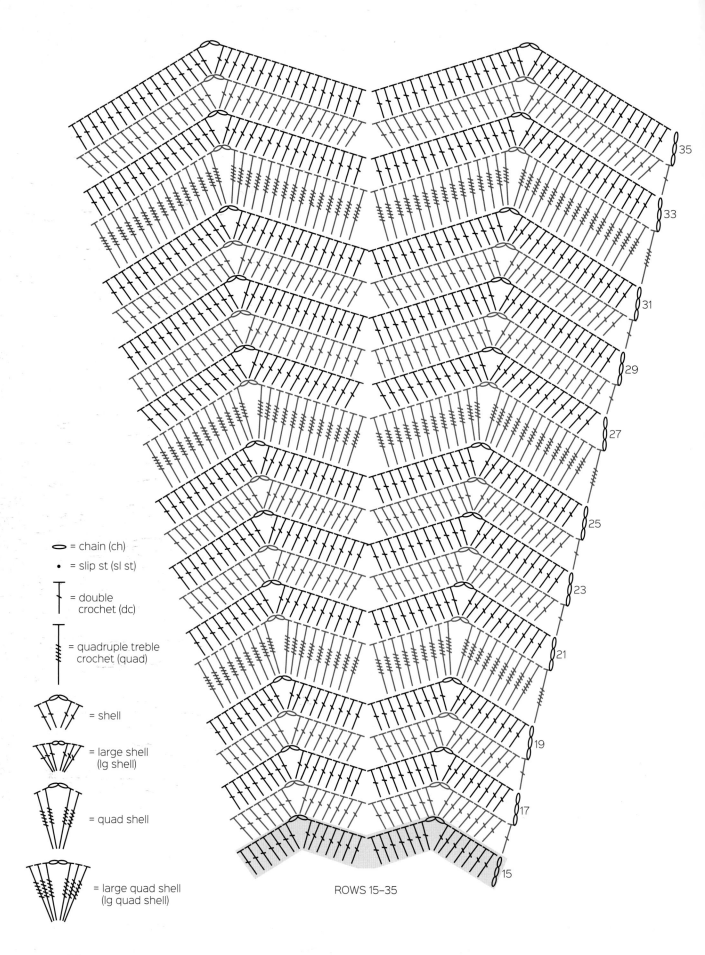

= chain (ch)

= slip st (sl st)

= double
crochet (dc)

= quadruple treble
crochet (quad)

= shell

= large shell
(lg shell)

= quad shell

= large quad shell
(lg quad shell)

ROWS 15–35

35

33

31

29

27

25

23

21

19

17

15

ROW 9: Ch 3, *sk next st, dc in each of next 2 sts, shell in next ch-2 sp, dc in each of next 2 sts, sk next st; rep from * across, dc in top of last st, turn.

ROW 10: Ch 3, *sk next 2 sts, dc in each of next 2 sts, shell in next ch-2 sp, dc in each of next 2 sts, sk next 2 sts; rep from * across, dc in last st, turn.

ROW 11: Ch 3, *sk next st, dc in each of next 3 sts, shell in next ch-2 sp, dc in each of next 3 sts, sk next st; rep from * across, dc in last st, turn.

ROW 12: Ch 3, *sk next 2 sts, dc in each of next 3 sts, shell in next ch-2 sp, dc in each of next 3 sts, sk next 2 sts; rep from * across, dc in last st, turn.

ROW 13: Ch 3, *sk next st, dc in each of next 4 sts, shell in next ch-2 sp, dc in each of next 4 sts, sk next st; rep from * across, dc in last st, turn.

ROW 14: Ch 7, *sk next 2 sts, quad st in each of next 4 sts, quad shell in next ch-2 sp, quad in each of next 4 sts, sk next 2 sts; rep from * across, quad in top of last st, turn.

ROW 15: Ch 3, *sk next st, dc in each of next 5 sts, shell in next ch-2 sp, dc in each of next 5 sts, sk next 2 sts; rep from * across, dc in last st, turn.

ROW 16: Ch 3, *sk next 2 sts, dc in each of next 5 sts, shell in next ch-2 sp, dc in each of next 5 sts, sk next 2 sts; rep from * across, dc in last st, turn.

ROW 17: Ch 3, *sk next st, dc in each of next 6 sts, shell in next ch-2 sp, dc in each of next 6 sts, sk next st; rep from * across, dc in last st, turn.

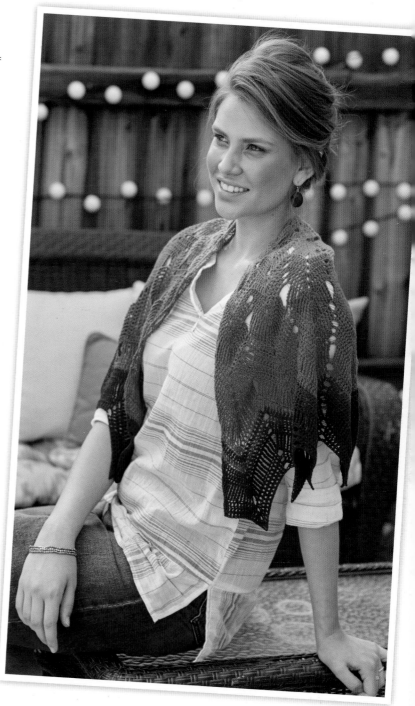

ROW 18: Ch 3, *sk next 2 sts, dc in each of next 6 sts, shell in next ch-2 sp, dc in each of next 6 sts, sk 2 sts; rep from * across, dc in last st, turn.

ROW 19: Ch 3, *sk next st,*dc in each of next 7 sts, shell in next ch-2 sp, dc in each of next 7 sts, sk next st; rep from * across, dc in last st, turn.

ROW 20: Ch 7, *sk next 2 sts, quad in each of next 7 sts, quad shell in next ch-2 sp, quad in each of next 7 sts, sk next 2 sts; rep from * across, quad in last st, turn.

ROW 21: Ch 3, *sk next st, dc in each of next 8 sts, shell in next ch-2 sp, dc in each of next 8 sts, sk next st; rep from * across, dc in last st, turn.

ROW 22: Ch 3, *sk next 2 sts, dc in each of next 8 sts, shell in next ch-2 sp, dc in each of next 8 sts, sk next 2 sts; rep from * across, dc in last st, turn.

ROW 23: Ch 3, *sk next st, dc in each of next 9 sts, shell in next ch-2 sp, dc in each of next 9 sts, sk next st; rep from * across, dc in last st, turn.

ROW 24: Ch 3, *sk next 2 sts, dc in each of next 9 sts, shell in next ch-2 sp, dc in each of next 9 sts, sk next 2 sts; rep from * across, dc in last st, turn.

ROW 25: Ch 3, *sk next st, dc in each of next 10 sts, shell in next ch-2 sp, dc in each of next 10 sts, sk next st; rep from * across, dc in last st, turn.

ROW 26: Ch 7, *sk next 2 sts, quad in each of next 10 sts, quad shell in next ch-2 sp, quad in each of next 10 sts, sk next 2 sts; rep from * across, quad in last st, turn.

ROW 27: Ch 3, *sk next st, dc in each of next 11 sts, shell in next ch-2 sp, dc in each of next 11 sts, sk next st; rep from * across, dc in last st, turn.

ROW 28: Ch 3, *sk next 2 sts, dc in each of next 11 sts, shell in next ch-2 sp, dc in each of next 11 sts, sk next 2 sts; rep from * across, dc in last st, turn.

ROW 29: Ch 3, *sk next st, dc in each of next 12 sts, shell in next ch-2 sp, dc in each of next 12 sts, sk next st; rep from * across, dc in last st, turn.

ROW 30: Ch 3, *sk next 2 sts, dc in each of next 12 sts, shell in next ch-2 sp, dc in each of next 12 sts, sk next 2 sts; rep from * across, dc in last st, turn.

ROW 31: Ch 3, *sk next st,dc in each of next 13 sts, shell in next ch-2 sp, dc in each of next 13 sts, sk next st; rep from * across, dc in last st, turn.

ROW 32: Ch 7, *sk 2 sts, quad in each of next 13 sts, quad shell in next ch-2 sp, quad in each of next 13 sts, sk 2 sts; rep from * across, quad in last st, turn.

ROW 33: Ch 3, *sk next st, dc in each of next 14 sts, shell in next ch-2 sp, dc in each of next 14 sts, sk next st; rep from * across, dc in last st, turn.

ROW 34: Ch 3, *sk next 2 sts, dc in each of next 14 sts, shell in next ch-2 sp, dc in each of next 14 sts, sk next 2 sts; rep from * across, dc in last st, turn.

ROW 35: Ch 3, *sk next st, dc in each of next 15 sts, shell in next ch-2 sp, dc in each of next 15 sts, sk next st; rep from * across, dc in last st, turn.

Fasten off.

FINISHING

Weave in ends. Handwash, block to finished measurements, and allow to dry.

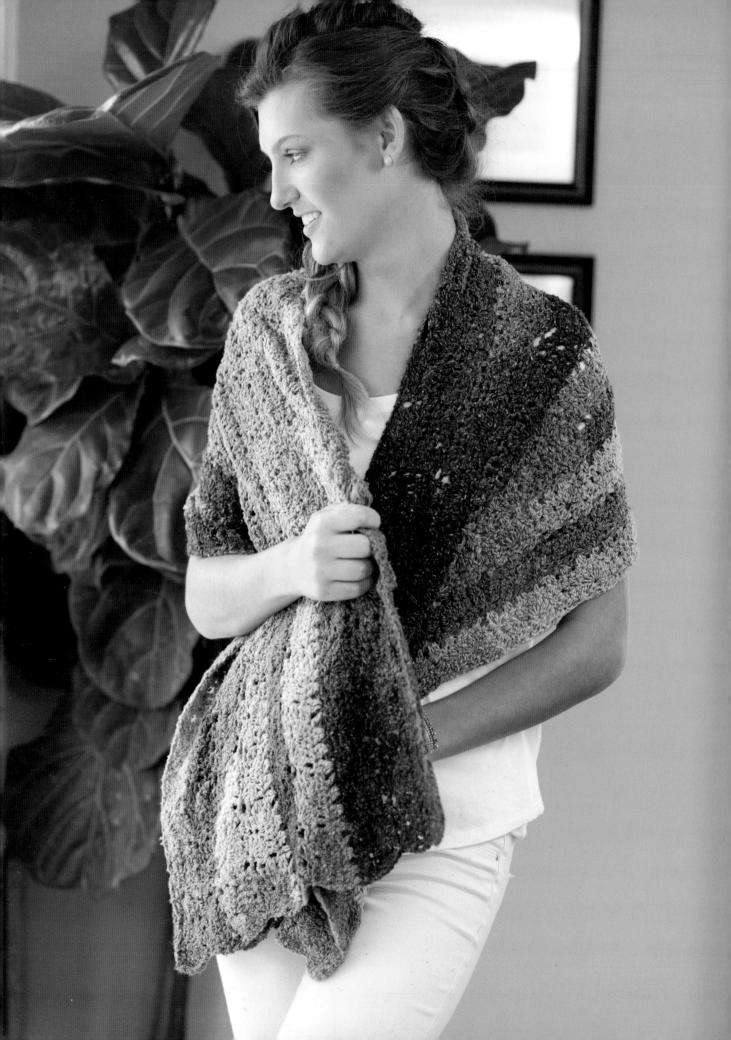

driftwood blues
MINI TILE WRAP

I love miniature motifs; they remind me of mosaic tiles. But I can't stand to weave in hundreds of ends! I designed this construction method to allow you to crochet mini tiles and join them as you go, without cutting yarn at all! Imagine the possibilities! You could take this technique and make anything, from baby blankets, rugs, afghans, scarves, and much more!

FINISHED SIZE
18" (45.5 cm) wide × 58" (147.5 cm) long (9 motifs × 29 motifs).

YARN
Shown here: Cascade Yarns Tangier (50% silk, 17% acrylic, 17% rayon, 16% cotton; 220 yd [200 m]/3.5 oz [100 g]): #11 Beach, 6 balls.

HOOK
H/8 (5 mm).

Adjust hook size if needed to obtain gauge.

GAUGE
Each mini square motif = 2" (5 cm) × 2 1/4" (5.5 cm).

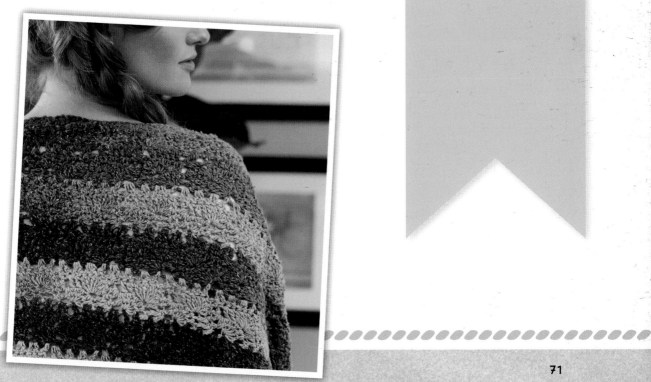

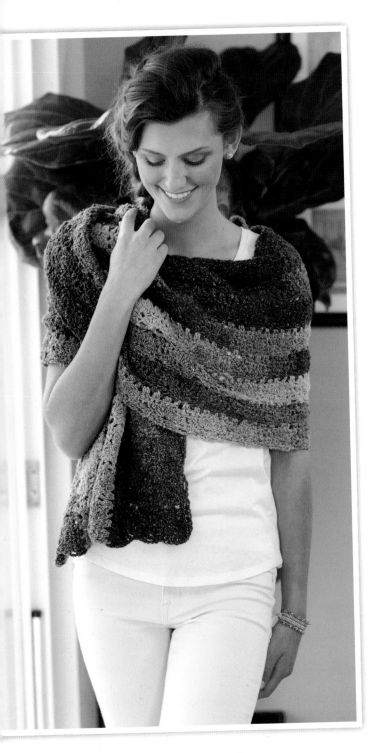

stitch guide
(see Techniques)

DOUBLE CROCHET 6 TOGETHER (DC6TOG)

DOUBLE CROCHET 7 TOGETHER (DC7TOG)

FIRST STRIP
FIRST MOTIF

ROW 1: Ch 15, dc in 4th ch from hook, dc in each ch across—13 dc.

ROW 2: Ch 3 (counts as dc here and throughout), dc in each of next 2 sts, dc7tog over next 7 sts, dc in each of last 3 sts, turn—7 dc.

ROW 3: Ch 3, dc6tog over next 6 sts, turn—2 sts.

SECOND MOTIF

ROW 1: Ch 9, dc in 4th ch from hook, dc in each ch of next 5 ch, work 6 dc evenly spaced across side of previous motif—13 sts.

ROWS 2 AND 3: Rep Rows 2 and 3 of first motif.

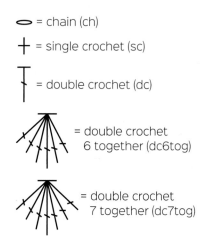

⊖ = chain (ch)

✝ = single crochet (sc)

T = double crochet (dc)

= double crochet 6 together (dc6tog)

= double crochet 7 together (dc7tog)

FIRST STRIP SECOND STRIP THIRD STRIP

3RD–29TH MOTIF FIRST MOTIF 3RD–29TH MOTIF

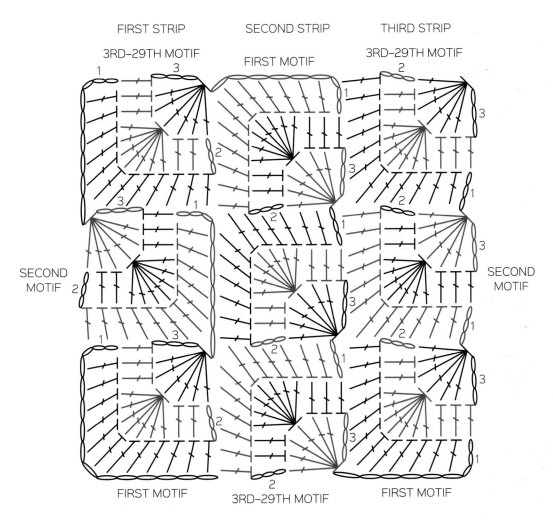

SECOND MOTIF SECOND MOTIF

FIRST MOTIF 3RD–29TH MOTIF FIRST MOTIF

REDUCED SAMPLE OF PATTERN

29	28	27	26	25	24	23	22	21	20	19	18	17	16	15	14	13	12	11	10	9	8	7	6	5	4	3	2	1	Ninth Strip
29	28	27	26	25	24	23	22	21	20	19	18	17	16	15	14	13	12	11	10	9	8	7	6	5	4	3	2	1	Eighth Strip
29	28	27	26	25	24	23	22	21	20	19	18	17	16	15	14	13	12	11	10	9	8	7	6	5	4	3	2	1	Seventh Strip
29	28	27	26	25	24	23	22	21	20	19	18	17	16	15	14	13	12	11	10	9	8	7	6	5	4	3	2	1	Sixth Strip
29	28	27	26	25	24	23	22	21	20	19	18	17	16	15	14	13	12	11	10	9	8	7	6	5	4	3	2	1	Fifth Strip
29	28	27	26	25	24	23	22	21	20	19	18	17	16	15	14	13	12	11	10	9	8	7	6	5	4	3	2	1	Fourth Strip
29	28	27	26	25	24	23	22	21	20	19	18	17	16	15	14	13	12	11	10	9	8	7	6	5	4	3	2	1	Third Strip
29	28	27	26	25	24	23	22	21	20	19	18	17	16	15	14	13	12	11	10	9	8	7	6	5	4	3	2	1	Second Strip
29	28	27	26	25	24	23	22	21	20	19	18	17	16	15	14	13	12	11	10	9	8	7	6	5	4	3	2	1	First Strip

ASSEMBLY DIAGRAM

THIRD THROUGH TWENTY-NINTH MOTIFS

Work same as second motif. At end of last motif, do not turn.

SECOND STRIP

FIRST MOTIF

ROW 1: Ch 9, dc in 4th ch from hook, dc in each ch of next 5 ch, work 6 dc evenly spaced across right-hand side of previous motif—13 sts.

ROW 2: Ch 3 (counts as dc here and throughout), dc in each of next 2 sts, dc7tog over next 7 sts, dc in each of last 3 sts, turn—7 dc.

ROW 3: Ch 3, dc6tog over next 6 sts, do not turn—2 sts.

SECOND MOTIF

ROW 1: Ch 3, work 6 dc evenly spaced across last motif crocheted, work 6 dc evenly spaced across side of next motif directly below—13 dc.

ROWS 2 AND 3: Rep Rows 2 and 3 of first motif.

THIRD THROUGH TWENTY-NINTH MOTIFS

Work same as second motif. At end of last row, turn.

THIRD THROUGH NINTH STRIPS

Rep second strip. Fasten off at end of last motif.

FINISHING

Weave in ends. Handwash, block to finished measurements, and allow to dry.

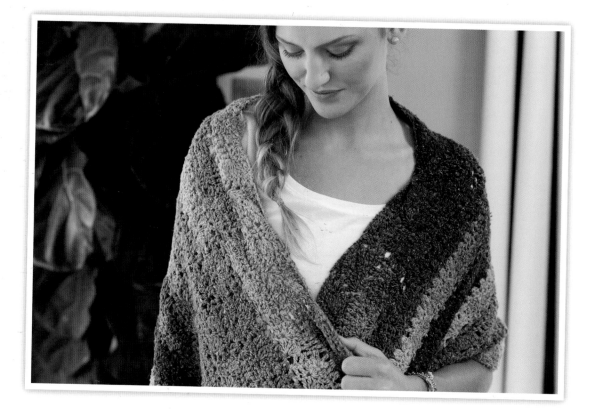

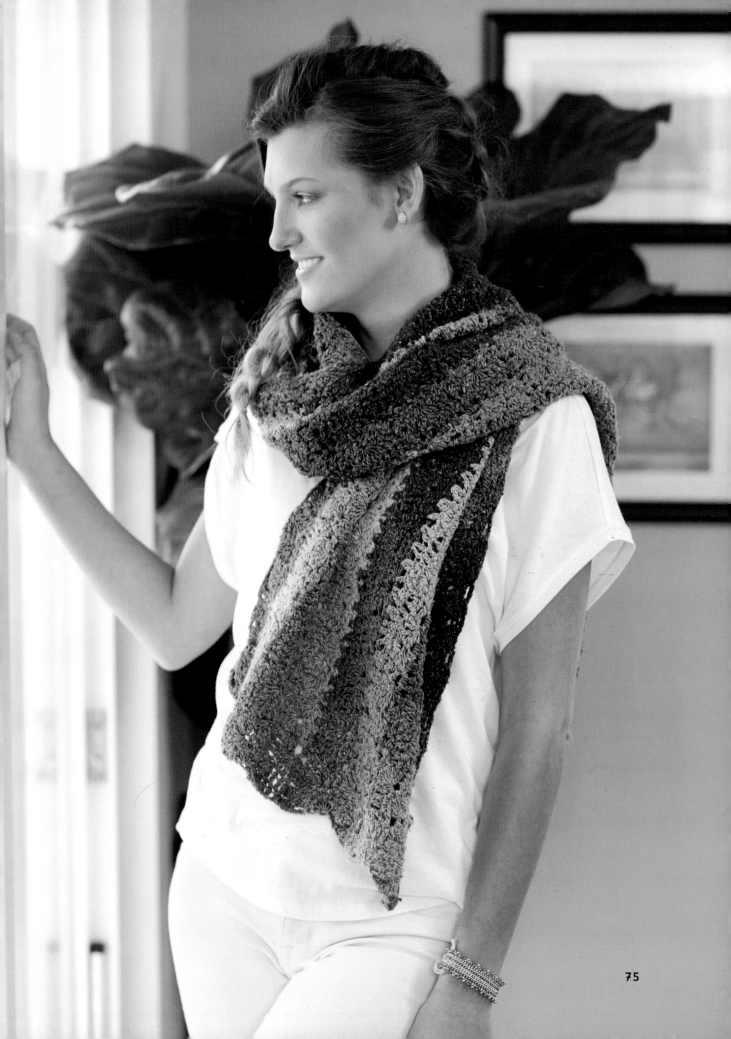

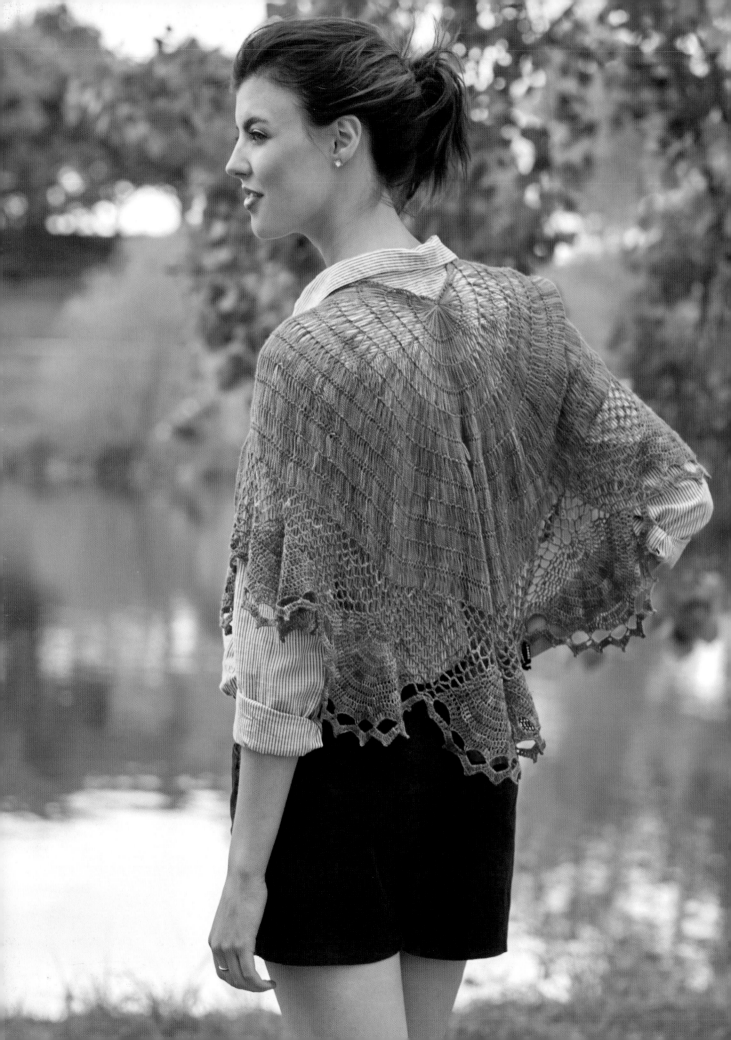

ramblin' rose
HAIRPIN LACE SHAWL

Hairpin lace is a wonderful technique of delicate stitchwork, traditionally worked in straight strips and joined evenly. I wanted to apply what I know about increases in shawls to create a new shape in hairpin lace. The increase strips manipulate how many loops you join to the adjacent strip, while the straight sections join one-to-one. Inspired by the edging on a friend's beautiful handmade Mexican macramé hammock, this edging creates scallops from within a mesh border.

FINISHED SIZE
21" (53.5 cm) deep × 42" (106.5 cm) wide.

YARN
Sock weight
(#1 Superfine).

Shown here: Black Bunny Fibers BFL Sock (100% Bluefaced Leicester wool; 650 yd (594 m)/3.5 oz [100 g]): Pink, 1 hank.

HOOK
E/4 (3.5 mm).

Adjust hook size if needed to obtain gauge.

NOTIONS
Yarn needle; hairpin lace loom set to 2½" (6.5 cm) wide.

GAUGE
6 sts / 3 rows = 1" (2.5 cm) in double crochet

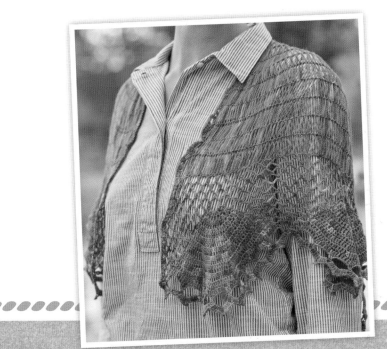

stitch guide

PICOT: Ch 3, sl st in 3rd ch from hook.

SHAWL

Note: Shawl is worked from the top down with progressively larger hairpin lace strips joined together to increase. The strips are joined as you go, and the edging is worked onto the last strip at the end.

FIRST STRIP

Make a hairpin lace strip with 39 loops on each side. Fasten off.

SECOND STRIP

Make a hairpin lace strip with 78 loops on each side. Fasten off. Join to first strip using 2 loops from second strip and joining to 1 loop on first strip.

THIRD STRIP

Make a hairpin lace strip with 156 loops on each side. Fasten off. Join to second strip using 2 loops from third strip and joining to 1 loop on second strip.

FOURTH STRIP

Make a hairpin lace strip with 312 loops on each side. Fasten off. Join to third strip using 2 loops from fourth strip and joining to 1 loop on third strip.

FIFTH STRIP

Make a hairpin lace strip 312 loops on each side. Fasten off. Join to fourth strip using 1 loop from fifth strip and joining to 1 loop on fourth loop.

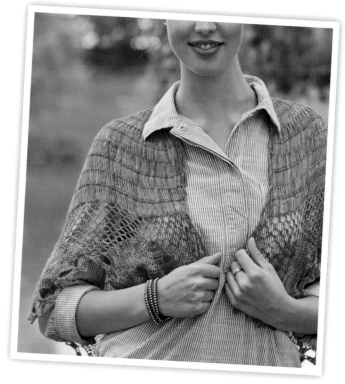

SIXTH STRIP

Make a hairpin lace strip with 312 loops on each side. Fasten off. Join to fifth strip using 1 loop from sixth strip and joining to 1 loop on fourth strip.

EDGING

ROW 1: Sl st to first loop on outer edge of sixth strip, ch 1, sc in same loop, sc in each loop across, turn—312 sc.

ROW 2: Ch 1, sc in same st, ch 5, sk next 3 sts, *sc in next sc, ch 5, sk next 2 sts; rep from * across to last 4 sts, sk next 3 sts, sc in last sc, turn—103 ch-5 sps.

ROW 3: Ch 5 (counts as dc, ch 2 here and throughout), sc in first ch-5 sp, *ch 5, sc in next ch-5 sp; rep from * across, ch 2, dc in last sc, turn—102 ch-5 sps; 2 ch-2 sps.

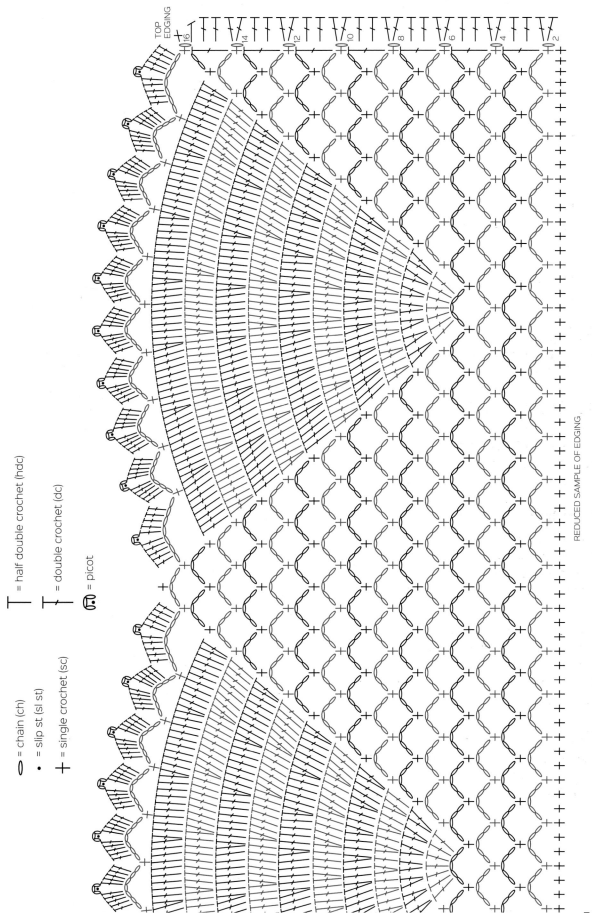

= chain (ch)

• = slip st (sl st)

+ = single crochet (sc)

⊤ = half double crochet (hdc)

⊤ = double crochet (dc)

🖗 = picot

TOP EDGING

2 4 6 8 10 12 14 16

REDUCED SAMPLE OF EDGING

ROW 4: Ch 1, sc in first dc, *ch 5, sc in next ch-5 sp; rep from * across, turn.

ROW 5: Rep Row 3.

ROW 6: Ch 1, sc in first sc, (ch 5, sc) in each of next 5 ch-5 sps, *7 dc in next ch-5 sp, sc in next ch-5 sp**, (ch 5, sc) in each of next 11 ch-5 sps; rep from * across, ending last rep at **, (ch 5, sc) in each of next 5 ch-5 sps, turn.

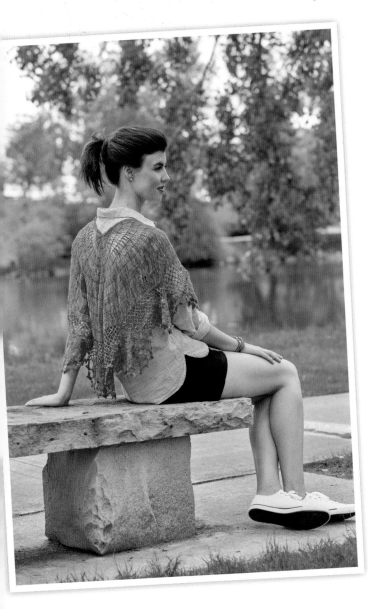

ROW 7: Ch 5, sc in first ch-5 sp, (ch 5, sc) in each of next 4 ch-5 sps, *2 dc in each of next 7 dc, sc in next ch-5 sp**, (ch 5, sc) in each of next 10 ch-5 sps; rep from * across, ending last rep at **, (ch 5, sc) in each of next 4 ch-5 sps, ch 2, dc in last sc, turn.

ROW 8: Ch 1, sc in first dc, (ch 5, sc) in each of next 4 ch-5 sps, *[dc in next dc, 2 dc in next dc] 7 times, sc in next ch-5 sp**, (ch 5, sc) in each of next 9 ch-5 sps; rep from * across, ending last rep at **, (ch 5, sc) in each of next 4 ch-5 sps, turn.

ROW 9: Ch 5, sc in first ch-5 sp, (ch 5, sc) in each of next 3 ch-5 sps, *[dc in each of next 2 dc, 2 dc in next dc] 7 times, sc in next ch-5 sp**, (ch 5, sc) in each of next 8 ch-5 sps; rep from * across, ending last rep at **, (ch 5, sc) in each of next 3 ch-5 sps, ch 2, dc in last sc, turn.

ROW 10: Ch 1, sc in first dc, (ch 5, sc) in each of next 3 ch-5 sps, *[dc in each of next 3 dc, 2 dc in next dc] 7 times, sc in next ch-5 sp**, (ch 5, sc) in each of next 7 ch-5 sps; rep from * across, ending last rep at **, (ch 5, sc) in each of next 3 ch-5 sps, turn.

ROW 11: Ch 5, sc in first ch-5 sp, (ch 5, sc) in each of next 2 ch-5 sps, *[dc in each of next 4 dc, 2 dc in next dc] 7 times, sc in next ch-5 sp**, (ch 5, sc) in each of next 6 ch-5 sps; rep from * across, ending last rep at **, (ch 5, sc) in each of next 2 ch-5 sps, ch 2, dc in last sc, turn.

ROW 12: Ch 1, sc in first dc, (ch 5, sc) in each of next 2 ch-5 sps, *[dc in each of next 5 dc, 2 dc in next dc] 7 times, sc in next ch-5 sp**, (ch 5, sc) in each of next 5 ch-5 sps; rep from * across, ending last rep at **, (ch 5, sc) in each of next 2 ch-5 sps, turn.

ROW 13: Ch 5, sc in first ch-5 sp, ch 5, sc in next ch-5 sp, *[dc in each of next 6 dc, 2 dc in next dc] 7 times, sc in next ch-5 sp**, (ch 5, sc) in each of next 4 ch-5 sps; rep from * across, ending last rep at **, ch 5, sc in next ch-5 sp, ch 2, dc in last sc, turn.

ROW 14: Ch 1, sc in first dc, ch 5, sc in next ch-5 sp, *[dc in each of next 7 dc, 2 dc in next dc] 7 times, sc in next ch-5 sp**, (ch 5, sc) in each of next 3 ch-5 sps; rep from * across, ending last rep at **, ch 5, sc in next ch-5 sp, turn.

ROW 15: Ch 5, sc in first ch-5 sp, *[dc in each of next 8 dc, 2 dc in next dc] 7 times, sc in next ch-5 sp**, (ch 5, sc) in each of next 2 ch-5 sps; rep from * across, ending last rep at **, ch 2, dc in last sc, turn.

ROW 16: Ch 1, sc in first dc, *[ch 7, sk next 6 dc, sc in next st] 9 times**, ch 7, sc in next ch-5 sp, ch 5, sc in next ch-5 sp; rep from * across, ending last rep at **, ch 7, sc in last ch-5 sp, turn.

ROW 17: Ch 3 (counts as dc), (4 dc, picot, 5 dc) in next ch-7 sp, (5 dc, picot, 5 dc) in each of next 9 ch-7 sps, sc in next ch-5 sp *(5 dc, picot, 5 dc) in each of next 10 ch-7 sps**, sc in next ch-5 sp; rep from * across, ending last rep at **. Do not fasten off.

TOP EDGING

Weave a separate length of yarn through all 39 loops on top edge of first strip of hairpin lace, gather, and secure.

ROW 1: Ch 1, turn to work across top edge of shawl, sc, hdc in first row-end st, work 2 dc in each row-end st across edging, 6 dc in each hairpin lace loop along edge (working into at least 2 loops together), work 2 dc in each row-end st across edging to last row-end st, hdc, sc, sl st in last row-end st. Fasten off.

FINISHING

Weave in ends. Handwash, block to finished measurements, and allow to dry.

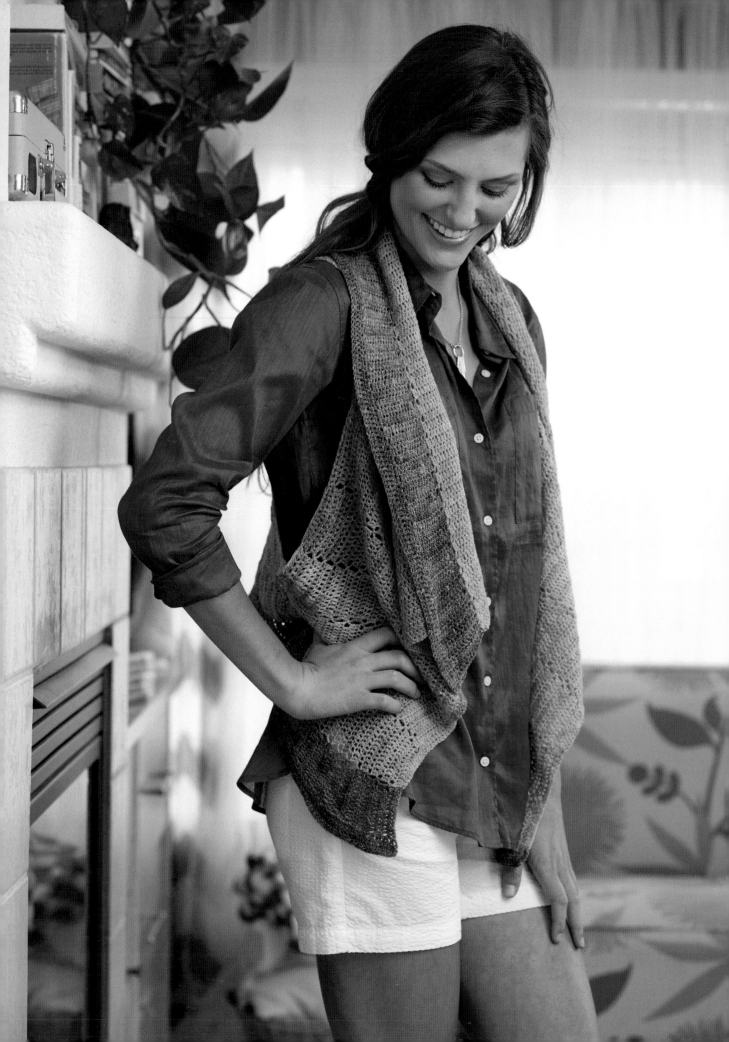

coral gables
CARDI WRAP

Inspired by the gradient yarn in Art Deco Miami colors, this project explores the variety of ways you can join strips of simple crochet: log-cabin style spiral for the center back and join-as-you-go strips for the fronts, collar, and hem. Take special care to read the notes on how to create as much color symmetry as possible while crocheting garments in gradient yarn.

FINISHED SIZE
43" (109 cm) wide × 24" (61 cm) tall.

YARN
Fingering weight (#0 Lace).

Shown here: Freia Yarns Ombré Lace (75% wool, 25% nylon; 645 yd [589 m]/2.64 oz [75 g]): South Beach, 2 skeins.

HOOK
F/5 (3.75 mm).

Adjust hook size if needed to obtain gauge.

NOTIONS
Yarn needle.

GAUGE
20 sts and 12 rows dc = 4" (10 cm) after blocking.

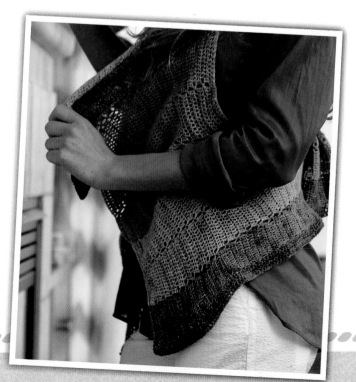

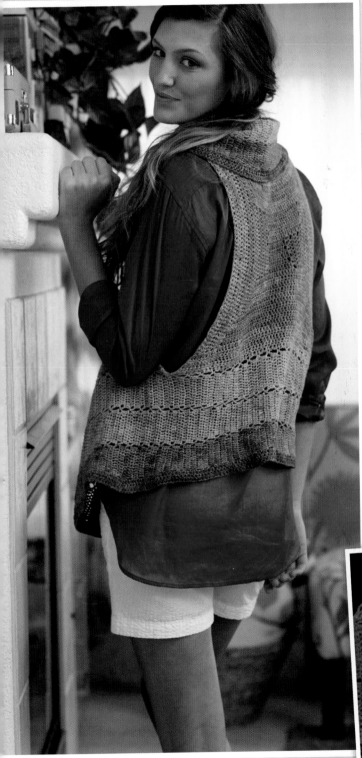

CENTER BACK

Note: This project is worked with two skeins of a gradient yarn (color changes only once per ball). Work the center back, center right front, and center right back, alternating both skeins of yarn so the color stays close to the same. Use the remaining two partial balls, one each for the top and bottom edgings.

FIRST SQUARE

Ch 12.

ROW 1: Dc in 3rd ch from hook and in each ch across, turn—10 dc.

ROW 2: Ch 3 (counts as dc here and throughout), dc in each st across, turn—10 dc.

ROWS 3–5: Rep Row 2. Do not turn at end of last row.

SECOND SQUARE

ROW 1: Rotate square 90°, ch 3, working across row-end sts, dc in first row-end st, 2 dc in each of row-end st across, turn—10 dc.

ROWS 2–5: Ch 3, dc in each st across, turn—10 dc. Do not turn at end of last row.

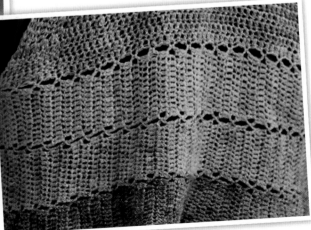

CENTER BACK THROUGH SEVENTH RECTANGLE
CONTINUE IN PATTERN THROUGH THIRTEENTH RECTANGLE

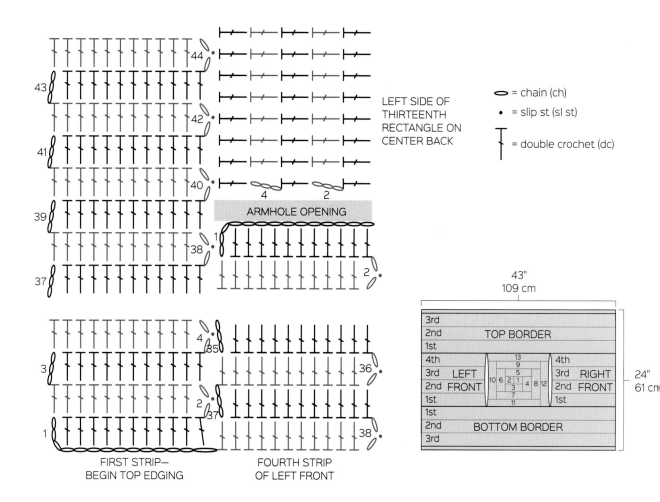

LEFT SIDE OF
THIRTEENTH
RECTANGLE ON
CENTER BACK

⬭ = chain (ch)

• = slip st (sl st)

† = double crochet (dc)

ARMHOLE OPENING

FIRST STRIP—
BEGIN TOP EDGING

FOURTH STRIP
OF LEFT FRONT

43"
109 cm

3rd						
2nd	TOP BORDER					
1st						
4th		13	4th			
3rd	LEFT	9	3rd	RIGHT		
2nd	FRONT	10 6 2 1 4 8 12	2nd	FRONT		
1st		3	1st			
1st		7				
2nd	BOTTOM BORDER	11				
3rd						

24"
61 cm

THIRD RECTANGLE

ROW 1: Rotate square 90°, ch 3, dc in first row-end st, 2 dc in each of next 4 row-end sts, working in foundation ch, dc in each ch across bottom edge of first square, turn—20 dc.

ROWS 2–5: Ch 3, dc in each st across, turn—20 dc. Do not turn at end of last row.

FOURTH RECTANGLE

ROW 1: Rotate square 90°, dc in first row-end st, 2 dc in each of row-end st across—20 dc.

ROWS 2–5: Ch 3, dc in each st across, turn—20 dc. Do not turn at end of last row.

FIFTH RECTANGLE

ROW 1: Rotate square 90°, ch 3, dc in first row-end st, 2 dc in each of next 4 row-end sts, dc in each st across top of first square, 2 dc in each of next 5 row-end sts—30 dc.

ROWS 2–5: Ch 3, dc in each st across, turn—30 dc. Do not turn at end of last row.

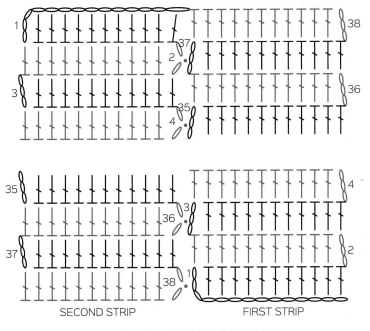

SECOND STRIP FIRST STRIP

REDUCED SAMPLE OF RIGHT FRONT

SIXTH RECTANGLE

ROW 1: Rotate square 90°, ch 3, dc in first row-end st, 2 dc in each of next 4 row-end sts, dc in each st across top of second square, 2 dc in each of next 5 row-end sts—30 dc.

ROWS 2–5: Ch 3, dc in each st across, turn—30 dc. Do not turn at end of last row.

SEVENTH RECTANGLE

ROW 1: Rotate square 90°, ch 3, dc in first row-end st, 2 dc in each of next 4 row-end sts, dc in each st across top of third rectangle, 2 dc in each of next 5 row-end sts—40 dc.

ROWS 2–5: Ch 3, dc in each st across, turn—40 dc. Do not turn at end of last row.

EIGHTH RECTANGLE

ROW 1: Rotate square 90°, ch 3, dc in first row-end st, 2 dc in each of next 4 row-end sts, dc in each st across top of fourth rectangle, 2 dc in each of next 5 row-end sts—40 dc.

ROWS 2–5: Ch 3, dc in each st across, turn—40 dc. Do not turn at end of last row.

NINTH RECTANGLE

ROW 1: Rotate square 90°, ch 3, dc in first row-end st, 2 dc in each of next 4 row-end sts, dc in each st across top of fifth rectangle, 2 dc in each of next 5 row-end sts—50 dc.

ROWS 2–5: Ch 3, dc in each st across, turn—50 dc. Do not turn at end of last row.

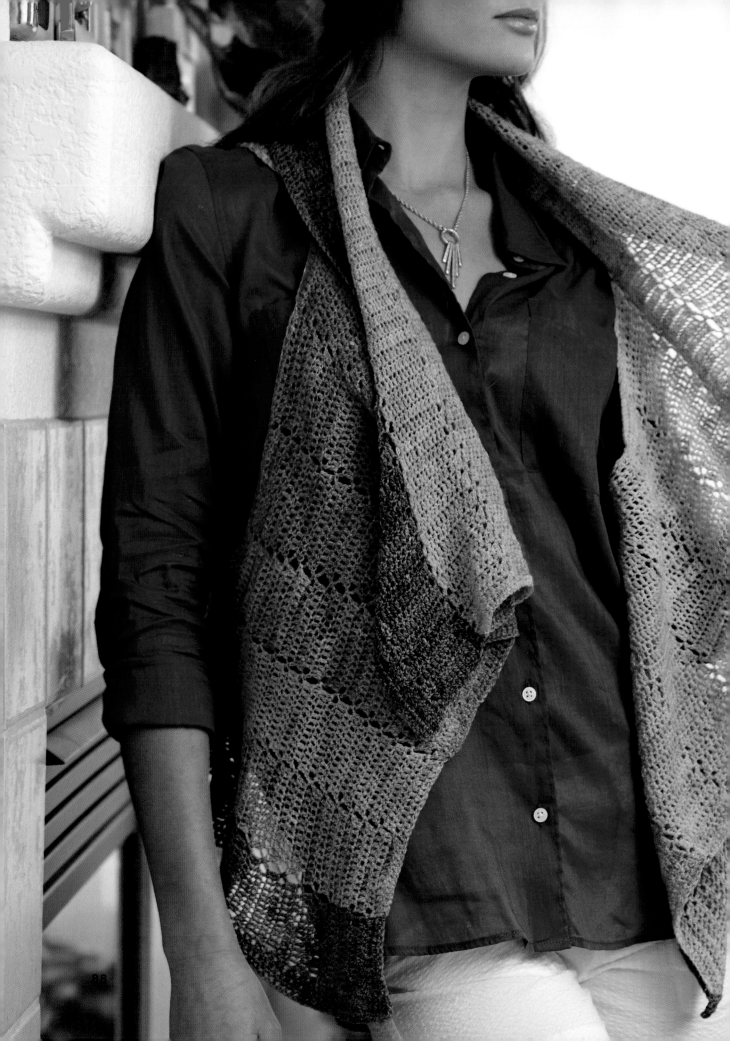

TENTH RECTANGLE

ROW 1: Rotate square 90°, ch 3, dc in first row-end st, 2 dc in each of next 4 row-end sts, dc in each st across top of sixth rectangle, 2 dc in each of next 5 row-end sts—50 dc.

ROWS 2–5: Ch 3, dc in each st across, turn—50 dc. Do not turn at end of last row.

ELEVENTH RECTANGLE

ROW 1: Rotate square 90°, ch 3, dc in first row-end st, 2 dc in each of next 4 row-end sts, dc in each st across top of seventh rectangle, 2 dc in each of next 5 row-end sts—60 dc.

ROWS 2–5: Ch 3, dc in each st across, turn—60 dc. Do not turn at end of last row.

TWELFTH RECTANGLE

ROW 1: Rotate square 90°, ch 3, dc in first row-end st, 2 dc in each of next 4 row-end sts, dc in each st across top of eighth rectangle, 2 dc in each of next 5 row-end sts—60 dc.

ROWS 2–5: Ch 3, dc in each st across, turn—60 dc. Do not turn at end of last row.

THIRTEENTH RECTANGLE

ROW 1: Rotate square 90°, ch 3, dc in first row-end st, 2 dc in each of next 4 row-end sts, dc in each st across top of ninth rectangle, 2 dc in each of next 5 row-end sts—70 dc.

ROWS 2–5: Ch 3, dc in each st across, turn—70 dc. Fasten off.

RIGHT FRONT
FIRST STRIP

Ch 15.

ROW 1: Dc in 3rd ch from hook and each ch across, turn—13 dc.

ROW 2: Ch 3, dc in each st across, turn—13 dc.

ROWS 3–38: Rep Row 2. Do not fasten off.

SECOND STRIP

ROW 1: Ch 15, sc in 3rd ch from hook and each ch across, working back toward first strip—13 dc.

ROW 2: Ch 1, sl st in next row-end st on adjacent strip, ch 1 (ch 1, sl st, ch 1 counts as first dc of row here and throughout), dc in each st across, turn—13 dc.

ROW 3: Ch 3, dc in each st across, turn.

ROWS 4–38: Rep Rows 2 and 3. Do not fasten off.

THIRD STRIP

Rep second strip.

FOURTH STRIP

Rep second strip. Fasten off.

LEFT FRONT

Work same as right front. Do not turn or fasten off at end of last row.

TOP BORDER
FIRST STRIP

Note: Use only one of the two remaining partial skeins of yarn for entire top border.

ROW 1: Ch 15, sc in 3rd ch from hook and each ch across, working back toward fourth strip of left front—13 dc.

ROW 2: Ch 1, sl st in next row-end st on adjacent strip, ch 1, dc in each st across, turn—13 dc.

ROW 3: Ch 3, dc in each st across, turn.

ROWS 4–38: Rep Rows 2 and 3 (17 times); then rep Row 2 once.

ROW 39: Rep Row 3.

ROW 40: Ch 1, sl st in next dc on thirteenth rectangle of center back, ch 1, dc in each st across, turn—13 dc.

ROW 41: Rep Row 3.

ROW 42: Ch 1, sk next 2 sts on thirteenth rectangle of center back, sl st in next dc, ch 1, dc in each st across, turn—13 dc.

ROWS 43–108: Rep Rows 41–42 (33 times).

ROWS 109: Rep Row 3.

ROWS 110: Ch 1, sl st in next row-end st on fourth strip of right front, ch 1, dc in each st across, turn—13 dc.

ROW 111: Rep Row 3.

ROWS 112–146: Rep Rows 2 and 3 (127 times); then rep Row 2 once. Do not fasten off.

SECOND STRIP

ROW 1: Ch 15, sc in 3rd ch from hook and each ch across, working back toward first strip—13 dc.

ROW 2: Ch 1, sl st in next row-end st on adjacent strip, ch 1 (ch 1, sl st, ch 1 counts as first dc of row here and throughout), dc in each st across, turn—13 dc.

ROW 3: Ch 3, dc in each st across, turn.

ROWS 4–146: Rep Rows 2 and 3 (71 times); then rep Row 2 once. Do not fasten off.

THIRD STRIP

Rep second strip. Do not fasten off.

TOP EDGING

ROW 1: Rotate top border 90° to work across row-end sts of third strip, ch 3, dc in first row-end st, 2 dc in each row-end st across, turn—292 dc.

ROW 2: Ch 3, dc in each st across, turn.

ROW 3: Rep Row 2. Fasten off.

ROW 3: Ch 3, dc in each st across, turn.

ROWS 4–38: Rep Rows 2 and 3 (17 times); then rep Row 2 once.

ROW 39: Rep Row 3.

ROWS 40–43: Rep Rows 2 and 3 (twice) joining to row-end sts of twelfth rectangle of center back.

ROW 44: Ch 1, sl st in next dc on eleventh rectangle of center back, ch 1, dc in each st across, turn—13 dc.

ROW 45: Rep Row 3.

ROW 46: Ch 1, sk next 2 sts on thirteenth rectangle of center back, sl st in next dc, ch 1, dc in each st across, turn—13 dc.

ROWS 47–108: Rep Rows 41 and 42 (31 times).

ROW 109: Rep Row 3.

ROW 110: Ch 1, sl st in next row-end st on fourth strip of right front, ch 1, dc in each st across, turn—13 dc.

ROW 111: Rep Row 3.

ROWS 112–146: Rep Rows 2 and 3 (127 times); then rep Row 2 once. Do not fasten off.

SECOND AND THIRD STRIPS

Rep second strip of top border.

BOTTOM EDGING

Rep top edging. Fasten off.

FINISHING

Weave in ends. Handwash, block to finished measurements, and allow to dry.

BOTTOM BORDER
FIRST STRIP

Note: Use remaining partial balls for bottom border.

ROW 1: Ch 15, sc in 3rd ch from hook and each ch across, working back toward first strip of right front—13 dc.

ROW 2: Ch 1, sl st in next row-end st on adjacent strip, ch 1, dc in each st across, turn—13 dc.

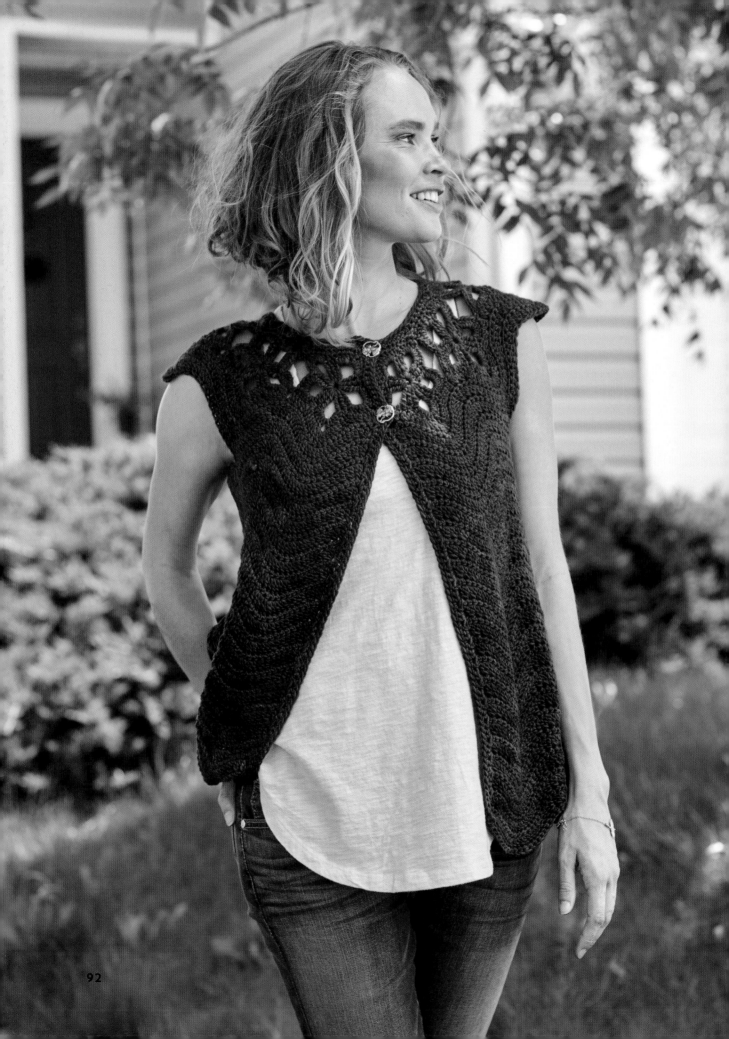

GARMENTS

In this chapter, I was inspired to use traditionally two-dimensional crochet techniques to create three-dimensional shaping. Applying raglan shaping and spirals to bruges lace, combining triangles and squares together to create raglan shaping in motifs, and using pentagon motifs in place of squares to increase a yoke are only a few of the experiments I explored. The teardrop sweater features a gorgeous stitch that is not only unusual and fun to make, but is beautiful to admire in a yoke, too.

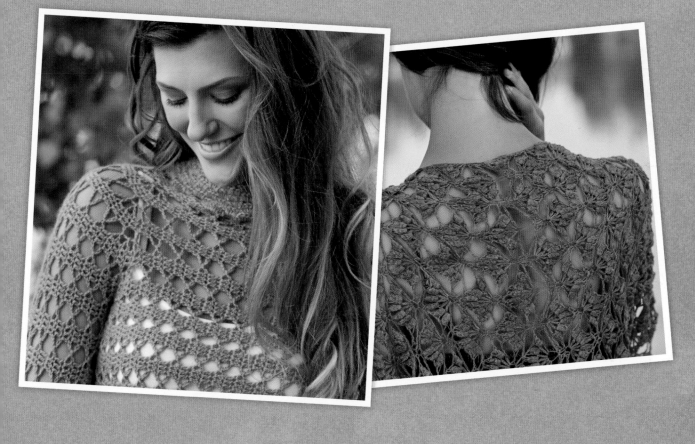

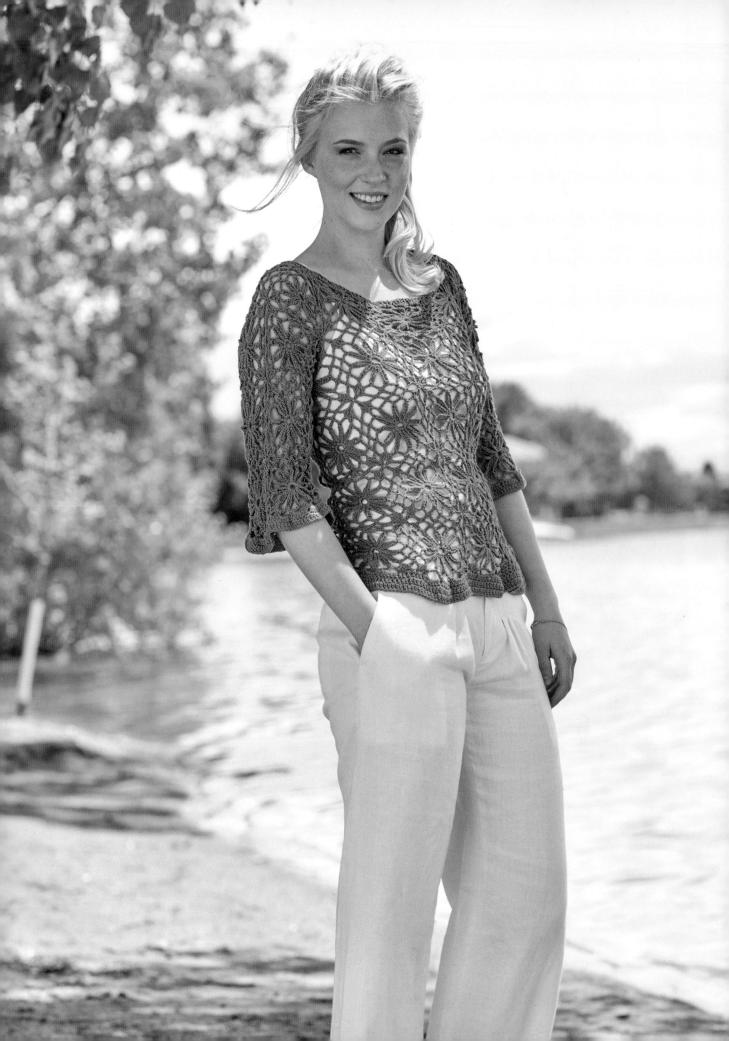

isle of capri
MOTIF PULLOVER

Square motifs make beautiful garments, albeit boxy ones. To create yoke shaping in this figure-flattering pullover, I implemented triangle motifs in the raglan corners to add increases and still maintain a beautiful lace pattern. This could be easily modified to make the sleeves or body longer as well. Most square motifs are four repeats and can generally be modified into three repeats to create this triangular-motif concept for shaping.

FINISHED SIZES
Directions are given for size S. Changes for M and L are in parentheses.

Finished bust: 32 (40, 48)" (81.5 [101.5, 122] cm).

Finished length: 24" (61 cm).

YARN
Sportweight (#2 Fine).

Shown here: Lotus Yarns Z-Twisted (52% cotton, 48% rayon; 256 yd [235 m]/3.5 oz [100 g]): #023 Teal Glimmer, 3 hanks.

HOOK
E/4 (3.5 mm).

Adjust hook size if needed to obtain gauge.

GAUGE
Motif = 4.5" (11.5 cm) square after blocking.

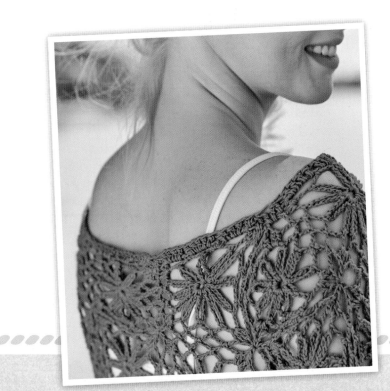

FIRST MOTIF

Ch 6, sl st in first ch to form a ring.

RND 1: Ch 1, sc in ring, *ch 11, sc in ring; rep from * 10 times, ch 6, dtr in first sc instead of last ch-11 sp—12 ch-11 sps.

RND 2: Ch 1, sc in same ch-11 sp, (ch 5, sc) in each ch-11 sp around, ch 2, dc in first sc instead of last ch-5 sp—12 ch-5 sps.

RND 3: Ch 1, sc in same ch-5 sp, *ch 5, sc in next ch-5 sp, ch 5, (2 dc, ch 3, 2 dc) in next ch-5 sp, ch 5**, sc in next ch-5 sp; rep from * around, ending last rep at **, sl st in first sc to join. Fasten off.

SECOND AND SUCCESSIVE MOTIFS (JOINED ON ONE SIDE)

Work same as first motif through Rnd 2.

RND 3: Ch 1, sc in same ch-5 sp, ch 5, sc in next ch-5 sp, ch 5, (2 dc, ch 1, sl st in corner ch-3 sp on previous motif, ch 1, 2 dc) in next ch-5 sp, (ch 2, sl st in next ch-5 sp on previous motif, ch 2, sc) in each of next 2 ch-5 sps, ch 2, sl st in next ch-5 sp on previous motif, ch 2, (2 dc, ch 1, sl st in next corner ch-3 sp on previous motif, ch 1, 2 dc) in next ch-5 sp, *(ch 5, sc) in each of next 2 ch-5 sps, ch 5, (2 dc, ch 3, 2 dc) in next ch-5 sp; rep from * once, ch 5, sl st in first sc to join.

MOTIF (JOINED ON TWO SIDES)

Work same as first motif through Rnd 2.

RND 3: Ch 1, sc in same ch-5 sp, ch 5, sc in next ch-5 sp, ch 5, (2 dc, ch 1, sl st in corner ch-3 sp on previous motif, ch 1, 2 dc) in next ch-5 sp, *(ch 2, sl st in next ch-5 sp on previous motif, ch 2, sc) in each of next 2 ch-5 sps, ch 2, sl st in next ch-5 sp on previous motif, ch 2, (2 dc, ch 1, sl st in next corner ch-3 sp on previous motif, ch 1, 2 dc) in next ch-5 sp; rep from * once, (ch 5, sc) in each of next 2 ch-5 sps, ch 5, (2 dc, ch 3, 2 dc) in next ch-5 sp, ch 5, sl st in first sc to join.

MOTIF (JOINED ON THREE SIDES)

Work same as first motif through Rnd 2.

RND 3: Ch 1, sc in same ch-5 sp, ch 5, sc in next ch-5 sp, ch 5, (2 dc, ch 1, sl st in corner ch-3 sp on previous motif, ch 1, 2 dc) in next ch-5 sp, *(ch 2, sl st in next ch-5 sp on previous motif, ch 2, sc) in each of next 2 ch-5 sps, ch 2, sl st in next ch-5 sp on previous motif, ch 2, (2 dc, ch 1, sl st in next corner ch-3 sp on previous motif, ch 1, 2 dc) in next ch-5 sp; rep from * twice, ch 5, sl st in first sc to join.

TRIANGLE MOTIF (JOINED ON ONE SIDE)

Ch 6, sl st in first ch to form a ring.

RND 1: Ch 1, sc in ring, *ch 11, sc in ring; rep from * 8 times, ch 6, dtr in first sc instead of last ch-11 sp —9 ch-11 sps.

RND 2: Ch 1, sc in same ch-11 sp, (ch 6, sc) in each ch-11 sp around, ch 3, dc in first sc instead of last ch-6 sp—12 ch-5 sps.

RND 3: Ch 1, sc in same ch-5 sp, ch 5, (2 dc, ch 1, sl st in corner ch-3 sp on previous motif, ch 1, 2 dc) in next ch-5 sp, (ch 2, sl st in next ch-5 sp on previous motif, ch 2, sc) in each of next 2 ch-5 sps, ch 2, sl st in next ch-5 sp on previous motif, ch 2, (2 dc, ch 1, sl st in next corner ch-3 sp on previous motif, ch 1, 2 dc) in next ch-5 sp, (ch 5, sc) in each of next 2 ch-5 sps, ch 5, (2 dc, ch 3, 2 dc) in next ch-5 sp, ch 5, sc in next ch-5 sp, ch 5, sl st in first sc to join. Fasten off.

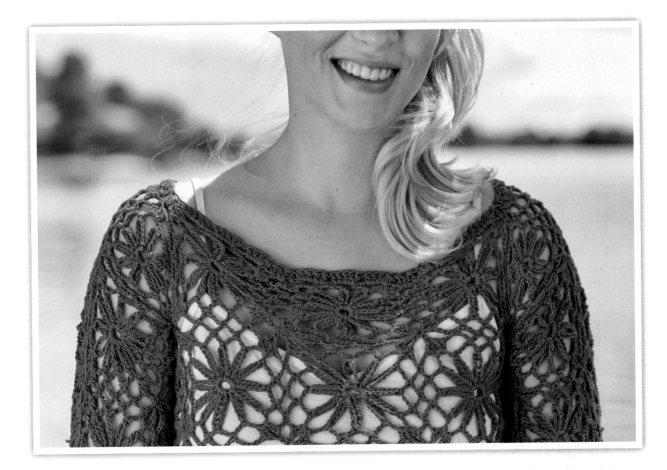

YOKE
FIRST RING OF MOTIFS

*Make and join 3 (4, 5) motifs for front, make and join 1 triangle motif for front raglan shaping, make and join 1 motif for top of sleeve, make and join 1 triangle motif for back raglan shaping; rep from * once for back and 2nd sleeve, using the one-sided and two-sided joining techniques for forming into a ring of motifs—12 (14, 16) motif edges around lower edge; 8 (10, 12) motif edges around top edge. Fasten off.

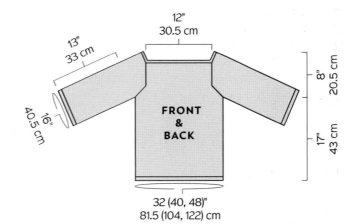

13"
33 cm

12"
30.5 cm

16"
40.5 cm

8"
20.5 cm

17"
43 cm

FRONT
&
BACK

32 (40, 48)"
81.5 (104, 122) cm

FIRST MOTIF

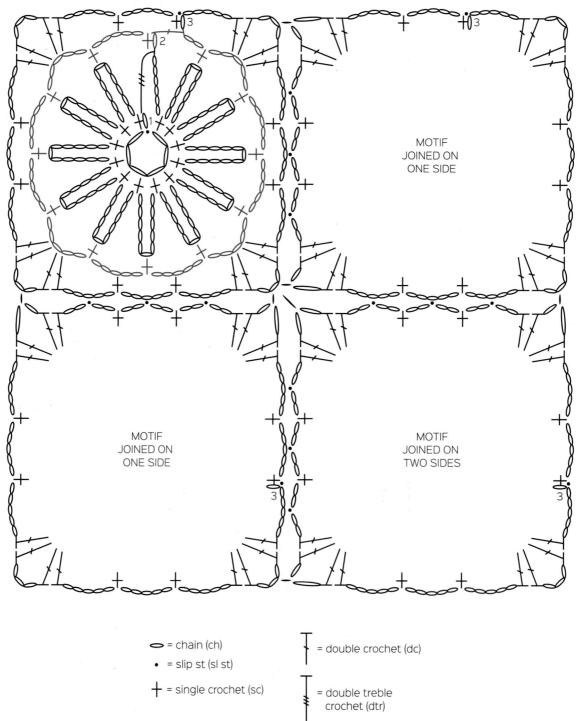

MOTIF
JOINED ON
ONE SIDE

MOTIF
JOINED ON
ONE SIDE

MOTIF
JOINED ON
TWO SIDES

⬭ = chain (ch)

• = slip st (sl st)

+ = single crochet (sc)

┬ = double crochet (dc)

┬ = double treble
crochet (dtr)

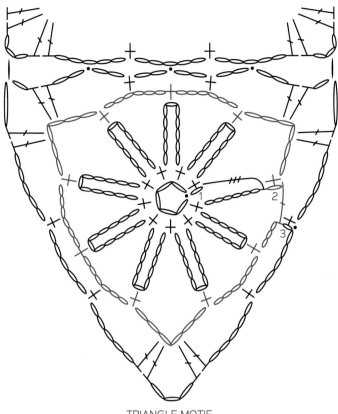

TRIANGLE MOTIF
JOINED ON ONE SIDE

SECOND RING OF MOTIFS (SEPARATE FOR BODY AND SLEEVES)

*Join 3 motifs along bottom edge of the 3 front motifs, join 1 motif to end of last motif joined (do not join to bottom edge of triangle motif), sk next 3 motifs for sleeve; rep from * once for back and 2nd sleeve— 8 (10, 12) body motifs. Fasten off.

THIRD, FOURTH, AND FIFTH RINGS OF MOTIFS

Join 8 (10, 12) motifs to previous ring of motifs. Do not fasten off at end of last motif.

BOTTOM EDGING

RND 1: Ch 3 (counts as dc here and throughout), dc in each st, dc in each corner sp and 5 dc in each ch-5 sp around, skipping each seam, sl st to top of beg ch-3 to join—184 (230, 276) dc.

RNDS 2 AND 3: Ch 3, dc in each st around, sl st to top of beg ch-3 to join. Fasten off.

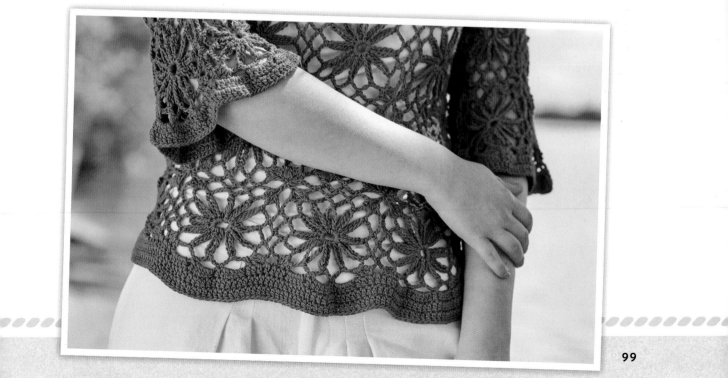

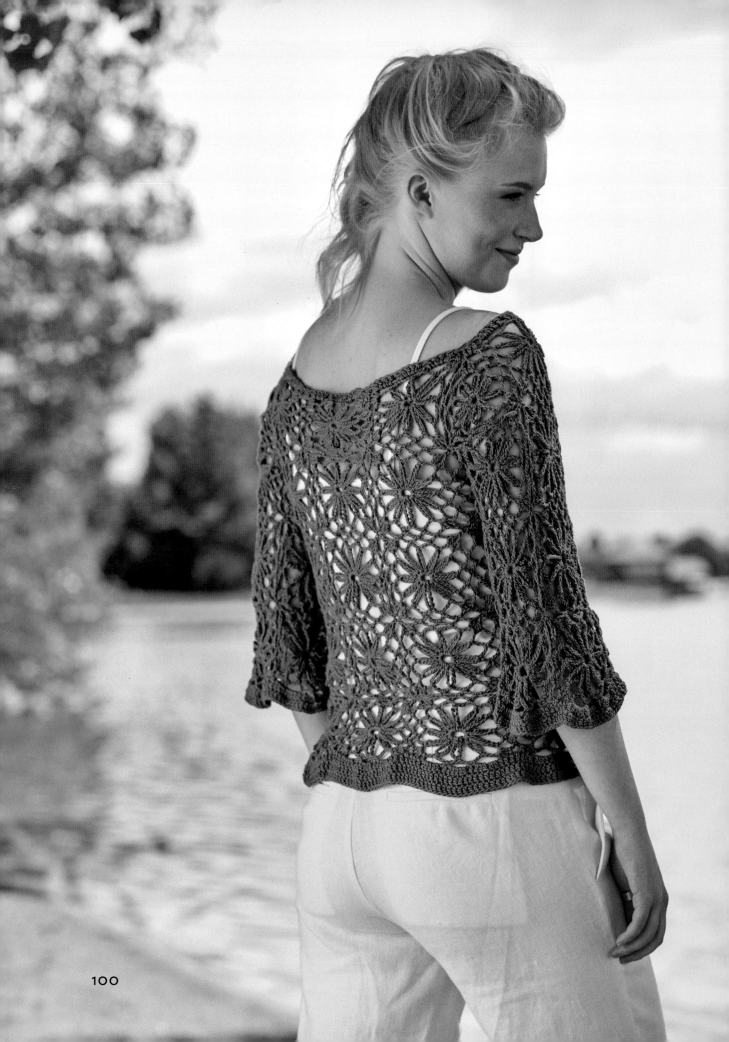

SLEEVE (MAKE 2)
FIRST RING OF MOTIFS
Join 4 motifs around lower edge of sleeve opening.

SECOND, THIRD, AND FOURTH RINGS OF MOTIFS
Join 8 (10, 12) motifs to previous ring of motifs.

Join 4 motifs to previous ring of motifs. Do not fasten off at end of last motif.

CUFF
RND 1: Ch 3, dc in each st, dc in each corner sp and 5 dc in each ch-5 sp around, skipping each seam, sl st to top of beg ch-3 to join—92 dc.

RND 2: Ch 3, dc in each st around, sl st to top of beg ch-3 to join. Fasten off.

NECK EDGING
The neckband is crocheted tighter than the cuff and lower hem.

RND 1: Ch 3, work dc in each corner sp and 5 dc in each ch-5 sp around, skipping all other sts, sl st to top of beg ch-3 to join—136 (170, 204) dc. Fasten off.

FINISHING
Weave in ends. Handwash, block to finished measurements, and allow to dry.

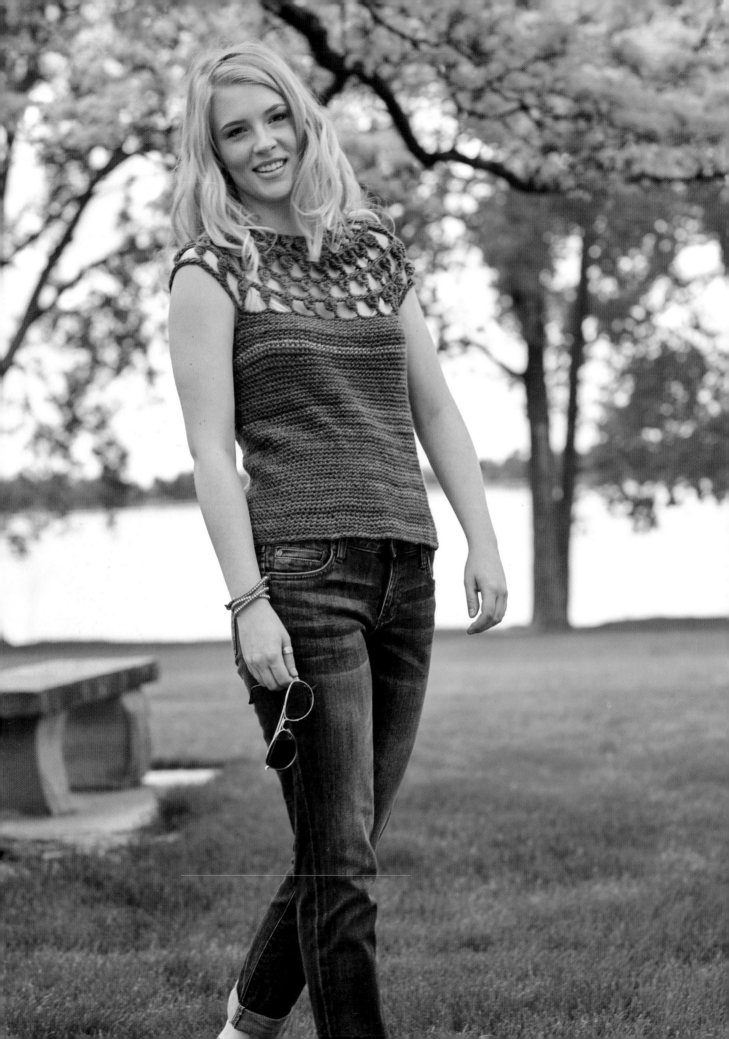

bed of ferns
TEARDROP LACE YOKE SWEATER

I love the look of open lacework yokes over solid, opaque stitchwork body garments. This elongated stitch is so unusual to crochet, but once you get the hang of it it's really simple. The increases are cleverly placed within the spaces between the teardrop stitches for a very simple and invisible construction. The rest of the body is worked in single crochet in the round. This can easily be modified to add sleeves by just picking up the stitches around the yoke and body opening and working in the round to desired sleeve length.

FINISHED SIZES
Directions are given for size S. Changes for M, L, XL, and 2X are in parentheses.

Finished bust: 33½ (35½, 40, 44½, 46½)" (85 [90, 101.5, 113, 118] cm).

Finished length: 19" (48.5 cm).

YARN
Worsted weight (#4 Medium).

Shown here: Trendsetter Tonalita (52% wool, 48% acrylic; 100 yd [91 m]/1.75 oz [50 g]): #2371 Mossy Tree, 6 (7, 7, 8, 9) balls.

HOOK
H/8 (5 mm).

Adjust hook size if needed to obtain gauge.

NOTIONS
Yarn needle; stitch marker.

GAUGE
18 sts and 16 rows sc = 4" (10 cm) after blocking.

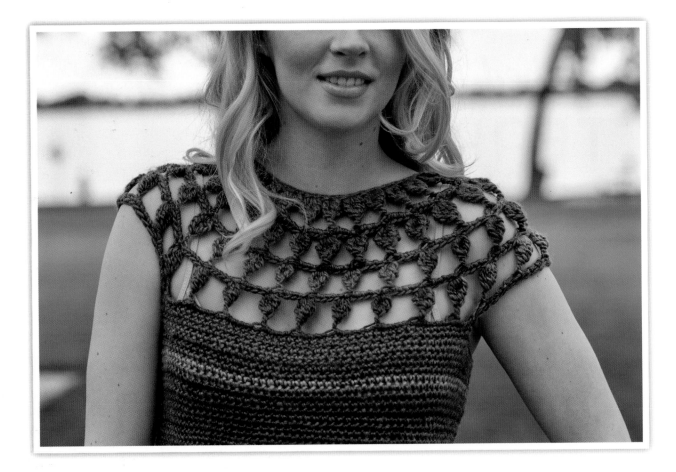

stitch guide

FOUNDATION SINGLE CROCHET (FSC):
see Techniques.

BEG TEARDROP STITCH (BEG TEAR-DROP): Ch 4, 3-tr cluster in same sp, ch 3.

TEARDROP STITCH (TEARDROP): Yo (5 times), insert hook in next st, yo, draw up a loop, (yo, draw through 2 loops on hook) twice, *yo (twice), insert hook in next st, draw up a loop, (yo, draw through 2 loops on hook) twice; rep from * 3 times in same st, yo, draw through 5 loops on hook, (yo, draw through 2 loops on hook) 3 times.

YOKE

Note: Sweater is worked in the round from the top down.

RND 1: Fsc 60 (64, 72, 80, 84), without twisting foundation, sl st in first st to join into a ring—60 (64, 72, 80, 84) Fsc.

RND 2: Working on ch side of foundation, beg teardrop in first st, ch 3, sk next st, *teardrop in next st, ch 3, sk next st; rep from * around, sl st to top of beg ch-3 to join—30 (32, 36, 40, 42) teardrops.

RND 3: Ch 1, *sc in top of teardrop, 3 sc in next ch-3 sp; rep from * around, sl st in first sc to join—120 (128, 144, 160, 168) sc.

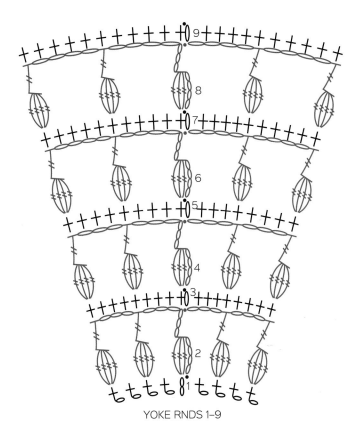

YOKE RNDS 1–9

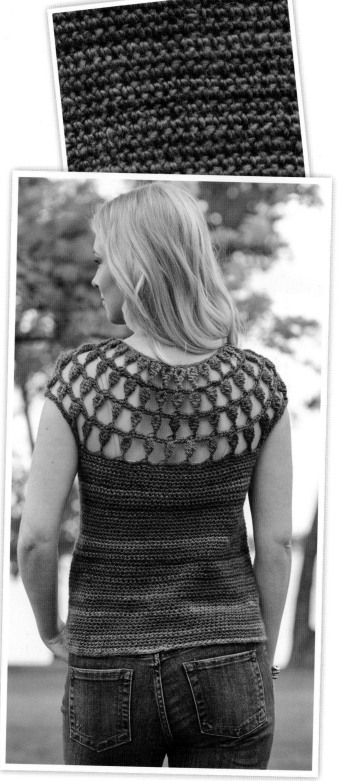

○ = chain (ch)

• = slip st (sl st)

+ = single crochet (sc)

Ⴆ = Foundation single crochet (fsc)

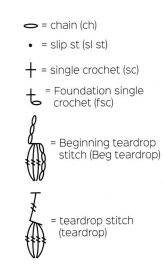 = Beginning teardrop stitch (Beg teardrop)

= teardrop stitch (teardrop)

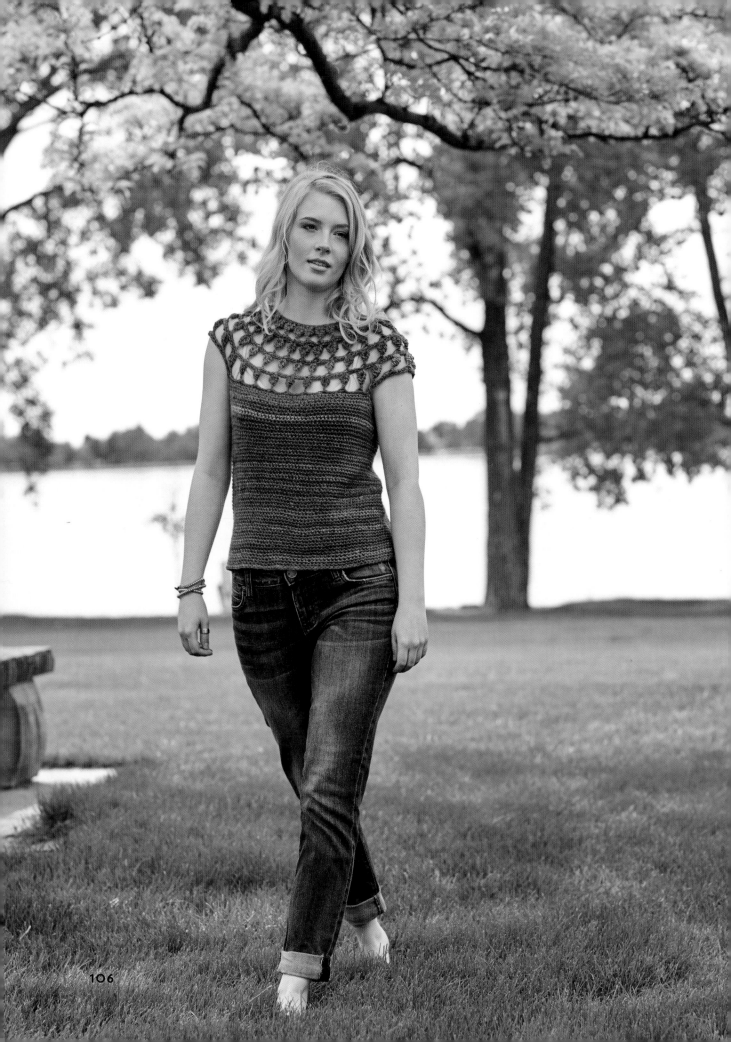

RND 4: Beg teardrop in first st, ch 3, sk 3 sts, *teardrop in next st, ch 3; rep from * around, sl st to top of beg ch-3 to join—30 (32, 36, 40, 42) teardrops.

RND 5: Rep Rnd 3.

RND 6: Beg teardrop in first st, ch 3, sk 3 sts, *teardrop in next st, ch 4, sk next 3 sts; rep from * around, sl st to top of beg ch-3 to join—30 (32, 36, 40, 42) teardrops.

RND 7: Ch 1, *sc in top of teardrop, 4 sc in next ch-4 sp; rep from * around, sl st in first sc to join—150 (160, 180, 200, 210) sc.

RND 8: Beg teardrop in first st, ch 3, sk 3 sts, *teardrop in next st, ch 4, sk next 4 sts; rep from * around, sl st to top of beg ch-3 to join—30 (32, 36, 40, 42) teardrops.

RND 9: Rep Rnd 7—150 (160, 180, 200, 210) sc.

SEPARATE FOR BODY AND SLEEVES

RND 1: Ch 1, *sc in each of next 45 (48, 54, 60, 63) sts, Fsc 15 (16, 18, 20, 21), sk next 30 (32, 36, 40, 42) sts; rep from * once, do not join—120 (128, 144, 160, 168) sts. Work in a spiral, marking beg of each rnd and moving marker up as work progresses.

RNDS 2–52: Sc in each sc around. At end of last rnd, sl st in next st to join. Fasten off.

FINISHING

Weave in ends. Handwash, block to finished measurements, and allow to dry.

13½ (14, 16, 18, 18½)"
34.5 (35.5, 40.5, 45.5, 47) cm

FRONT & BACK

6"
15 cm

13"
33 cm

33½ (35½, 40, 44½, 46½)"
84 (90, 113, 101.5, 118) cm

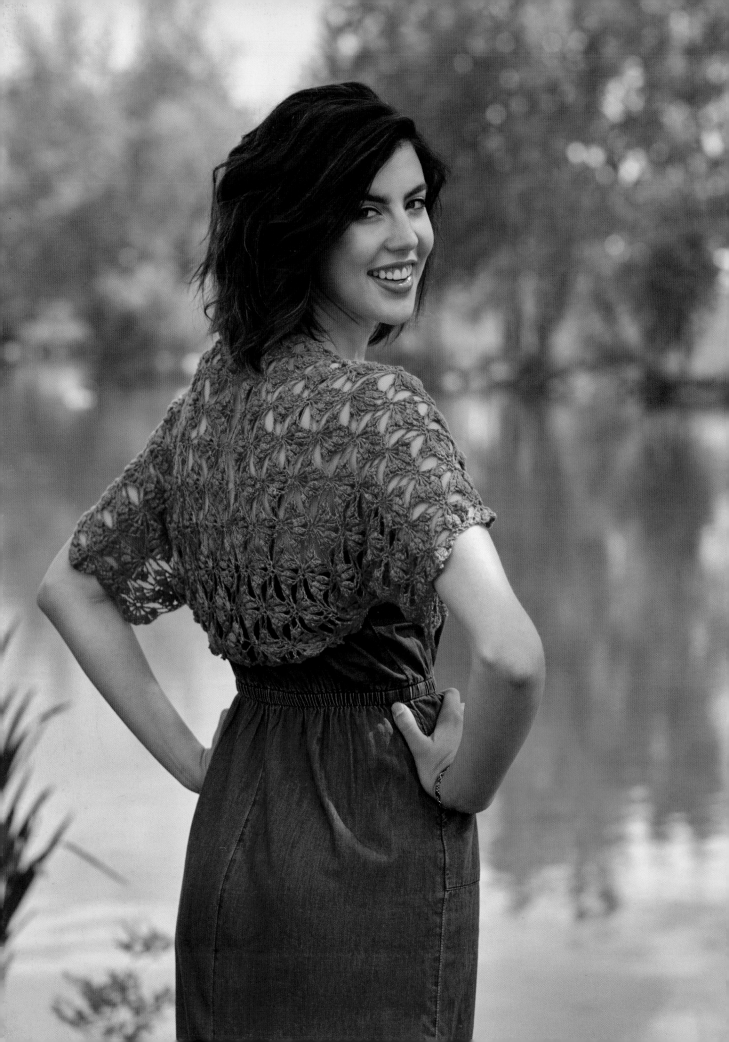

geisha fan
PETAL STITCH SHRUG

The fanned, petal-like clusters in this stitch pattern are so reminiscent of geisha fans to me. The heavy texture brings body to an otherwise very light garment. Worked from the center out, each side is completely symmetrical. This is the type of shrug that could be worn over just about anything in your wardrobe to add a splash of color and pizazz. You'll be surprised how often it becomes your go-to layer.

FINISHED SIZE
31" (79 cm) wide × 16" (40.5 cm) deep.

Sleeves: 4" (10 cm).

YARN
Fingering weight (#1 Superfine).

Shown here: Kristin Omdahl Yarns Be So Fine (100% bamboo; 650 yd [594 m]/4 oz [113 g]): Crushed berries, 1 hank.

HOOK
D/3 (3.25 mm).

Adjust hook size if needed to obtain gauge.

GAUGE
One pattern rep = 3" (7.5 cm); 8 rows in pattern = 3½" (9 cm).

stitch guide

CLUSTER: [Yo, insert hook in next st, yo, draw yarn through st, yo, draw yarn through 2 loops on hook] 5 times in same st or sp, yo, draw yarn through 6 loops on hook.

SHELL: ([Dc, ch 1] 6 times, dc) in same st.

SHRUG

Note: Shrug is worked in two halves. First half is worked outward from foundation chain. Second half is worked in free loops on opposite side of foundation chain.

Ch 110 (multiple of 18 + 20 ch sts).

FIRST HALF

ROW 1: Sc in 2nd ch from hook, *sc in each of next 2 ch, ch 2, skip next 6 ch, shell in next ch, ch 2, skip next 6 ch, sc in each of next 3 ch; rep from * across, turn—6 shells.

ROW 2: Ch 1, sc in each of first 2 sts, *ch 2, sk next sc and ch-2 sp, (cluster, ch 2) in each of next 6 ch-1 sps, sk next sc, sc in each of next 3 sc; rep from * across, omitting last sc, turn.

ROW 3: Ch 4 (counts as dc, ch 1 here and throughout), (dc, ch 1, dc, ch 1, dc) in first st, ch 2, sk next 2 clusters, sc in next cluster, 3 sc in next ch-2 sp, sc in next cluster, ch 2, sk next 3 ch-2 sps, sk next sc**, shell in next sc; rep from * across, ending last rep at **, ([dc, ch 1] 3 times, dc) in last sc, turn—5 shells; 2 half shells.

ROW 4: Ch 4, (cluster, ch 2) in each of next 3 ch-1 sps, *sk next sc, sc in each of next 3 sc, sk next ch-2 sp**, (cluster, ch 2) in each of next 6 ch-1 sps; rep from * across, ending last rep at **, (cluster, ch 2) in each of next 2 ch-1 sps, cluster in next ch-1 sp, ch 1, dc in 3rd ch of turning ch, turn.

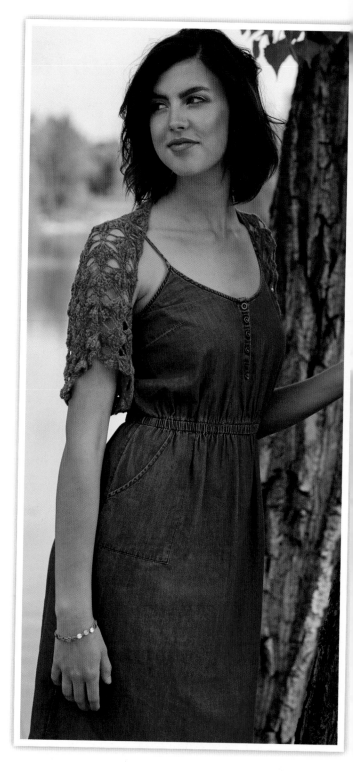

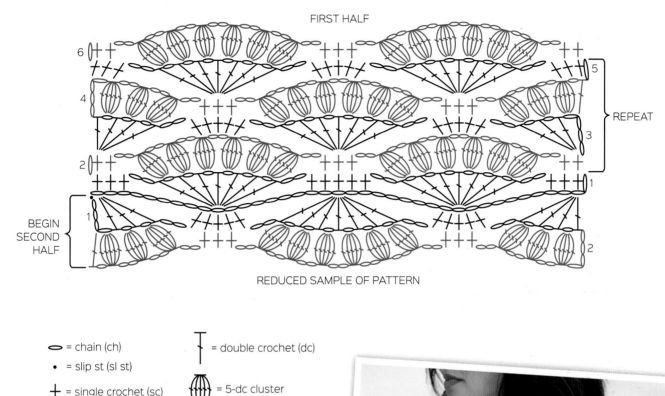

FIRST HALF

BEGIN SECOND HALF

REPEAT

REDUCED SAMPLE OF PATTERN

⬯ = chain (ch)

• = slip st (sl st)

+ = single crochet (sc)

T = double crochet (dc)

🜊 = 5-dc cluster

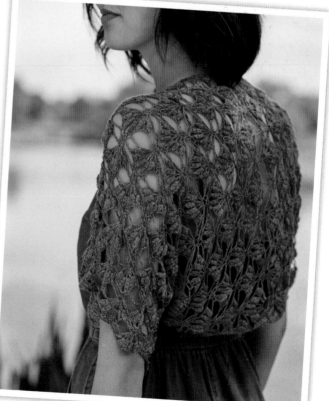

ROW 5: Ch 1, sc in first dc, sc in next ch-1 sp, sc in next cluster, *ch 2, sk next 3 ch-2 sps, sk next sc, shell in next sc, ch 2, sk next 3 ch-2 sps, sc in next cluster**, 3 sc in next ch-2 sp, sc in next cluster; rep from * across, ending last rep at **, sc in next ch-1 sp, sc in 3rd ch of turning ch, turn.

ROWS 6–33: Rep Rows 2–5 (7 times). Fasten off, leaving a long sewing length.

SECOND HALF

ROW 1: With RS facing, working across opposite side of foundation ch, join yarn with sl st in first ch, ch 4, (dc, ch 1, dc, ch 1, dc) in first ch, ch 2, sk next 7 ch, sc in next ch, 3 sc in next ch, sc in next ch,, ch 2, sk next 7 ch**, shell in next ch; rep

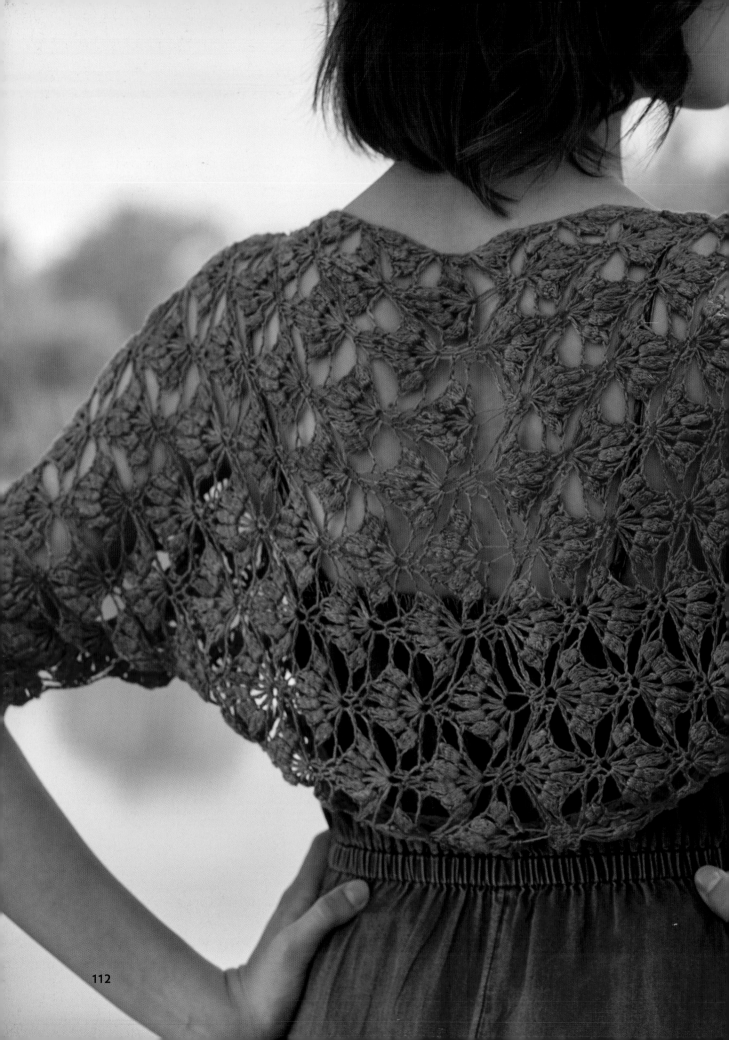

from * across, ending last rep at **, ([dc, ch 1] 3 times, dc) in last ch, turn—5 shells; 2 half shells.

ROWS 2–33: Rep Rows 4–33 of first half; then rep Rows 3 and 4. Fasten off, leaving a long sewing length.

ASSEMBLY
Fold shrug in half lengthwise. Sew sides together for 4" (10 cm) above each end forming sleeves.

FINISHING
Weave in ends. Handwash, block to finished measurements, and allow to dry.

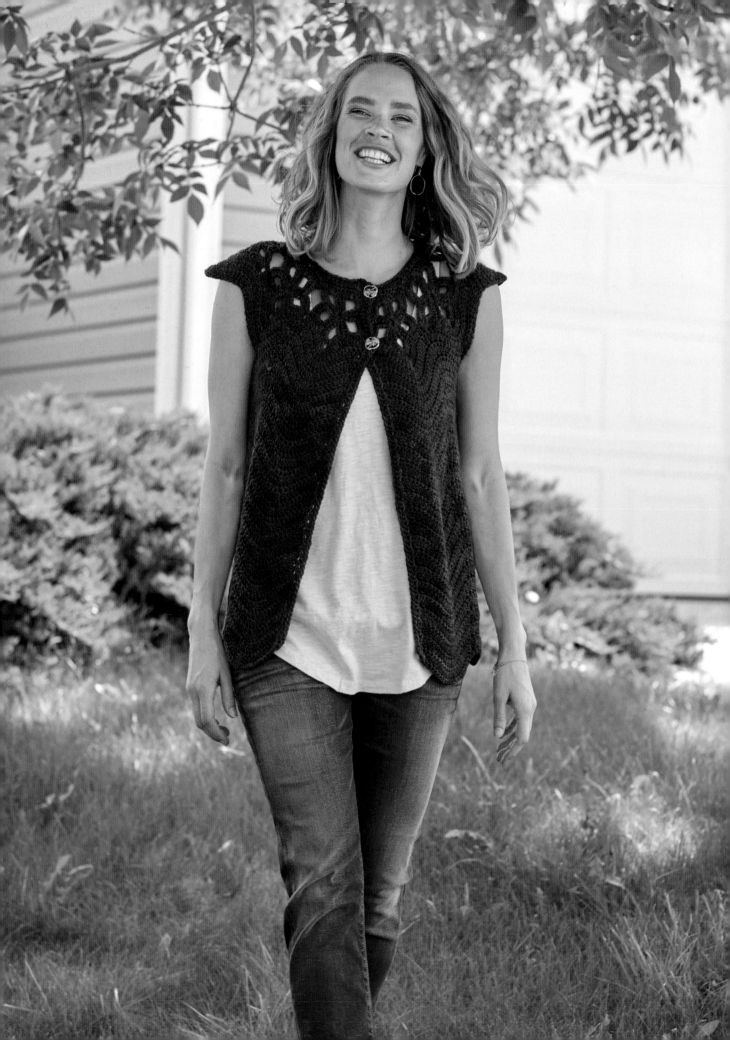

twilight skies
PENTAGON MOTIF YOKE CARDIGAN

Openwork motifs add visually stunning lace to the yoke, which frames the face beautifully. By making the motifs pentagons rather than squares, you not only add extra width at the lower edge (creating the increases required for a sweater yoke), but also give you a wonderful scalloped edge from which to continue the body of the sweater in a chevron pattern. The rest of the sweater is worked even in pattern. Buttons offer a casual closure, but it can be beautifully worn open as well.

FINISHED SIZES
Directions are given for size S. Changes for M, L, XL, and 2X are in parentheses.

Finished bust: 40 (43½, 47, 51, 54½)" (101.5 [110.5, 119.5, 129.5, 138.5] cm).

Finished length: 26 (26, 26, 26, 27)" (66 [66, 66, 66, 68.5] cm).

YARN
Worsted weight (#4 Medium).

Shown here: Malabrigo Yarn Merino Worsted (100% merino wool; 210 yd [192 m]/3.5 oz [100 g]): #508 Blue Graphite, 2 (3, 3, 3, 3) skeins.

HOOK
G/6 (4 mm).

Adjust hook size if needed to obtain gauge.

NOTIONS
Yarn needle; two ⁷⁄₈" (22 mm) buttons. Sample features Blumenthal Lansing Co's Vintage Ode #1725.

GAUGE
Motif = 4" (10 cm) in diameter; one pattern rep after increasing for body = 5 (5½, 6, 6½, 7)" (12.5 [14, 15, 16.5, 18] cm); 8 rows in body pattern = 3" (7.5 cm).

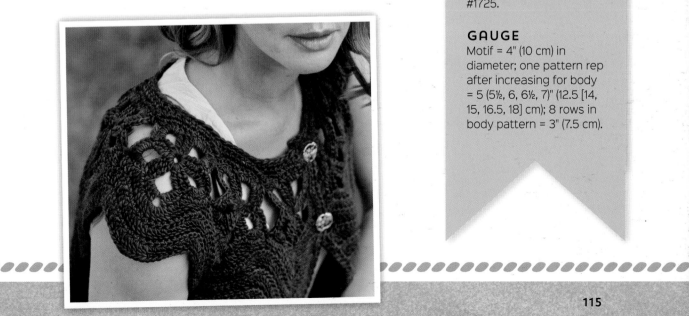

stitch guide

SINGLE CROCHET 2 TOGETHER
(SC2TOG): Insert hook in next stitch, yarn over and pull up loop (2 loops on hook), insert hook in next stitch, yarn over and pull up loop (3 loops on hook), yarn over and draw through all 3 loops on hook—1 stitch decreased.

SINGLE CROCHET 4 TOGETHER
(SC4TOG): [Insert hook in next stitch, yarn over, pull loop through stitch] 4 times. Yarn over and draw yarn through all 5 loops on hook. Completed sc4tog—3 stitches decreased.

DOUBLE CROCHET 2 TOGETHER
(DC2TOG): [Yarn over, insert hook in next stitch, yarn over and pull up loop, yarn over, draw through 2 loops] 2 times, yarn over, draw through all loops on hook—1 stitch decreased.

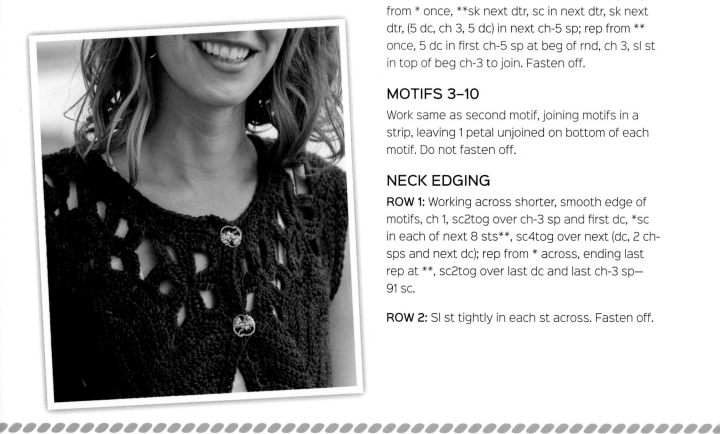

YOKE
FIRST MOTIF

Ch 5, sl st to first ch to form a ring.

RND 1: Ch 5 (counts as dtr), 2 dtr in ring, *ch 5, 3 dtr in ring; rep from * 3 times, ch 2, dc in top of beg ch-3 to join (counts as ch-5 sp)—5 ch-5 sps.

RND 2: Ch 3 (counts as dc here and throughout), 4 dc in same sp, *sk next dtr, sc in next dtr, sk next dtr, (5 dc, ch 3, 5 dc) in next ch-5 sp; rep from * around, 5 dc in first ch-5 sp at beg of rnd, ch 3, sl st in top of beg ch-3 to join—5 petals. Fasten off.

SECOND MOTIF (JOINED ON ONE SIDE)

Work same as first motif through Rnd 1.

RND 2: Ch 3, 4 dc in same sp, *sk next dtr, sc in next dtr, sk next dtr, (5 dc, ch 1, sl st in ch-3 sp on previous motif, ch 1, 5 dc) in next ch-5 sp; rep from * once, **sk next dtr, sc in next dtr, sk next dtr, (5 dc, ch 3, 5 dc) in next ch-5 sp; rep from ** once, 5 dc in first ch-5 sp at beg of rnd, ch 3, sl st in top of beg ch-3 to join. Fasten off.

MOTIFS 3–10

Work same as second motif, joining motifs in a strip, leaving 1 petal unjoined on bottom of each motif. Do not fasten off.

NECK EDGING

ROW 1: Working across shorter, smooth edge of motifs, ch 1, sc2tog over ch-3 sp and first dc, *sc in each of next 8 sts**, sc4tog over next (dc, 2 ch-sps and next dc); rep from * across, ending last rep at **, sc2tog over last dc and last ch-3 sp—91 sc.

ROW 2: Sl st tightly in each st across. Fasten off.

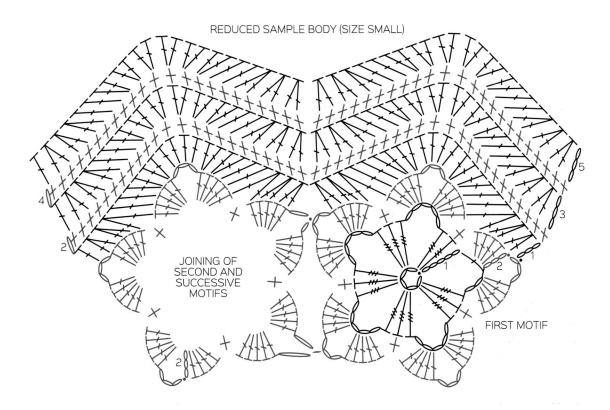

REDUCED SAMPLE BODY (SIZE SMALL)

JOINING OF
SECOND AND
SUCCESSIVE
MOTIFS

FIRST MOTIF

⬭ = chain (ch)

• = slip st (sl st)

✛ = single crochet (sc)

⊤ = double crochet (dc)

⊤ = double treble crochet (dtr)

⋏ = double crochet 2 together (dc2tog)

BODY

Note: Body begins across lower edge of motifs (the side with the points), and a scalloped pattern is begun to complement the existing wavy design.

Size S only:

ROW 1: With RS facing, join yarn with sl st in first ch-3 sp on bottom edge of first motif, ch 3, *[dc2tog over next 2 sts] twice, work dc2tog over next 3 sts, skipping sc bet 2 dc's, dc in each of next 2 sts, 2 dc in each of next 2 dc, 4 dc in next ch-3 sp, 2 dc in each of next 2 dc, dc in each of next 2 dc, work dc2tog over next 3 sts, skipping sc bet 2 dc's, [dc2tog over next 2 sts] twice; rep from * across, dc in last ch-3 sp, turn—222 sts.

Sizes M, L, XL, and 2X only:

ROW 1: With RS facing, join yarn with sl st in first ch-3 sp on bottom edge of first motif, ch 3, *[dc2tog over next 2 sts] 3 times, dc in each of next 3 sts, 2 dc in each of next 2 dc,

REDUCED SAMPLE BODY (SIZE MEDIUM)

5

4

3

2

JOINING OF
SECOND AND
SUCCESSIVE
MOTIFS

2

1

2

1

FIRST MOTIF

◯ = chain (ch)

• = slip st (sl st)

+ = single crochet (sc)

⊥ = double crochet (dc)

‡ = double treble crochet (dtr)

⋏ = double crochet 2 together
(dc2tog)

REDUCED SAMPLE BODY (SIZE LARGE)

5

4

3

2

JOINING OF
SECOND AND
SUCCESSIVE
MOTIFS

2

1

2

1

FIRST MOTIF

4 dc in next ch-3 sp, 2 dc in each of next 2 dc, dc in each of next 3 dc, [dc2tog over next 2 sts] 3 times; rep from * across, dc in last ch-3 sp, turn—242 sts.

All Sizes:

ROW 2: Ch 1, sc in each st across—202 (242, 242, 242, 242) sc.

ROW 3: Ch 3, *[dc2tog over next 2 sts] 3 (3, 2, 2, 2) times, dc in each of next 2 (3, 5, 5, 5) sts, 2 dc in each of next 6 dc, dc in each of next 2 (3, 5, 5, 5) sts, [dc2tog over next 2 sts] 3 (3, 2, 2, 2) times; rep from * across, dc in last ch-3 sp, turn—222 (242, 262, 262, 262) sts.

ROW 4: Rep Row 2—222 (242, 262, 262, 262) sc.

ROW 5: Ch 3, *[dc2tog over next 2 sts] 3 (3, 3, 2, 2) times, dc in each of next 2 (3, 4, 5, 5) sts, 2 dc in each of next 6 dc, dc in each of next 2 (3, 4, 5, 5) sts, [dc2tog over next 2 sts] 3 (3, 3, 2, 2) times; rep from * across, dc in last ch-3 sp, turn—222 (242, 262, 282, 282) sts.

Size 2X only:

ROW 6: Rep Row 2.

ROW 7: Ch 3, *[dc2tog over next 2 sts] twice, dc in each of next 6 sts, 2 dc in each of next 6 dc, dc in each of next 6 sts, [dc2tog over next 2 sts] twice; rep from * across, dc in last ch-3 sp, turn—302 sts.

SEPARATE FOR BODY AND SLEEVES

ROW 6: Ch 1, sc in each of next 33 (36, 39, 42, 45) sts, ch 22 (24, 26, 28, 30), sk next 44 (48, 52, 56, 60) sts, sc in each of next 66 (72, 78, 84, 90) sts, ch 22 (24, 26, 28, 30), sk next 44 (48, 52, 56, 60) sts, sc in each of next 33 (36, 39, 42, 45) sts—178 (194, 210, 226, 222) sts.

ROW 7: Ch 3, *(dc2tog over next 2 sts) 3 times, dc in each of next 2 (3, 4, 5, 6) sts, 2 dc in each

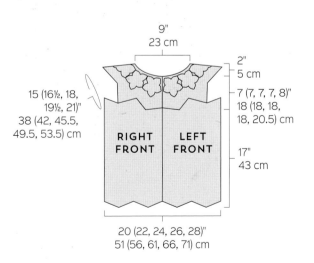

9"
23 cm

2"
5 cm

7 (7, 7, 7, 8)"
18 (18, 18, 18, 20.5) cm

15 (16½, 18, 19½, 21)"
38 (42, 45.5, 49.5, 53.5) cm

RIGHT FRONT

LEFT FRONT

17"
43 cm

20 (22, 24, 26, 28)"
51 (56, 61, 66, 71) cm

of next 6 dc, dc in each of next 2 (3, 4, 5, 6) sts, (dc2tog over next 2 sts) TKTK times; rep from * across, dc in last ch-3 sp, turn—178 (194, 210, 226, 222) sts.

ROW 8: Ch 1, sc in each st across, turn—178 (194, 210, 226, 222) sc.

ROWS 9–44: Rep Rows 6 and 7 (18 times). Do not fasten off.

BUTTONBAND

ROW 1: Ch 1, working across right front edge, work 3 sc in each row-end dc across to motif, sc in each st across motif, sc in each of next 2 row-end sts of neck edging, turn.

ROW 2: Ch 1, sc in each sc across. Fasten off.

BUTTONHOLE BAND

ROW 1: With RS facing, join yarn with sl st in top corner of left front edge, ch 1, sc in each of next 2 row-end sts of neck edging, ch 3, sk next 2 sts, sc in each st across motif, ch 3, sk 2 2 row-end sts, 3 sc in each row-end dc across, turn.

ROW 2: Ch 1, sc in each st across, working 3 sc in each ch-3 sp. Fasten off.

FINISHING

Weave in ends. Handwash, block to finished measurements, and allow to dry. Sew buttons to buttonband opposite buttonholes.

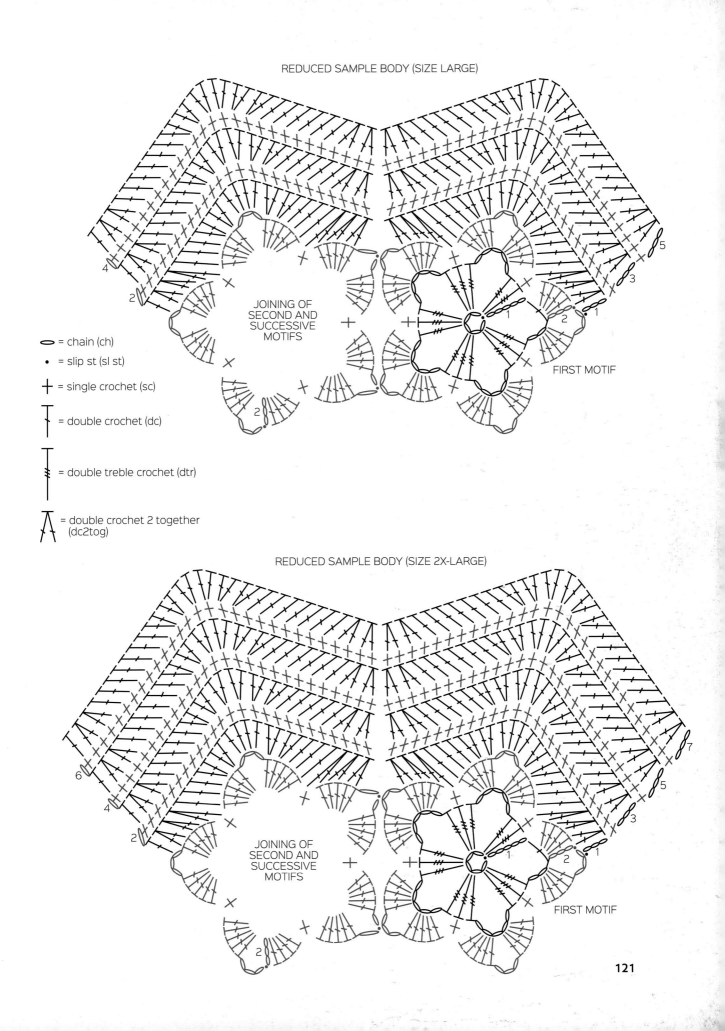

REDUCED SAMPLE BODY (SIZE LARGE)

JOINING OF
SECOND AND
SUCCESSIVE
MOTIFS

FIRST MOTIF

⬯ = chain (ch)

• = slip st (sl st)

+ = single crochet (sc)

† = double crochet (dc)

‡ = double treble crochet (dtr)

⋏ = double crochet 2 together
(dc2tog)

REDUCED SAMPLE BODY (SIZE 2X-LARGE)

JOINING OF
SECOND AND
SUCCESSIVE
MOTIFS

FIRST MOTIF

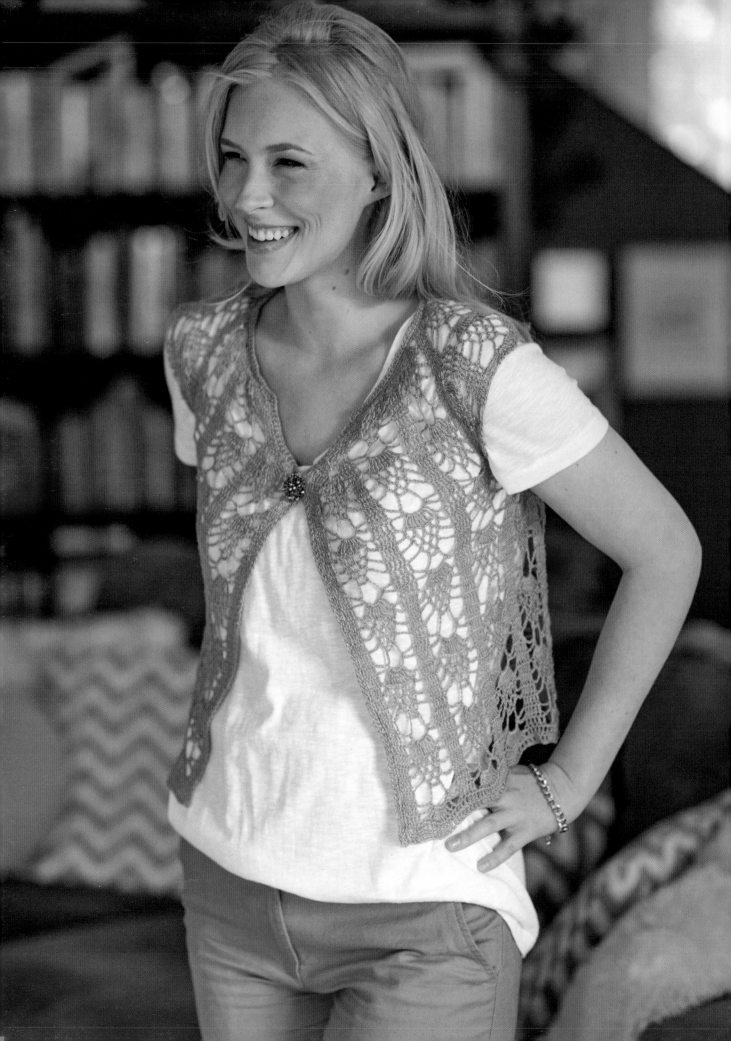

monticello meadow
CROPPED PINEAPPLE CARDI

Columns in an otherwise complicated stitch pattern allow for ease in increasing invisibly. The yoke increases are added within the columns for super-easy instructions. The rest of the garment is worked even in pattern. A wonderful go-to layer that transcends seasons. Wear this beautiful lace topper in place of a vest or as a focal-point accessory. Choose a color that complements your jewelry, and this will become one of your favorite go-to layering accessories!

FINISHED SIZES
Directions are given for size S. Changes for M, L, XL, and 2X are in parentheses.

Finished bust: 33 (36, 39, 48)" (84 [91.5, 99, 122] cm).

Finished length: 17½" (44.5 cm).

YARN
Fingering weight (#1 Superfine).

Shown here: Louet North America Euroflax Lace (100% wet-spun linen; 630 yd [576 m]/3.9 oz [110 g]; Terra Cotta, 2 cones all sizes.

HOOK
D/3 (3.25mm) crochet hook.

Adjust hook size if needed to obtain gauge.

NOTIONS
Yarn needle; stitch marker; one 1" (2.5 cm) button. Sample features The Collection by La Mode #4507.

GAUGE
1 pattern rep = 3" (7.5 cm); 6 rows in pattern =2½" (6.5 cm) after blocking.

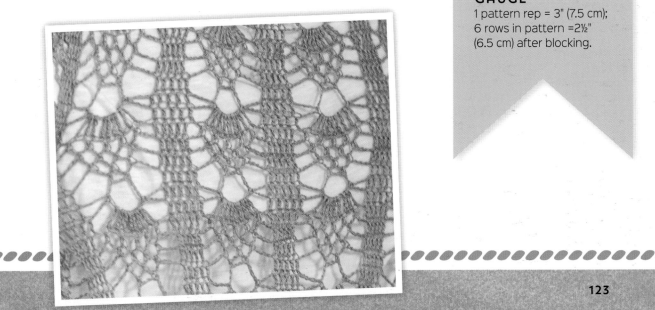

stitch guide

STITCH PATTERN
Ch a multiple of 10 + 8.

ROW 1: Dc in 4th ch from hook, and in each of next 4 sts, *ch 1, sk next 2 ch, 9 tr in next ch, ch 1, sk next 2 ch, dc in each of next 5 ch; rep from * across, turn.

ROW 2: Ch 3 (counts as dc here and throughout), dc in each of next 4 dc, *ch 3, sk next ch-1 sp, sc in next tr, [ch 3, sk next tr, sc in next tr] 4 times, ch 3, dc in each of next 5 dc; rep from * across, turn.

ROW 3: Ch 3, dc in each of next 4 dc, *ch 4, sk next ch-3 sp, sc in next ch-3 sp, (ch 3, sc) in each of next 3 ch-3 sps, ch 4, sk next ch-3 sp, dc in each of next 5 dc; rep from * across, turn.

ROW 4: Ch 3, dc in each of next 4 dc, *ch 4, sk next ch-4 sp, sc in next ch-3 sp, (ch 3, sc) in each of next ch-3 sps, ch 4, sk next ch-4 sp, dc in each of next 5 sts; rep from * across, turn.

ROW 5: Ch 3, dc in each of next 4 dc, *ch 7, sk next ch-4 sp, sc in next ch-3 sp, ch 3, sc in next ch-3 sp, ch 7, sk next ch-4 sp, dc in each of next 5 dc; rep from * across, turn.

ROW 6: Ch 3, dc in each of next 4 dc, *ch 4, sc in next ch-7 sp, ch 5, sk next ch-3 sp, sc in next ch-7 sp, ch 4, dc in each of next 5 dc; rep from * across, turn.

ROW 7: Ch 3, dc in each of next 4 dc, *ch 1, sk next ch-4 sp, 9 tr in next ch-5 sp, ch 1, sk next ch-4 sp, dc in each of next 5 dc; rep from * across, turn.

Rep Rows 2–7 for patt.

YOKE
Ch 108 (118, 128, 158).

ROW 1: (WS) Dc in 4th ch from hook, and in each of next 4 sts, *ch 1, sk next 2 ch, 9 tr in next ch, ch 1, sk next 2 ch, dc in each of next 5 ch; rep from * across, turn—10 (11, 12, 15) reps.

ROWS 2–5: Work Rows 2–5 of patt.

ROW 6 (INC): Ch 3, dc in first st, 2 dc in next dc, (dc, ch 5, dc) in next st, 2 dc in each of next 2 dc (inc made), *ch 4, sc in next ch-7 sp, ch 5, sc in next ch-7 sp, ch 4, dc in each of next 5 dc*; rep from * 0 (0, 0, 1) time, ch 4, sc in next ch-7 sp, ch 5, sc in next ch-7 sp, ch 4, 2 dc in each of next 2 dc, (dc, ch 5, dc) in next st, 2 dc in each of next 2 dc (inc made), ch 4, sc in next ch-7 sp, ch 5, sc in next ch-7 sp, ch 4, 2 dc in each of next 2 dc, (dc, ch 5, dc) in next st, 2 dc in each of next 2 dc (inc made); rep from * to * 3 (4, 5, 6) times, ch 4, sc in next ch-7 sp, ch 5, sc in next ch-7 sp, ch 4, 2 dc in each of next 2 dc, (dc, ch 5, dc) in next st, 2 dc in each of next 2 dc (inc made), ch 4, sc in next ch-7 sp, ch 5, sc in next ch-7 sp, ch 4, 2 dc in each of next 2 dc, (dc, ch 5, dc) in next st, 2 dc in each of next 2 dc (inc made); rep from * to * 1 (1, 1, 2) time(s), 2 dc in each of next 2 dc, (dc, ch 5, dc) in next st, 2 dc in each of next 2 dc (inc made), turn—16 (17, 18, 21) ch-5 sps.

Note: Place marker at the beginning of this round. When working the Edging, a buttonhole will be placed here.

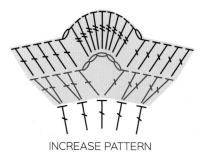

INCREASE PATTERN

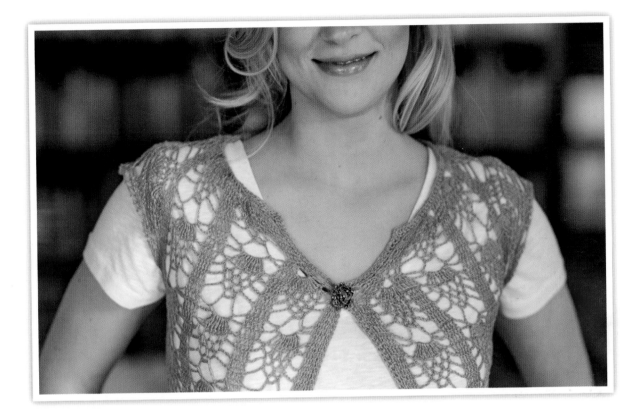

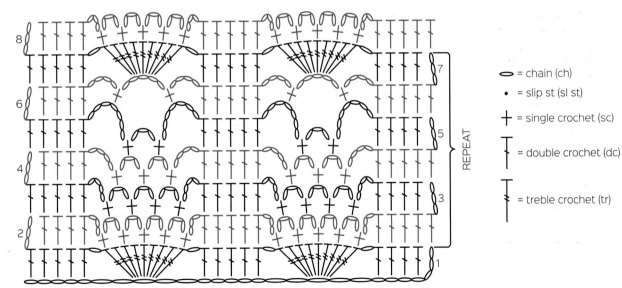

REDUCED SAMPLE OF PATTERN WITHOUT INCREASES

= chain (ch)

= slip st (sl st)

= single crochet (sc)

= double crochet (dc)

= treble crochet (tr)

ROW 7: Ch 3, dc in each of next 4 dc, *ch 1, 9 tr in next ch-5 sp, ch 1, dc in each of next 5 dc; rep from * across, turn—16 (17, 18, 21) 9-tr shells.

Sizes S and M Only:

ROWS 8–13: Work Rows 2–7 of patt.

Sizes L and XL Only:

ROWS 8–11: Work Rows 2–5 of patt.

ROW 12 (INC): Ch 3, dc in each of next 4 dc, *ch 4, sc in next ch-7 sp, ch 5, sk next ch-3 sp, sc in next ch-7 sp, ch 4, dc in each of next 5 dc*; rep from * to * 2 (3) times, ch 4, sc in next ch-7 sp, ch 5, sk next ch-3 sp, sc in next ch-7 sp, ch 4, 2 dc in each of next 2 dc, (dc, ch 5, dc) in next st, 2 dc in each of next 2 dc (inc made), ch 4, sc in next ch-7 sp, ch 5, sc in next ch-7 sp, ch 4, 2 dc in each of next 2 dc, (dc, ch 5, dc) in next st, 2 dc in each of next 2 dc (inc made); rep from * to * 7 (8) times, ch 4, sc in next ch-7 sp, ch 5, sk next ch-3 sp, sc in next ch-7 sp, ch 4, 2 dc in each of next 2 dc, (dc, ch 5, dc) in next st, 2 dc in each of next 2 dc (inc made), ch 4, sc in next ch-7 sp, ch 5, sc in next ch-7 sp, ch 4, 2 dc in each of next 2 dc, (dc, ch 5, dc) in next st, 2 dc in each of next 2 dc (inc made); rep from * to * 4 (5) times, turn—22 (25) ch-5 sps.

ROW 13: Ch 3, dc in each of next 4 dc, *ch 1, 9 tr in next ch-5 sp, ch 1, dc in each of next 5 dc; rep from * across, turn—22 (25) 9-tr shells.

ROWS 14–19: Work Rows 2–7 of patt.

SEPARATE FOR BODY AND SLEEVES

ROW 1: Ch 3 (counts as dc here and throughout), dc in each of next 4 dc, *ch 3, sk next ch-1 sp, sc in next tr, [ch 3, sk next tr, sc in next tr] 4 times, ch 3, dc in each of next 5 dc*; rep from * to * 1 (1, 1, 2) time(s), ch 3, sk next ch-1 sp, sc in next tr, [ch 3,

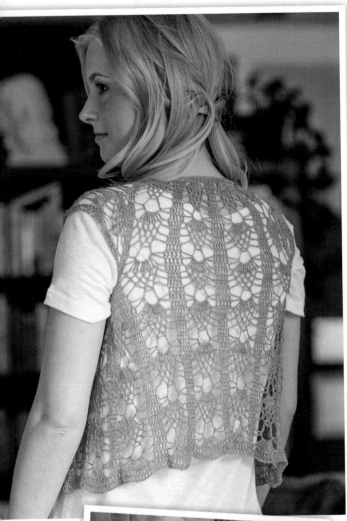

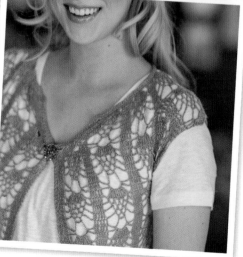

sk next tr, sc in next tr] 4 times, ch 3, dc in each of next 2 dc, ch 10, sk next 3 (3, 5, 5) 9-tr shells, sk next 3 dc, dc in each of next 2 dc; rep from * to * 3 (4, 5, 6) times, ch 3, sk next ch-1 sp, sc in next tr, [ch 3, sk next tr, sc in next tr] 4 times, ch 3, dc in each of next 2 dc, ch 10, sk next 3 (3, 5, 5) 9-tr shells, sk next 3 dc, dc in each of next 2 dc; rep from * 3 (3, 3, 4) times.

ROW 2: *Work in pattern Row 3 across first 3 (3, 3, 3, 4) reps, ending with dc in each of last 2 dc before ch-10 sp, 11 dc in next ch-10 sp, dc in each of next 2 dc; rep from * once, work in pattern Row 3 across, ending with dc in each of last 5 dc, turn—10 (11, 12, 15) patt reps: two 15-dc sections at underarms.

ROW 3: *Work in pattern Row 4 across to 15-dc section, dc in each of next 15; rep from * once, work in pattern Row 4 across, ending with dc in each of last 5 dc, turn.

ROW 4: *Work in pattern Row 5 across to 15-dc section, dc in each of next 15; rep from * once, work in pattern Row 5 across, ending with dc in each of last 5 dc, turn.

ROW 5: *Work in pattern Row 6 across to 15-dc section, dc in each of next 5 dc, [ch 5, dc in each of next 5 dc] twice; rep from * once, work in pattern Row 6 across, ending with dc in each of last 5 dc, turn—14 (15, 16, 19) ch-5 sps.

ROW 6: Ch 3, dc in each of next 4 dc, *ch 1, 9 tr in next ch-5 sp, ch 1, dc in each of next 5 dc; rep from * across, turn—14 (15, 16, 19) 9-tr shells.

ROWS 7–24: Work even in pattern.

ROW 25: Ch 3, dc in each st and ch-1 sp across, turn.

ROW 26: Ch 3, dc in each dc across. Do not fasten off.

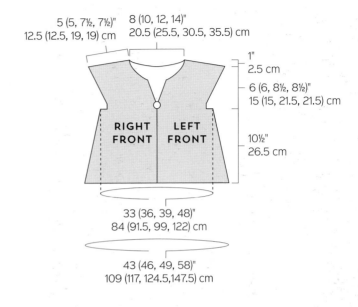

EDGING

ROW 1: Ch 1, sc evenly across Right Front edge to corner at neck edge, 3 sc in corner st, sc in each st across neck edge, 3 sc in corner st, sc evenly across Left Front to marker, ch 7, sk next row-end st, sc evenly across Left Front edge to bottom corner, turn.

ROW 2: Ch 1, sc in each sc across to ch-7 sp, work 9 tr in next ch-7 sp, *sc in each st across to next corner 3 sc in corner st; rep from * once, sc in each st across to bottom corner, turn.

ROW 3: Ch 1, sc in each st across working 3 sc in each neck corner. Fasten off.

FINISHING

Weave in ends. Handwash, block to finished measurements and allow to dry. Sew button to top Right Front edge opposite buttonhole.

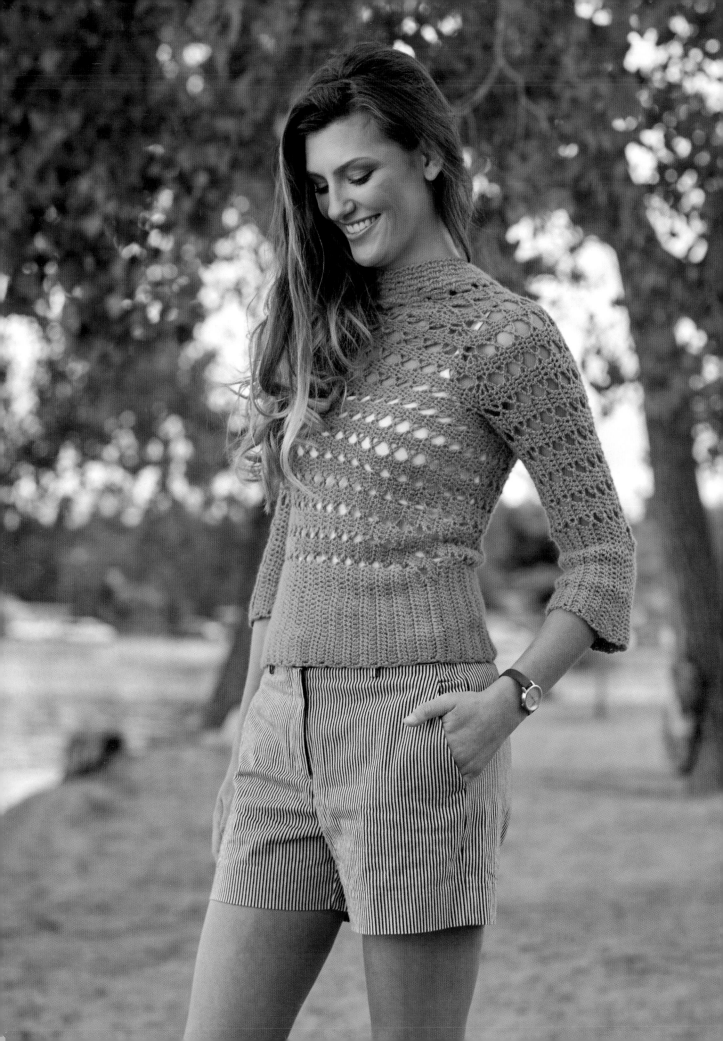

tigress
SPIRALING BRUGES LACE PULLOVER

This bruges lace piece is created by spiraling a simple strip and making concentrated joins in four strategically placed increase points to create a shaped yoke. The rest of the sweater is worked even in bruges lace spiral. If you are looking for a little spice in your skill set, you must give this sweater a try. So fun and such a different way to look at sweater construction! For a simpler capelet, end at the bottom of the yoke.

FINISHED SIZES
Directions are given for size S. Changes for M, L, XL, and 2X are in parentheses.

Finished bust: 30½ (35, 40, 45, 51)" (77.5 [89, 101.5, 114.5, 129.5] cm).

Finished length: 27" (68.5 cm)

YARN
Sportweight (#2 Fine).

Shown here: The Fibre Company Road to China Light (65% baby alpaca, 15% silk, 10% camel, 10% cashmere; 159 yd [145 m]/1.76 oz [50 g]): Topaz, 5 (6, 7, 8, 9) hanks.

HOOK
G/6 (4 mm).

Adjust hook size if needed to obtain gauge.

NOTIONS
Yarn needle.

GAUGE
4 dc = 1" (2.5 cm) after blocking; 10 rows dc = 4" (10 cm).

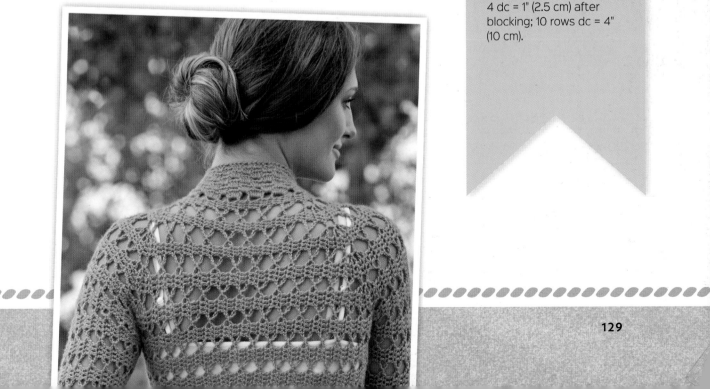

YOKE

Note: Sweater is worked in strips that spiral around the body and are joined as you go. The raglan increase corners on the yoke (four) have three bruges joins per corner for the increase. The remainder of the sweater is worked in simple 1:1 spiral. The cuffs and bottom band are incorporated right into the spiral. The cowl neckline is crocheted onto the neck opening last.

FIRST SPIRAL RING

ROW 1: Ch 6, 3 dc in 6th ch from hook, turn.

ROW 2: Ch 5, dc in each of next 3 sts, turn.

ROWS 3–40: Rep Row 2.

SECOND SPIRAL RING

ROW 41: Ch 2, sl st in adjacent ch-5 sp, ch 2, dc in each of next 3 sts, turn.

ROW 42: Rep Row 2.

ROW 43 (INC): Ch 2, sl st in SAME ch-5 sp, ch 2, dc in each of next 3 sts, turn.

ROWS 44 AND 45 (INC): Rep Rows 42 and 43 once.

ROWS 46–53: Rep Rows 40 and 41 (4 times).

ROWS 54–57: Rep Rows 42–45.

ROWS 58–69: Rep Rows 40 and 41 (6 times).

ROWS 70–73 (INC): Rep Rows 42–45.

ROWS 74–81: Rep Rows 40 and 41 (4 times).

ROWS 82–85 (INC): Rep Rows 42–45.

ROWS 86–97: Rep Rows 40 and 41 (6 times).

THIRD SPIRAL RING

ROWS 98–101 (INC): Rep Rows 42–45.

ROWS 102–113: Rep Rows 40 and 41 (6 times).

ROWS 114–117 (INC): Rep Rows 42–45.

ROWS 118–133: Rep Rows 40 and 41 (8 times).

ROWS 134–137 (INC): Rep Rows 42–45.

ROWS 138–149: Rep Rows 40 and 41 (6 times).

ROWS 150–153 (INC): Rep Rows 42–45.

ROWS 154–171: Rep Rows 40 and 41 (9 times).

FOURTH SPIRAL RING

ROWS 172–175 (INC): Rep Rows 42–45.

ROWS 176–191: Rep Rows 40 and 41 (8 times).

ROWS 192–195 (INC): Rep Rows 42–45.

ROWS 196–215: Rep Rows 40 and 41 (10 times).

ROWS 216–219 (INC): Rep Rows 42–45.

ROWS 220–235: Rep Rows 40 and 41 (8 times).

ROWS 236–239 (INC): Rep Rows 42–45.

ROWS 240–261: Rep Rows 40 and 41 (11 times).

FIFTH SPIRAL RING

ROWS 262–265 (INC): Rep Rows 42–45.

ROWS 266–285: Rep Rows 40 and 41 (9 times).

ROWS 286–289 (INC): Rep Rows 42–45.

ROWS 290–313: Rep Rows 40 and 41 (12 times).

ROWS 314–317 (INC): Rep Rows 42–45.

ROWS 318–337: Rep Rows 40 and 41 (10 times).

ROWS 338–341 (INC): Rep Rows 42–45.

ROWS 342–365: Rep Rows 40 and 41 (12 times).

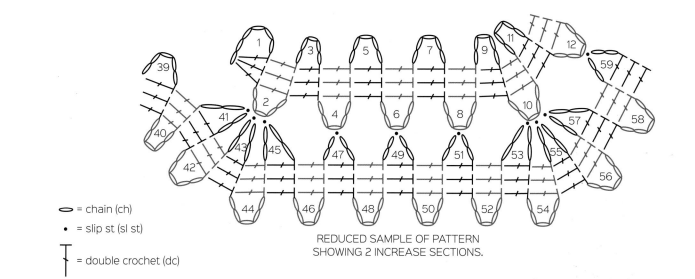

REDUCED SAMPLE OF PATTERN
SHOWING 2 INCREASE SECTIONS.

◯ = chain (ch)

• = slip st (sl st)

⊤ = double crochet (dc)

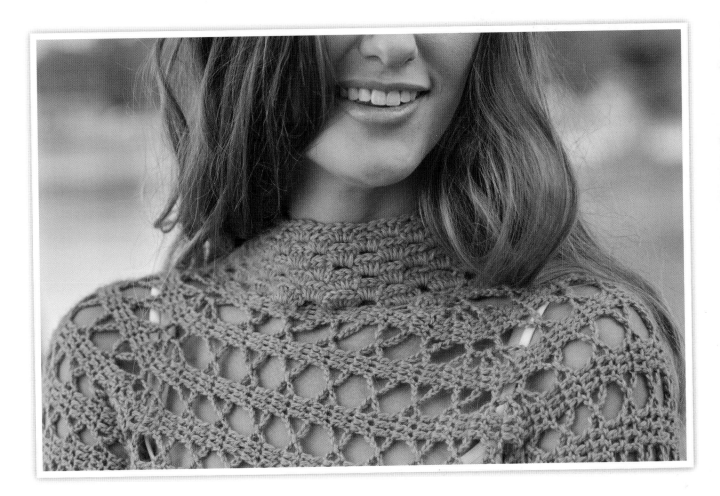

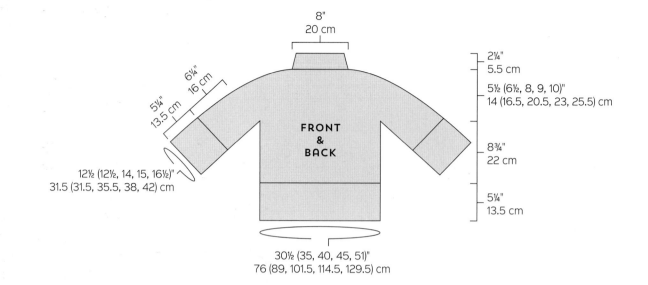

8"
20 cm

2¼"
5.5 cm

5½ (6½, 8, 9, 10)"
14 (16.5, 20.5, 23, 25.5) cm

6¼"
16 cm

5¼"
13.5 cm

FRONT
&
BACK

8¾"
22 cm

5¼"
13.5 cm

12½ (12½, 14, 15, 16½)"
31.5 (31.5, 35.5, 38, 42) cm

30½ (35, 40, 45, 51)"
76 (89, 101.5, 114.5, 129.5) cm

Sizes M, L, XL, and 2X only:

SIXTH SPIRAL RING

ROWS 366–369 (INC): Rep Rows 42 and 43.

ROWS 370–393: Rep Rows 40 and 41 (12 times).

ROWS 394–397 (INC): Rep Rows 42–45.

ROWS 398–425: Rep Rows 40 and 41 (14 times).

ROWS 426–429 (INC): Rep Rows 42–45.

ROWS 430–453: Rep Rows 40 and 41 (12 times).

ROWS 454–457 (INC): Rep Rows 42–45.

ROWS 458–485: Rep Rows 40 and 41 (14 times).

Sizes L, XL, and 2X only:

SEVENTH SPIRAL RING

ROWS 486–489 (INC): Rep Rows 42 and 43.

ROWS 490–517: Rep Rows 40 and 41 (14 times).

ROWS 518–521 (INC): Rep Rows 42–45.

ROWS 522–553: Rep Rows 40 and 41 (16 times).

ROWS 554–557 (INC): Rep Rows 42–45.

ROWS 558–585: Rep Rows 40 and 41 (14 times).

ROWS 586–589 (INC): Rep Rows 42–45.

ROWS 590–621: Rep Rows 40 and 41 (16 times).

Sizes XL and 2X only:

EIGHTH SPIRAL RING

ROWS 622–623: Rep Rows 40 and 41.

ROWS 624–627 (INC): Rep Rows 42 and 43.

ROWS 628–659: Rep Rows 40 and 41 (16 times).

ROWS 660–663 (INC): Rep Rows 42–45.

ROWS 664–699: Rep Rows 40 and 41 (18 times).

ROWS 700–703 (INC): Rep Rows 42–45.

ROWS 704–735: Rep Rows 40 and 41 (16 times).

ROWS 736–739 (INC): Rep Rows 42–45.

ROWS 740–773: Rep Rows 40 and 41 (16 times).

Size 2X only:

NINTH SPIRAL RING

ROWS 774–775: Rep Rows 40 and 41.

ROWS 776–779 (INC): Rep Rows 42 and 43.

ROWS 780–815: Rep Rows 40 and 41 (18 times).

ROWS 816–819 (INC): Rep Rows 42–45.

ROWS 820–859: Rep Rows 40 and 41 (20 times).

ROWS 860–863 (INC): Rep Rows 42–45.

ROWS 864–899: Rep Rows 40 and 41 (18 times).

ROWS 900–903 (INC): Rep Rows 42–45.

ROWS 904–941: Rep Rows 40 and 41 (19 times).

All Sizes:

SEPARATE YOKE FOR BODY AND SLEEVES
FIRST SPIRAL

ROWS 1–8 (8, 8, 8, 10): Rep Row 2.

Sk next 12 (12, 13, 14, 15) ch-5 sps on body.

ROWS 9–36 (44, 50, 56, 64): Rep Rows 40 and 41 (14 [18, 21, 24, 27] times), joining to yoke.

ROWS 37–44 (45–52, 51–58, 57–64, 65–74): Rep Row 2.

Sk next 12 (12, 13, 14, 15) ch-5 sps on body.

ROWS 45–72 (53–88, 59–100, 65–112, 75–128): Rep Rows 40 and 41 (14 [18, 21, 24, 27] times), joining to yoke.

Remainder of body is worked even in spiral rnds.

Rep Rows 40 and 41 until 7 more spiral rings have been worked, ending with Row 40. Do not fasten off.

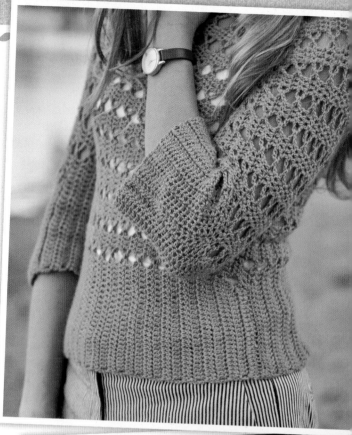

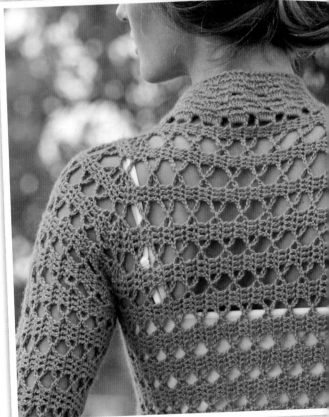

LOWER BODY BAND

ROW 1: Ch 2, sl st in adjacent ch-5 sp, ch 2, dc in each of next 3 sts, work 21 Fdc, turn.

ROW 2: Ch 3 (counts as dc here and throughout), dc in each st across.

ROW 3: Ch 2, sl st in adjacent ch-5 sp, ch 2, turn, dc in each st across, turn.

ROWS 4–75 (87, 99, 111, 127): Rep Rows 2 and 3 (36 [42, 48, 54, 62] times).

ROW 76 (88, 100, 112, 128): Ch 3, dc in each st across to last 4 sts, dc4tog over last 4 sts.

ROW 77 (89, 101, 113, 129): Ch 2, sl st in adjacent ch-5 sp, ch 2, turn, dc in next st, sl st to adjacent dc on Row 1 of band, *dc in next st on current row, sl st to adjacent dc on Row 1 of band, rep from * across. Fasten off.

SLEEVE (MAKE 2)
FIRST SPIRAL

ROW 1: Ch 6, 3 dc in 6th ch from hook, turn.

ROW 2: Ch 2, sl st in adjacent ch-5 sp on armhole, ch 2, dc in each of next 3 sts, turn.

ROW 3: Ch 5, dc in each of next 3 sts, turn.

ROWS 4–31 (31, 35, 37, 41): Rep Rows 2 and 3 (14 [14, 16, 17, 19] times).

Remainder of sleeve is worked even in spiral rnds.

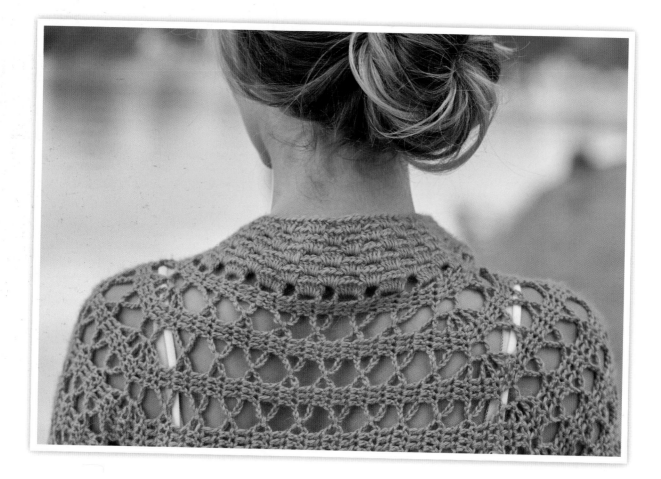

SECOND AND SUCCESSIVE SPIRALS

ROW 1: Ch 2, sl st in adjacent ch-5 sp on Row 1 of first spiral, ch 2, dc in each of next 3 sts, turn.

ROW 2: Ch 5, dc in each of next 3 sts, turn.

ROW 3: Ch 2, sl st in next adjacent ch-5, ch 2, dc in each of next 3 sts, turn.

Rep Rows 2 and 3 until 5 more spiral rings have been worked, ending with Row 2.

SLEEVE BAND

ROW 1: Ch 2, sl st in adjacent ch-5 sp, ch 2, dc in each of next 3 sts, work 21 Fdc, turn.

ROW 2: Ch 3 (counts as dc here and throughout), dc in each st across.

ROW 3: Ch 2, sl st in adjacent ch-5 sp, ch 2, turn, dc in each st across, turn.

ROWS 4–31 (31, 35, 37, 41): Rep Rows 2 and 3 (14 [14, 16, 18, 19] times).

ROW 32 (32, 36, 38, 42): Ch 3, dc in each st across to last 4 sts, dc4tog over last 4 sts.

ROW 33 (33, 37, 39, 43): Ch 2, sl st in adjacent ch-5 sp, ch 2, turn, dc in next st, sl st to adjacent dc on Row 1 of band, *dc in next st on current row, sl st to adjacent dc on Row 1 of band, rep from * across. Fasten off.

COWL NECKBAND

RND 1: Join yarn with sl st in any ch-5 sp on neck edge, ch 3 (counts as dc), 6 dc in same ch-5 sp, 7 dc in each ch-5 sp around, sl st in top of beg ch-3 to join—273 dc.

RND 2: Sl st across 7 sts, sl st in sp bet two 7-dc shells, ch 3, 4 dc in same sp, *skip next 7 sts, 5 dc in sp before next shell; rep from * around, sl st in top of beg ch-3 to join—195 dc.

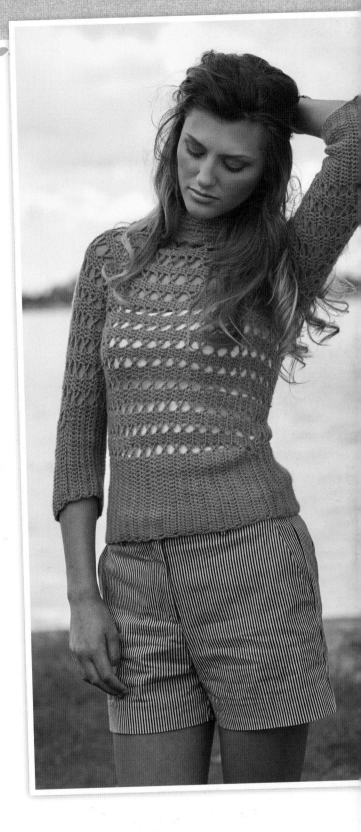

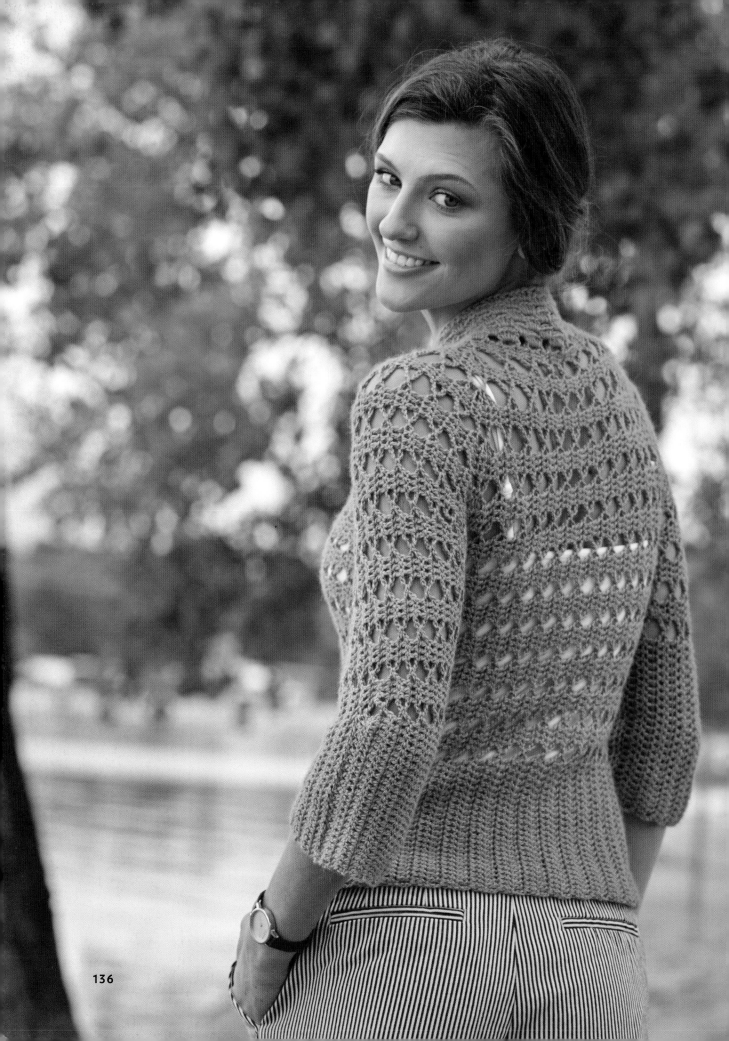

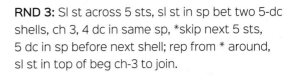

RND 3: Sl st across 5 sts, sl st in sp bet two 5-dc shells, ch 3, 4 dc in same sp, *skip next 5 sts, 5 dc in sp before next shell; rep from * around, sl st in top of beg ch-3 to join.

RNDS 4–6: Rep Rnd 3.

RND 7: Sl st across 5 sts, sl st in sp bet two 5-dc shells, ch 3, 3 dc in same sp, *skip next 5 sts, 4 dc in sp before next shell; rep from * around, sl st in top of beg ch-3 to join—156 dc.

RND 8: Sl st across 4 sts, sl st in sp bet two 4-dc shells, ch 3, 3 dc in same sp, *skip next 4 sts, 4 dc in sp before next shell; rep from * around, sl st in top of beg ch-3 to join. Fasten off.

FINISHING

Weave in ends. Handwash, block to finished measurements, and allow to dry.

abbreviations

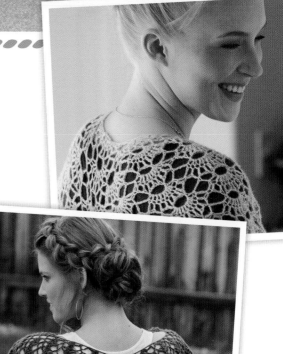

beg	begin; begins; beginning
bet	between
blo	back loop only
ch	chain(s) centimeter(s)
cont	continue(s); continuing double crochet
dc	double crochet
dc2tog	double crochet 2 stitches together
dc6tog	double crochet 6 stitches together
dc7tog	double crochet 7 stitches together
dc-tbl	double crochet through back loops long
dec	decrease(s); decreasing; decreased
dtr	double treble (triple)
fpdc	front post double crochet
fpdc2tog	front post double crochet 2 stitches together
fpdc3tog	front post double crochet 3 stitches together
fpdc5tog	front post double crochet 5 stitches together
g	gram(s)
hdc	half double crochet
inc	increase(s); increasing; increased loop(s)
m	marker
mm	millimeter(s)
patt	pattern(s)
pm	place marker
rem	remain(s); remaining
rep	repeat; repeating
rev sc	reverse single crochet
rnd	round(s)
RS	right side
sc	single crochet

sk	skip
sl st	slip; slipped stitch
sp(s)	space(s)
st(s)	stitch(es)
tch	turning chain
tog	together
tr	treble crochet
tr tr	triple treble crochet
WS	wrong side
*****	repeat starting point
yd(s)	yard(s)
yo	yarn over
()	work sts in parentheses in designated st or number of times indicated

techniques

FOUNDATION SINGLE CROCHET (FSC)

Ch 2 (**Figure 1**), insert hook in 2nd ch from hook (**Figure 2**), yarn over hook and draw up a loop (2 loops on hook), yarn over hook, draw yarn through first loop on hook (**Figure 3**), yarn over hook and draw through 2 loops on hook (**Figure 4**)—1 fsc made (**Figure 5**). *Insert hook under 2 loops of ch made at base of previous stitch (**Figure 6**), yarn over hook and draw up a loop (2 loops on hook), yarn over hook and draw through first loop on hook, yarn over hook and draw through 2 loops on hook (**Figure 7**). Repeat from * for length of foundation.

FOUNDATION DOUBLE CROCHET (FDC)

Ch 3. Yarn over, insert hook in 3rd chain from hook, yarn over and pull up loop (3 loops on hook), yarn over and draw through 1 loop (1 chain made), [yarn over and draw through 2 loops] 2 times (**Figure 1**)—foundation double crochet. Yarn over, insert hook under 2 loops of chain at bottom of stitch just made, yarn over and pull up loop (3 loops on hook) (**Figure 2**), yarn over and draw through 1 loop (1 chain made), [yarn over and draw through 2 loops] 2 times (**Figure 3**). *Yarn over, insert hook under 2 loops of chain at bottom of stitch just made (**Figure 4**), yarn over and pull up loop (3 loops on hook), yarn over and draw through 1 loop (1 chain made), [yarn over and draw through 2 loops] 2 times. Repeat from * as needed (**Figure 5**).

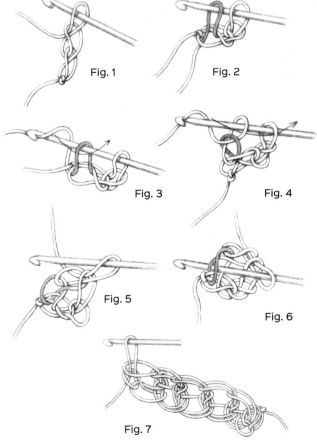

Fig. 1

Fig. 2

Fig. 3

Fig. 4

Fig. 5

Fig. 6

Fig. 7

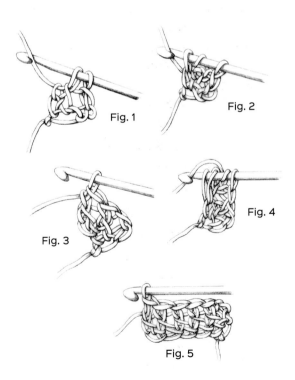

Fig. 1

Fig. 2

Fig. 3

Fig. 4

Fig. 5

DOUBLE CROCHET 2 TOGETHER (DC2TOG)

[Yarn over, insert hook in next stitch, yarn over and pull up loop, yarn over, draw through 2 loops] 2 times, yarn over, draw through all loops on hook —1 stitch decreased.

FRONT POST DOUBLE CROCHET (FPDC)

Yarn over hook, insert hook from front to back to front again around post of stitch indicated, yarn over hook and pull up a loop (3 loops on hook), [yarn over hook and draw through 2 loops on hook] twice— 1 fpdc made.

BACK POST DOUBLE CROCHET (BPDC)

Yarn over hook, insert hook from back to front, to back again around the post of stitch, yarn over hook, draw yarn through stitch, [yarn over hook, draw yarn through 2 loops on hook] twice.

FRONT POST TREBLE CROCHET (FPTR)

Yarn over 2 times, insert hook from front to back to front around the post of the corresponding stitch below, yarn over and pull up loop [yarn over, draw through 2 loops on hook] 3 times.

BACK POST TREBLE CROCHET (BPTR)

Yarn over 2 times, insert hook from back to front to back around the post of the corresponding stitch below, yarn over and pull up loop [yarn over, draw through 2 loops on hook] 3 times.

2 DOUBLE CROCHET CLUSTER (2-DC CLUSTER)

Yarn over, insert hook into st, pull up a loop, yarn over, draw through 2 loops only (2 loops left on hook), yarn over, insert hook into same st, pull up a loop, yarn over, draw through 2 loops only (3 loops left on hook), yarn over, pull through all 3 loops on hook.

DOUBLE TREBLE CROCHET CLUSTER (DTR CLUSTER)

*Yarn over 3 times, insert hook into st (5 loops on hook); [yarn over and draw through 2 loops] 4 times; repeat from * for desired number of dtr, yarn over, pull through all loops on hook.

DOUBLE CROCHET–HALF DOUBLE CROCHET CLUSTER (DC-HDC CLUSTER)

Yarn over, insert hook into st, pull up a loop, yarn over, draw through 2 loops only (2 loops left on hook), yarn over, insert hook into same stitch, yarn over and pull up loop (3 loops on hook), yarn over and draw through all loops on hook.

TRIPLE TREBLE CROCHET (TRTR)

Yarn over 4 times, insert hook in stitch, yarn over and pull up loop (6 loops on hook), yarn over and draw through 2 loops 5 times.

QUAD STITCH (QUAD ST)

Yarn over 5 times, insert hook in stitch, yarn over and pull up loop (7 loops on hook), yarn over and draw through 2 loops 6 times.

sources for yarn

BIJOU BASIN RANCH

PO Box 154
Elbert, CO 80106
(303) 601-7544
bijoubasinranch.com

LHASA WILDERNESS

Black Bunny Fibers Yarns
blackbunnyfibers.com
BFL sock

CASCADE

PO Box 58168
1224 Andover Park E.
Tukwila, WA 98188
cascadeyarns.com
Cascade 220

DESIGNING VASHTI YARN

shop.designingvashti.com
Lotus

DREW EMBORSKY YARNS

drewemborsky.com/yarn
Gemstones

THE FIBRE COMPANY

Distributed by Kelbourne Woolens
2000 Manor Rd.
Conshohocken, PA 19428
kelbournewoolens.com
Road to China Light

FREIA YARNS

freiafibers.com
Ombré Lace

KNITTING ROSE YARNS

knittingrose.net
Budding Tracks Sock Yarn

KRISTIN OMDAHL YARNS

kristinomdahl.com
Be So Fine Yarn, Be So Sporty Yarn

LANTERN MOON

lanternmoon.com
crochet hooks

LOTUS YARN BY VASHTI

designingvashti.com
Lotus

LOUET NORTH AMERICA

3425 Hands Rd.
Prescott, ON
Canada K0E 1T0
(800) 897-6444
louet.com
Euroflax Lace

MALABRIGO YARN

malabrigoyarn.com
Merino Worsted, Silky Merino

MISS BABS HAND-DYED YARNS & FIBERS

PO Box 78
Mountain City, TN 37683
(423) 727-0670
missbabs.com
Alpacacita

ROWAN

Green Lane Mill
Holmfirth, West Yorkshire
England HD9 2DX
44 (0)1484 681881
knitrowan.com

TRENDSETTER YARNS

16745 Saticoy St. #101
Van Nuys, CA 91406
(800) 446-2425
trendsetteryarns.com
Tonalita

WESTMINSTER FIBERS

165 Ledge St.
Nashua, NH 03060
(800) 445-9276
westminsterfibers.com
Fine Art, Kid Classic

ACQUISITIONS EDITOR Kerry Bogert
EDITOR Erica Smith
TECH EDITOR Karen Manthey
COVER & INTERIOR DESIGN Kerry Jackson
PHOTOGRAPHY Donald Scott
STYLING Allie Liebgott
HAIR & MAKEUP Janie Rocek

CONTINUOUS CROCHET © 2016 by Kristin Omdahl. Manufactured in China. All rights reserved. No part of this book may be reproduced in any form or by any electronic or mechanical means including information storage and retrieval systems without permission in writing from the publisher, except by a reviewer who may quote brief passages in a review. Published by Interweave, an imprint of F+W Media, Inc., 10151 Carver Road, Suite 200, Blue Ash, Ohio 45242. (800) 289-0963. First Edition.

fw
a content + ecommerce company

www.fwcommunity.com

19 18 17 16 15 5 4 3 2 1

Distributed in Canada by Fraser Direct
100 Armstrong Avenue
Georgetown, ON, Canada L7G 5S4
Tel: (905) 877-4411

Distributed in the U.K. and Europe by
F&W MEDIA INTERNATIONAL
Brunel House, Newton Abbot,
Devon, TQ12 4PU, England
Tel: (+44) 1626 323200
Fax: (+44) 1626 323319
E-mail: enquiries@fwmedia.com

Distributed in Australia by Capricorn Link
P.O. Box 704, S. Windsor NSW, 2756 Australia
Tel: (02) 4560 1600, Fax: (02) 4577 5288
Email: books@capricornlink.com.au

SRN 16CR02
ISBN 978-1-63250-165-3 (pbk.)
ISBN 978-1-63250-166-0 (PDF)

To my sweet, smart, funny, caring, and silly teenager, Marlon. Wow: My first time calling you a teenager in a book! To think that I picked up a crochet hook for the first time when I was pregnant with you. I'm so proud of how hard you are working toward your dreams. Your lofty goals remind me of when I was your age, and they help me to remember I still have big dreams, too. The world is our oyster. With big dreams, big passion, and hard work, we can do and be anything we strive to be. I love you with all my heart and soul.

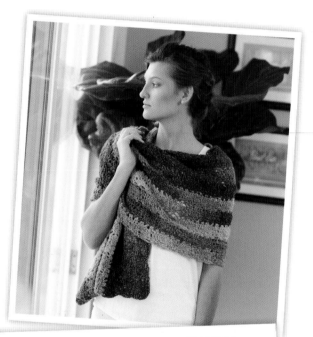

METRIC CONVERSION CHART

TO CONVERT:	TO:	MULTIPLY BY:
inches	centimeters	2.54
centimeters	inches	0.4
feet	centimeters	30.5
centimeters	feet	0.03
yards	meters	0.9
meters	yards	1.1

index

acknowledgments

I am extremely grateful to be part of this incredibly talented bookmaking team. While it may start with my ideas and vision, it is by no means a one-person show. Watching my ideas blossom into full-color photos dripping with gorgeous color and style is such a treat. I marvel at seeing my crazy ideas turn into technically sound charts and instructions. Without a talented team, none of this would be possible. I wish to thank my editor, Erica Smith, for her support and attention to details along the way (it's a much longer process to create a book than you may think) and Kerry Bogert for acquiring the book and helping to refine the book concept. Karen Manthey has been my crochet technical editor for years and many, many books. Thank you for your incredibly meticulous attention to details and for your patience in making my crazy look sane. Thank you to Kerry Jackson (book designer), Janie Rocek (hair and makeup), and Allie Liebgott (stylist) for capturing the casual, beachy, bohemian look that I love so much. Thank you to Donald Scott for the beautiful photography. I'm an outdoorsy girl, so seeing my passion for nature in the photography delights my heart. Thank you to my teenager for humoring mom during long hours of crocheting and writing and taking my work with me everywhere we go. Thankfully, my work is portable, and I can maintain my look of being a stay-at-home mom even though I work more than most full-timers.

Happy Crocheting

THANKS TO THESE RESOURCES FROM INTERWEAVE

CROCHET SO LOVELY
21 Carefree Lace Designs
Kristin Omdahl
ISBN 978-1-62033-689-2, $22.99

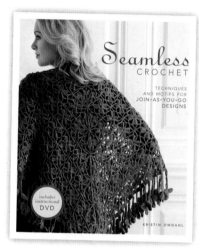

SEAMLESS CROCHET
Techniques and Designs for
Join-As-You-Go Motifs
Kristin Omdahl
ISBN 978-1-59668-297-9, $22.95

CROCHET SO FINE
Exquisite Designs
with Fine Yarns
Kristin Omdahl
ISBN 978-1-59668-198-9, $22.99

Available at your favorite retailer or **crochetme shop**
SHOP.CROCHETME.COM

INTERWEAVE CROCHET

From cover to cover, *Interweave Crochet* magazine presents great projects for the beginner to the advanced crocheter. Every issue is packed full of captivating designs, step-by-step instructions, easy-to-understand illustrations, plus well-written, lively articles sure to inspire. Visit interweavecrochet.com.

crochetme

Want to CrochetMe? *CrochetMe* is an online community that shares your passion for all things crochet. Browse through our free patterns, read our blogs, check out our galleries, chat in the forums, make a few friends. Sign up at crochetme.com.